Studio Photography

Essential Skills

Fourth Edition

John Child

Focal Press
Taylor & Francis Group
NEW YORK AND LONDON

First published 1999
This edition published 2013 by Focal Press
70 Blanchard Road, Suite 402, Burlington, MA 01803

Simultaneously published in the UK
by Focal Press
2 Park Square, Milton Park, Abingdon, Oxon OX14 4RN

Focal Press is an imprint of the Taylor & Francis Group, an informa business

Library of Congress Cataloguing in Publication Data
A catalog record for this book is available from the Library of Congress

ISBN: 978-0-240-52096-4 (pbk)

ISBN: 978-0-080-92693-3 (ebk)

Acknowledgements

Among the many people who have helped make this book possible, I wish to express my thanks to the following:

- Mark Galer, Les Horvat and Michael Wennrich for their help and advice.
- The students of RMIT University, Melbourne, for their illustrative input, enthusiasm and friendship.
- And to Gloria and my family for their continuing encouragement and understanding throughout my photographic career, thank you.

Contents

Introduction

Studio photography covers a wide range of disciplines. In its simplest form it is part of the documentation process for a driver's licence, ID, passport, etc.; at its most complex, cinematography and its role in the creation of films. Within this spectrum fall portraiture, fashion, still life, film library, product, advertising illustration, industrial, corporate and architectural. It may seem industrial, corporate and architectural are not studio photography but in most situations there is inadequate or non-existent illumination which must be supplemented or totally lit with artificial light. As lighting is the essential element in photography it is important to understand and improve this skill, along with the many others that contribute to the successful creation of studio images. This book deals with working in the studio using artificial light sources and on location using combinations of existing light sources and introduced lighting. The activities, assignments, basic photographic theory and useful practical advice provide the essential techniques for creative and competent photography.

Rodrick Bond

Acquisition of technique

This book concentrates on the acquisition and application of skills necessary for studio photography. The emphasis is on technique, communication and design within the genres of still life, advertising illustration, portraiture, fashion and lighting on location. Terminology is kept as simple as possible using common usage and avoiding complicated theoretical explanations.

Application of technique

The book concludes with several chapters devoted to the practical application of the skills acquired. Assignments can be undertaken allowing the photographer to express their ideas through the appropriate application of design and technique. This book offers a structured learning approach that will give the photographer a framework and solid foundation for working independently and confidently in a studio or on location.

The essential skills

The essential skills required to become a competent photographer take time and motivation. Skills should be practised repeatedly so they become practical working knowledge. Practise the skills obtained in one chapter and apply them to the next. Eventually these skills can be applied intuitively or instinctively and you will be able to communicate with clarity and creativity.

Process and progress

This book is intended as an introduction to studio photography. The emphasis has been placed upon a practical approach to the application of essential skills. The activities and assignments cover a broad range and it is possible to achieve acceptable results without the need for large amounts of expensive equipment.

A structured learning approach

The study guides contained in this book offer a structured learning approach forming the framework for working on photographic assignments and the essential skills for personal creativity and communication. They are intended as an independent learning source to help build design skills, including the ability to research, plan and execute work in a systematic manner. Adopting a thematic approach is encouraged, recording all research and activities in the form of a Visual Diary and Record Book.

Flexibility and motivation

The assignments contain a degree of flexibility, and allow for the choice of subject matter. This encourages the pursuit of individual interests whilst still directing work towards answering specific criteria. This approach allows the maximum opportunity to develop self-motivation. Emphasis is placed on image design, communication of content and the essential techniques required for competent and consistent image capture and creation. The practical problems of contrast are discussed and lighting in the form of flash and tungsten are introduced. Activities and assignments should be undertaken to encourage expression of ideas through the appropriate application of design and technique. Demonstration of skills learnt in preceding study guides is a desirable criterion whenever appropriate.

Implementation of the curriculum

This book provides a suitable adjunct to *Photographic Lighting: Essential Skills* and *Photoshop CS3 or CS4: Essential Skills*.

Web site

A dedicated web site exists to assist with the use of this book. Revision exercises are included on the site as are numerous links and up-to-date advice and references. The revision exercises should be viewed as another activity which the user resources and completes independently. This will encourage the demonstration of the skills and knowledge acquired in the process of working through the activities and revision exercises by completion of a self-directed series of projects and assignments in the books *Photographic Lighting: Essential Skills* and *Digital Photography: Essential Skills*. The address for the web site is: http://www.photographyessentialskills.com

Independent learning

The study guides are designed to help you learn both the technical and creative aspects of photography. You will be asked to complete various tasks including research activities, revision exercises and practical assignments. The information and experience you gain will provide you with a framework for all your future photographic work.

Activities and assignments

By completing all the activities, assignments and revision exercises you will learn how other images were created, how to create your own and how to communicate visually. The images you produce will be a means of expressing your ideas and recording your observations. Photography is a process best learnt in a series of steps. Once you apply these steps you will learn how to be creative and produce effective images. The study guides also explain many of the key issues which are confusing and often misunderstood – an understanding of which will reinforce and facilitate creative expression.

Using the study guides

The study guides have been designed to give you support during your photographic learning. On the first page of each study guide is a list of aims and objectives identifying the skills covered and how they can be achieved. The activities are to be started only after you have first read and understood the supporting section on the preceding pages. At the end of each chapter the relevant revision exercise from the supporting web site should be undertaken to determine the extent to which the information has been assimilated. After completion of the activities and revision exercises the 'Assignments' should be undertaken.

Equipment needed

The course has been designed to teach you studio photography with the minimum amount of equipment. You will need a camera with manual controls or manual override. Ideally you will need access to artificial light sources and a darkened work area. However, large amounts of expensive equipment are not necessary to gain an understanding of the use of light. Observation of daylight, ambient light, normal household light globes, desk lamps, outdoor lighting, torches and small flash units can be adapted and utilised to produce acceptable results. Supplemented with various reflectors (mirrors, foil, white card) and assorted diffusion material (netting, cheesecloth, tracing paper, Perspex) a degree of lighting control can be achieved. Many of the best photographs have been taken with very simple equipment. Photography is more about understanding and observing light, and then recreating lighting situations to achieve form, perspective and contrast when working with a two-dimensional medium.

Gallery

At the end of each study guide is a collection of work produced with varying combinations of daylight, ambient light, flash and tungsten light sources.

Research and resources

For maximum benefit use the activities as a starting point for your research. You will only realise your full creative potential by looking at a variety of images from different sources. Artists and designers find inspiration for their work in many different ways. Further, it is essential that the student of any creative endeavour has some understanding of the context of their art. Researching relevant artists and practitioners is an essential element of this process.

Getting started

Collect images relevant to the activity you have been asked to complete. This collection will act as a valuable resource for your future work. Do not limit your search to photographs. Explore all forms of the visual arts. By using elements of different images you are using the information as inspiration for your own creative output. Talking through ideas with friends, family, or anyone willing to listen will help you clarify your thinking and develop your ideas.

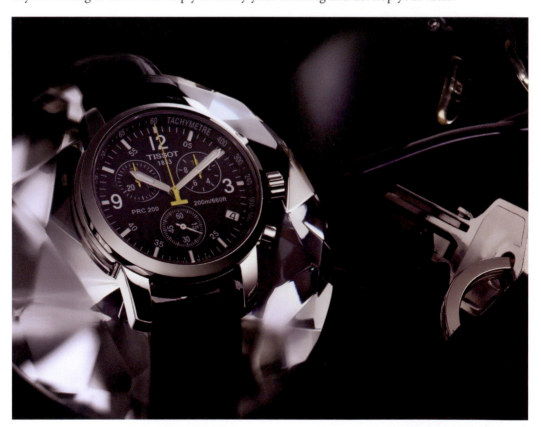

Daniel Tückmantel

Choosing resources

When looking for images, be selective. Use only high quality sources. Not all photographs printed are well designed or appropriate. Good sources include high quality magazines and journals, photographic books, exhibitions and the web.

Visual Diary

An important role in the development of the creative mind is discovering individual perspective by recognising that accepted rules and opinions are just the beginning of this process. A Visual Diary supports this process and becomes a record of visual and written stimulus influencing or forming the basis of ideas for the photographic assignments and practical work to be completed. In its most basic form this could be a scrapbook of tear sheets (examples) and personal scribbles. It would, however, be of far more value if your Visual Diary contained more detail relating to personal opinion and an increasing awareness of your visual development in discriminating between good and bad examples of lighting, design, composition and form applicable to any visual art form.

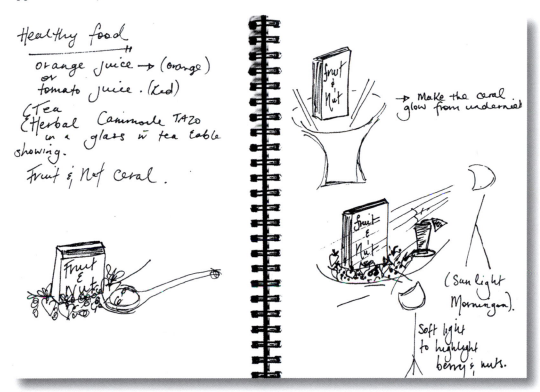

Joanne Gamvros

The Visual Diary should contain:

- A collection of work by photographers, artists, writers, filmmakers.
- Web site addresses and links.
- Sketches of ideas for photographs.
- A collection of images illustrating specific lighting and camera techniques.
- Brief written notes supporting each entry in the diary.
- Personal opinion and interpretation of collected images.

Record Book

The Record Book forms the documented evidence of the practical considerations and outcomes associated with the completion of each activity and assignment. It should contain comprehensive information enabling another photographer, not present at the original time of production, to reproduce the photograph. This is common professional practice.

Ball	26/04/08
Camera	Nikon D70
ISO	100
Lighting ratio	Spotlight f64
	Floodlight f45
	Reflector f32
Meter reading	Incident 2 seconds f45
Color balance	Tungsten
Exposure	3 seconds f45

Spotlight from back to create rim light. Floodlight from left, centre of light at point where front of ball falls into shadow. Creates gradual decrease in light across front. White reflector to right side of ball.

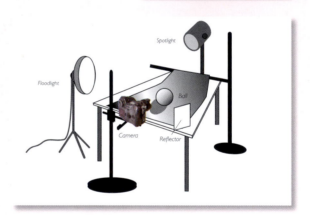

The Record Book should contain:
- An information sheet for each activity and assignment.
- Technical requirements and equipment used.
- Lighting diagram, camera to subject diagram, camera angle and height (measurements and specifications).
- Meter readings of light ratios and exposure.
- ISO and color balance.
- All digital files used to reach the final result.
- Props (use and source) and any other information relevant to each photograph.

Presentation

Research

With each assignment you should provide evidence of how you have developed your ideas and perfected the techniques you have been using. This should be presented in an organised way showing the creative and technical development of the finished piece of work. Make brief comments about images influencing your work. Photocopy these images and include them with your research.

Presentation

- Presentation can have a major influence on how your work is viewed.
- When presenting on-screen make sure the software and computer are compatible.
- Ensure all digital images are cropped and do not display edge pixels.
- Mount all printed work and label appropriately.
- Ensure horizontal and/or vertical elements are corrected (sloping horizon lines are visually disturbing).

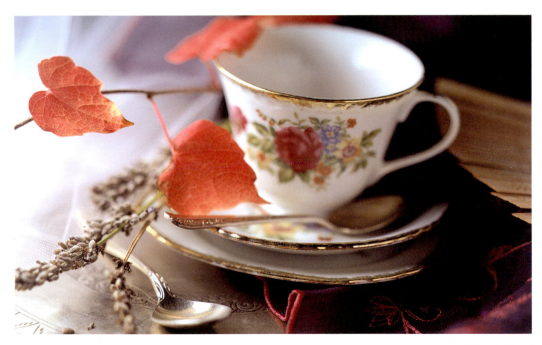

Shivani Tyagi

Storage

- It is best to standardise your portfolio so that it has an overall 'look' and style.
- Assignments should be kept in a folder slightly larger than your mounted work.
- Analog material should be stored in a dust- and moisture-free environment.
- Digital files should be burned to CD or saved to a portable disk or hard drive and stored away from magnetic devices that could corrupt the data.

History

The camera in its most basic form, the camera obscura, has existed since the time of Aristotle. As photographic emulsions became available in the mid 19th century, photographers began to build or adapt artists' studios to create photographic portraits. The camera and film took the place of the painter's canvas, brushes and paint. The primary source of light used by painters was, and in most cases still is, a large window or skylight facing away from direct sunlight, and usually above and to one side of the subject. Amongst many others this is best illustrated in paintings by Rembrandt, Michelangelo and Caravaggio.

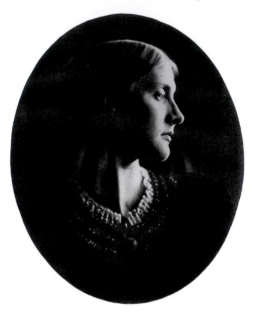

Julia Margaret Cameron,
Julia Jackson, Mrs. Herbert Duckworth/1867/
The Royal Photographic Society, Bath, England

Kata Bayer

Early portrait and still life photographs show photographers took a similar approach to lighting their subject. By the 1840s commercial portraiture, advertised as 'sun-drawn miniatures', had practically eliminated hand painted miniature portraits, and by 1854 the production of *cartes-de-visite*, or what we call today business cards, was thriving. Photography's major disadvantage compared to a painting was that it was black and white. Attempts were made to hand color these black and white images with limited success and early color film and processes in the late 19th and early 20th centuries were impractical. It was not until the 1930s that color film became capable of producing color at a consistent and reliable level.

Activity 1

Research examples of the use of similar light sources in paintings, early photographic portraits and contemporary photography.

Advancements in technology

Flash powder in its various forms was popular as a source of artificial light, but as electricity became readily available use was made of any new invention (vacuum tungsten lamp) giving a more controllable, safer, continuous source of light. Coupled with advances in lens and emulsion technology shorter exposure times were achieved. The availability of this controlled continuous light source made the use of photography in portraiture commonplace. Photography in commercial advertising took longer. The first use of photography appearing in newsprint using the newly invented halftone process was in the *New York Daily Graphic* in the 1880s. The first magazine entirely illustrated by photographs, the *Illustrated American*, was introduced in 1890. By 1915 most mainstream newspapers were using photography as their major source of illustration. Advances in camera and lens design, the development of film emulsions with faster film speed (its ability to record an image with a short exposure time) and the advent of digital capture, transmission and presentation are part of the continuing evolution of photography.

Fabio Sarraff

Light sensitive emulsion is no longer coated onto a glass plate prior to exposure. Since 1891 it could be purchased coated onto celluloid film. The ISO (film speed) has increased dramatically since the 1830s and color film, although first used in the late 19th century, has been commercially available since 1932. Early cameras were large and cumbersome as the 'print' (called a contact due to the negative being placed in direct contact with the photographic paper and exposed to light) rarely exceeded the size of the 'negative'. From cameras having a film format as large as 36 x 44˝ (the camera was mounted on wheels and drawn by a horse, c.1860) film technology advanced to the point where images of superior quality were recorded on a film format 24mm x 36mm (35mm) which in the case of motion pictures are projected to the size of the cinema screen without any apparent loss of definition. With digital imaging, where the image does not exist in any physical medium, enlargement is only limited by the number of pixels captured by the image sensor and the amount of memory available.

Current commercial practice

Although there has been a resurgence in the use of natural available light for portraiture brought about by capture media with greater latitude and dynamic range (increase in susceptibility to light and contrast), the majority of studio photographs are lit using artificial light. These light sources fall into four main categories.

Type	Color temperature	Output
Tungsten-halogen	3200K	to 20kW
Photoflood	3400K	to 1kW
AC discharge	5600K	to 18kW
Flash	5800K	to 10kW

Samantha Everton

Do not be confused by color temperature. If you choose to use film it is enough to know that you would achieve 'correct color' by using tungsten film with tungsten light and daylight film with AC discharge and flash. Black and white film is relatively unaffected by color temperature. When using digital capture set to auto white balance or choose from the menu the corresponding white balance to the known light source. See 'Light'. To best understand the output of these lights it should be taken into consideration that the average household light globe has an output of 100W. This means a 10kW (10,000W) tungsten lamp will have an output 100 times greater.

Methodology

The difference separating studio photography from all other forms is that the photographer has to create everything appearing in front of the camera. In most cases the photographer's starting point is an empty studio. With other forms of photography there is usually an environment, subject or distinct mood already in existence. Even if a subject does exist (person, product, etc.) what is the environment or context into which you are going to place that subject? In some cases it could be a simple white background, at other times something more complex. Whatever the solution, the photographer has to previsualise, pre-produce and create an environment using not only selected equipment, subject matter, props and maybe wardrobe but, far more importantly, light.

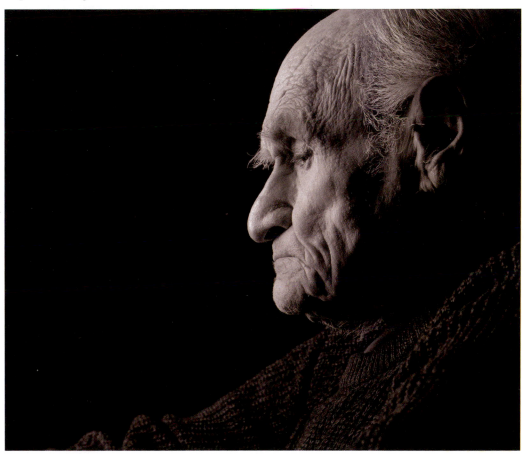

Tracey Hayes

Activity 2

Research examples where the subject matter is accentuated by the use of a plain background and where the subject is separated from a complicated background by the use of light and contrast. Having established this difference, find examples where the image is confusing because of a lack of attention to this basic concept.

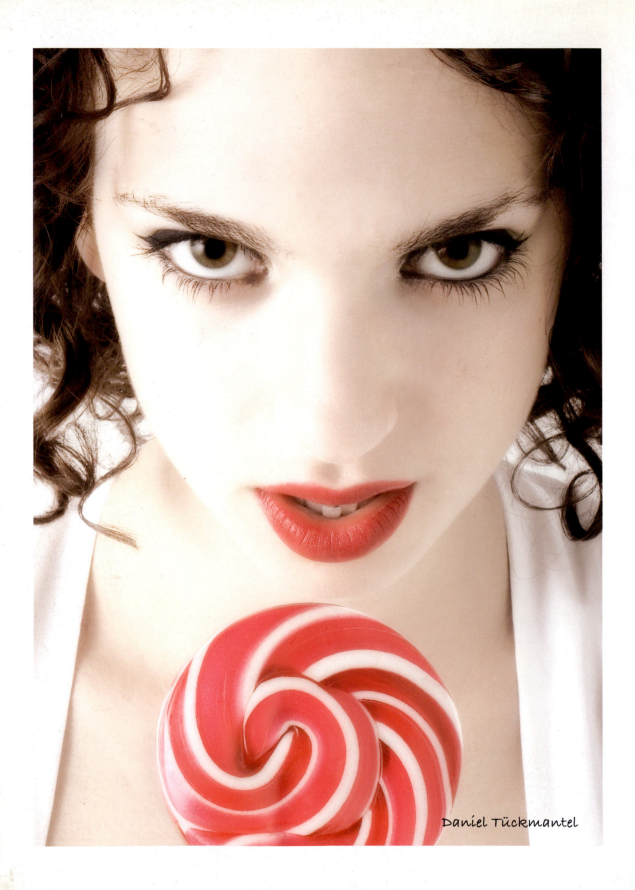

Daniel Tückmantel

studio genres

Rodrick Bond

essential skills

- An understanding of the history and development of the various genres of studio photography.
- An awareness of how photography changed our everyday life and how attitudes changed styles of photography.
- Producing research information related to the various genres of studio photography.
- Documenting the progress and development of your ideas.

Introduction

The limitations of the photographic medium determined the first photographs were of still life subjects. Within a short period portraits of people capable of keeping still during the long exposures required were possible. As photographic technology advanced diversification took place. The physical and financial restrictions placed upon family portraiture diminished as film and lens speed increased. As printing and reproduction processes developed, photography was used more and more as the primary source of visual reference. Today studio photography covers many genres. Within these fall advertising illustration, portraiture, corporate, architectural, film library and product photography. Advertising surrounds us in an urban environment, but within advertising illustration there are many other genres. Fashion, food, product, still life, car photography, etc. Each is a specialised area, but all have a common outcome. Communication. The style and power of visual communication have evolved in parallel with photography to the point where they are inseparable within the current concept of mass media. By definition, commercial practice means that as a photographer you become part of the marketing mechanism by which manufacturers advertise their product. It becomes your responsibility to communicate its visual merits and advantages. The fashion photographer on the other hand is trying to create an overall effect by communicating 'lifestyle' as a product merit. The catalogue photographer is more concerned with producing large volumes of work without sacrificing product detail. The main street portrait photographer is expected to make 'little Johnny' look like 'little Johnny' and the studio wedding and baby photographer is being paid to ensure a faithful record is kept of family members and sometimes to glamorise the ordinary.

Rodrick Bond

Advertising illustration

Advertising illustration covers many photographic genres, the most often seen being still life (product) and fashion. The greatest commercial user of photography is the mass media. In newspapers, magazines and the www the majority of images are advertisements for one product or another. Photographic advertising illustration began when there was the capability to produce reproductions in large numbers. It has since become an effective tool of the advertising industry. The use of photography for advertising illustration started in the 1850s but was restricted to actual prints handed out to customers. Halftone printing processes saw the introduction of photographs for advertising during the 1880s. Black and white photographs were widely used by the 1920s and reliable color reproduction became the dominant medium for advertising illustration from the 1950s.

1930　　　　　　　　　　　　　　　　　　　　　*Samantha Everton*

During the 1970s and early 1980s advertising photography became synonymous with expensive high quality imagery and reproduction. This created the environment where the skills photographers applied to lighting their photographs were used in the production and lighting of TV commercials. Prior to this the inherited limitations of television technology had meant that the approach to lighting was generally to turn on all the lights, flood the subject with sufficient light and keep contrast to a minimum. In advertising the primary purpose of the photographic image is to communicate information and attract attention. This is achieved by an image being used to support the headline and body copy or as the basis of the whole concept. See 'Art direction'.

Activity 1

Research old magazines and newspapers to trace the changes in styles of advertising over the last thirty years. Collate with publication dates and place in your Visual Diary.

Still life

The first photograph taken using light sensitive emulsion was a still life of the view from Niepce's workroom window (1826). This was due more to the length of the exposure (about eight hours in bright sunlight) than a creative decision to photograph something that didn't move. Early photography copied the approach of painters to their subject matter. This led to most examples of photographic images being centred on the stylised still life so popular with artists. The still life not only suited the long exposure times required by the film emulsions of the day but also provided a subject with which the photographer and the limited viewing public were familiar. Since then extensive use of still life has been used in advertising and commercial illustration. This can range from sophisticated photographs of perfume in expensive international magazines, visually and technically precise shots for the latest online car brochure to product catalogues that turn up in your mail box. In its current commercial form, still life photography falls into two categories. Large and small. Small is called table top, but size is only limited by the size of the table. This could be anything from a watch, a can of beans, a TV, to a sumptuous banquet. Large is everything else. Room sets, cars, trucks, right up to a Boeing 747.

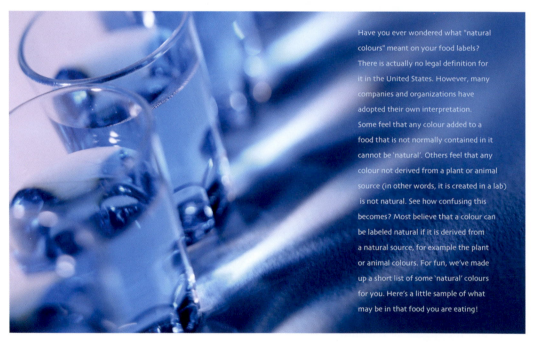

Have you ever wondered what "natural colours" meant on your food labels? There is actually no legal definition for it in the United States. However, many companies and organizations have adopted their own interpretation. Some feel that any colour added to a food that is not normally contained in it cannot be 'natural'. Others feel that any colour not derived from a plant or animal source (in other words, it is created in a lab) is not natural. See how confusing this becomes? Most believe that a colour can be labeled natural if it is derived from a natural source, for example the plant or animal colours. For fun, we've made up a short list of some 'natural' colours for you. Here's a little sample of what may be in that food you are eating!

Pauline Tanuwidjaja

Activity 2

Find examples of still life photography. Your research should cover national and international magazines, newspapers, car brochures and junk mail.

Compile your examples, in your Visual Diary, into a comprehensive presentation exploring the relationship between the quality of the photography and its purpose.

Portraiture

The first commercial use of photography was in the reproduction of portraits. Until photography became commercially viable painters had been the main source of portraiture. The process involved was long and painstaking for both the painter and the subject and the result was always only one picture. The photographic process was much shorter, almost immediate by the standards of the day. With the introduction of Calotypes in 1840 the production of a negative enabled the photographer to print as many copies as the customer required. In the 1850s small portraits called Ambrotypes were being produced with exposure times of between two and twenty seconds. These relatively short exposures made family portraits easier to co-ordinate and photograph. Photography became the primary visual history for families. Photographic portraiture remained, however, the privilege of the affluent.

In 1854 the French photographer Disdéri made a major technical advancement. His process of exposing multiple images onto one negative (similar to multiple image passport cameras) substantially reduced the cost of portrait photography. He was one of the first photographers to promote photographs to the level of consumer desirables. He began the business of photographing celebrities, producing large numbers of prints and selling them to the public as a purely profit-making exercise. The celebrity pin-up, family portrait, wedding or new baby photographs were no longer the domain of the wealthy. This affordability was the beginning of the photographic industry as we know it today. By the 20th century photographic portraiture was available to everyone. The Kodak Camera released in 1888, followed by the Box Brownie in 1900, created a worldwide market for amateur photography. Although not photographed in a studio the average snapshot has people as its dominant subject. Millions of photographic portraits are now taken every day.

Tracey Hayes

Activity 3

Through the use of family albums trace the development of photography from black and white to digital color. Compile in chronological order in your Visual Diary.

Commercial portraiture

Portraiture began to appear regularly in magazines such as *Vanity Fair* and *Vogue*, the forerunners of the pin-up and glamour magazines, after WW1. The content of the portrait was usually a celebrity of the time. The glamour portrait was to remain a benchmark until the 1960s when photographers such as Diane Arbus started to challenge the normal attitudes to portraiture with photographs of the less fortunate and society fringe dwellers. Between the wars, with the availability of high quality small format cameras, a genre known as 'environmental portraiture' became popular, with photographers such as Arnold Newman being one of the main exponents. The major difference between the two genres, studio and environmental, is that, as the name implies, the subject is photographed in their environment (home, workplace, etc.) and not in a formalised studio situation. At a commercial level the local photographer, found in the main street of most towns and cities around the world, has enough skill and technology available to produce a more than acceptable image. However, the role of the commercial portrait photographer has been seriously challenged since the introduction of fully automatic cameras and the constantly developing digital technology. The great portrait photographers, amongst them Yousuf Karsh and Richard Avedon, commanded large fees, and limited prints of their work are sold at a comparative level to works of art. They and others made photographic portraiture equal in stature to the painted images photography had tried to replace. The whole process has gone full circle leaving a legacy of thousands of practising portrait photographers.

Kata Bayer

Fashion

The first halftone reproductions direct from a photograph were appearing on a regular basis by the 1880s in magazines such as *Les Modes* and *Vogue*. Until then a photograph was used as source material to create a woodcut or lithograph as part of the printing process. The images were rigid portraits. An inanimate person in a very structured environment. This was due not only to an inherited approach to the painted portrait but also to the limits placed upon the photographer and subject by long exposures. The requirement of the image was to show the design and quality of the garment as clearly as the processes of the time allowed. This was the start of what is now one of the most lucrative and sophisticated genres of photographic illustration. From about 1911 onwards the use of soft focus and romanticism changed the look of fashion images appearing in *Vanity Fair* and *Vogue*. This was not a unique approach. The work of Julia Margaret Cameron had preceded this by over sixty years, but it was the first use at a commercial level in what we now call the mass media. It was not until the second decade of the 20th century that photographers such as Edward Steichen took fashion photography away from so-called high fashion into the arena of 'style' with which it is associated today. As the attitude of women began to change in the 1920s so did the approach to how they were photographed. They were no longer objects on which to hang clothes but independent personalities who happened to be wearing clothes. Fashion photography of the 1930s and 1940s reflected the feelings and limitations of the time. Fashion and design were determined by the materials available leading to an austere but natural approach to its imagery.

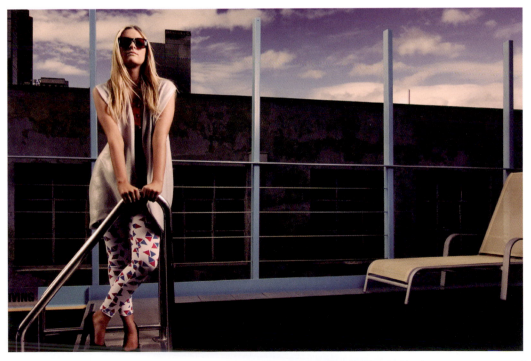

Tomas Friml

Fashion since 1950

Gradual change took place in the post-war 1950s. By the 1960s and 1970s gender equality and the use of color with its ability to create mood and excitement began to dominate fashion images. Youth culture became fashion and fashion became youth culture. A controversial change came in the late 1980s when a strong sense of independence, non-gender specific sexuality, eroticism and voyeurism became a dominant theme in fashion magazines and magazines featuring fashion. A style developed with great success by Helmut Newton and Guy Bourdin. The antithesis to this was the dream-like work of Sarah Moon where the image had a lyrical sense of imagination and unreal but desirable perfection. The garment was no longer the important object in the photograph. What wearing the garment could do for you was now the message. Throughout the development of fashion photography there was a distinction between advertising (design and quality) and editorial (lifestyle). The difference is now hard to distinguish. Fashion photography has reached the stage where lifestyle and image are so important that at times the design and quality of the clothes being worn by the model become obscure.

Alison Saunders

Activity 4

Compile a pictorial history in your Visual Diary, using magazines and books as reference, of the changes in the style of fashion and fashion photography over the last twenty years.

Jeph Ko

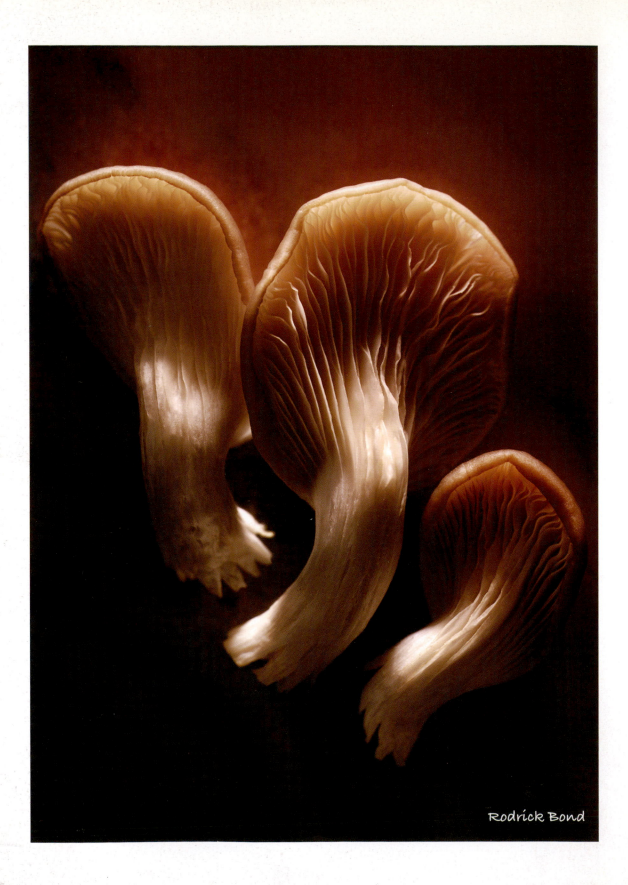

Rodrick Bond

communication and design

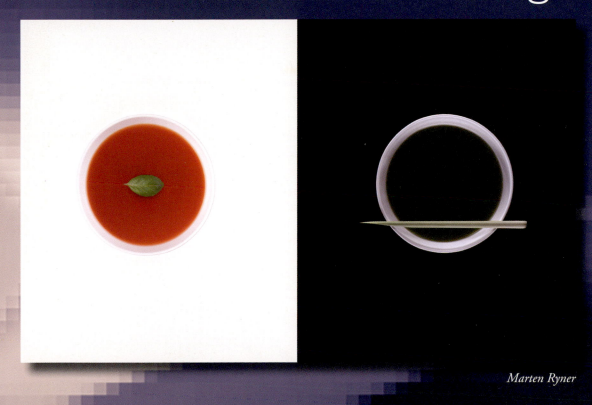

Marten Ryner

essential skills

- An understanding of how a photograph is a two-dimensional composition of lines, patterns and shapes.
- An understanding of how photographic technique can influence the emphasis and communication of the image.
- Produce research showing an understanding of composition and design in the creation of images.
- Complete a series of activities exploring the importance of communication and design in photographic imagery.

Introduction

In the context of communication and design there is no right or wrong, only good and bad relative to the styles and tastes of the day. Unlike most other genres of photography the inspiration for a studio photograph has to be preconceived. Studio photographers cannot observe, compose and interpret by pointing the camera at the world around them. In a darkened studio there is no world around them. The studio photographer has to create or obtain everything appearing in front of the camera. Compared to other forms of photographic illustration this could be seen as a disadvantage. In actual fact it is a major advantage as the photographer has total control over all aspects of the photographic process. Studio photography is not a random process. It should be highly pre-produced and previsualised. Studio photographers, especially in the area of still life, do not capture images. They construct images. This enables the photographer to compose and design a photograph almost without restriction. The studio photographer can change perspective, contrast, point of view and lighting at will. When coupled with astute observation of the subject there are few limitations inhibiting the design and composition of a photograph. Every element can be changed or moved to improve the image. It is the photographer's skill that can turn a mundane subject into a remarkable image.

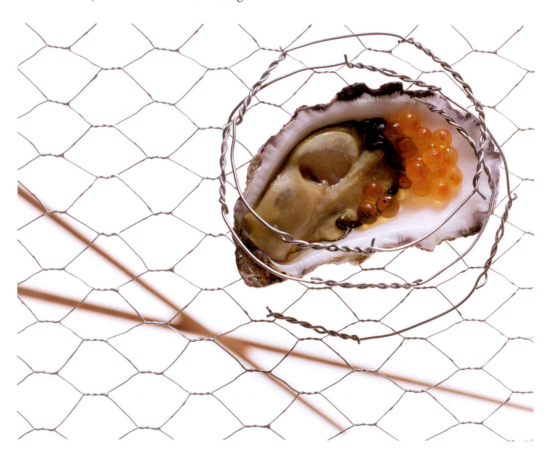

Jacqui Melville

Context

In reality the context of a studio photograph is the studio environment. The photographer can, however, create a different environment in which to place the subject. The context of the subject is therefore determined by the photographer and not by the subject. This enables a studio photographer to control, to varying degrees, the amount of information and thereby communication within each image. The image can be made obvious or ambiguous. Advertising illustration often excels at making the message obvious. Abstract images are by their very nature ambiguous. It is the viewer's interpretation of the photograph the photographer is attempting to influence. A viewer can be guided towards an objective opinion by placing the subject on a plain background (e.g. an egg on a white background). The information is singular and indisputable. However, if the egg is placed in a box of straw and lit and composed in such a way as to imply the egg is no longer in a studio, the viewer will be inclined to form a subjective opinion about the image. Imagination will create an environment 'existing' outside the frame of the photograph.

Tracey Hayes

Activity 1

Research (other than product and catalogue photography) and compile examples in your Visual Diary where you feel the viewer is being guided to make an objective opinion. Discuss what could have been changed in the photograph to encourage the viewer to make a subjective opinion.

Format

Format describes the size and proportions of an image. It applies to both 'image format' and 'camera format'. The difference need not be confusing as the outcome is the same.

Image format

A vertical image is described as 'portrait format' even though the dominant composition may be horizontal. A horizontal image is described as 'landscape format' even though the dominant composition may be vertical. The terminology dates to when artists first started to turn a rectangular canvas one way or the other to suit their subject matter. When working with an art director or designer the image format will be determined by the layout and final medium. In editorial work photographers must often ensure images are composed using both formats. This enables greater flexibility with page design.

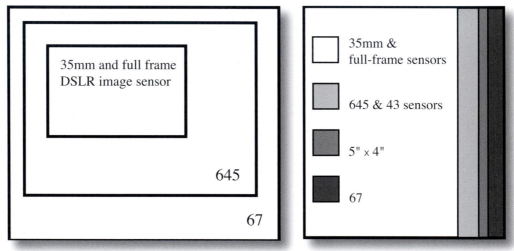

Relative size of formats *Relative shape of formats*

Camera format

Format also describes the size of camera being used (small, medium or large). Each of these cameras produces a different size image. The decision to use a particular format may lie with the client's requirements for reproduction (image quality) or the practicalities of one camera over another. Small format cameras frame images narrower than the proportions of a single page. The 6 x 4.5 and 6 x 9cm medium format cameras frame images in proportion to the size of this page. That is to say, if the size of the image was increased to the size of this page the image would fit exactly. The 6 x 6, 6 x 7, 6 x 8cm medium format and 5 x 4" large format cameras frame images shorter than the proportions of a single page. In these cases some of the visible image in the viewfinder will be lost when reproducing a full page image. This is easily monitored when using a digital back or camera with a computer interface and can therefore be taken into account when composing an image required to fit a specific layout format. See 'Art direction'.

Content

Viewing the subject in relation to its background is essential to forming an understanding of compositional framing. By definition a background is something secondary to the main subject. It should be at the back of the image and of relatively less importance. This does not mean it should be ignored, but should be controlled. It is a common fault to position the camera too far away from the subject. This is compounded by the problem of filling in the empty space (background) created by this point of view. Too much information can lead to confusing photographs. Keep it simple is often the best rule. Move closer, reduce the background to a minimum. Move even closer until the subject fills the whole frame and becomes the dominant part of the composition. A truck full of props is no substitute for a strong visual awareness of the virtues and merits of your subject, a preconceived idea of its context and the purpose of the communication.

Daniel Tückmantel

Activity 2

Research contemporary sources (other than product and catalogue photography) to find examples of photographs where the photographer has reduced the visual importance of the background to enhance composition and focus attention on the main subject.
Compile in your Visual Diary.

Balance

In nature there is a natural balance or harmony of texture, shape, form and color. Many objects upset this balance and impair the visual relationship between one object and another. It is this control of balance by the photographer, whether to achieve harmony or discord, that determines the level of acceptance of an image by the viewer. As humans we naturally gravitate towards a balanced image (symmetrical). When there is symmetry between the elements within the frame the image is said to have a sense of balance. A balanced image although pleasing to the eye can sometimes appear bland and conservative. Knowing this a photographer can change the balance of an image to achieve a different result. A dominant element of balance is visual weight created by the distribution of light and dark tones within the frame. To frame a large dark tone on one side of the image and place tones of equal visual weight on the other side will create an imbalance. An unbalanced image (asymmetrical) will often create visual tension, interest and a sense of things not being as they should be. The communication of harmony or tension is the deciding factor when composing an image intended to convey a specific message.

Fabio Sarraff

Activity 3

Research examples where the photographer has used imbalance to create tension and examples where the photographer has used visual balance to create visual harmony.

Composition

Composition is not a question of getting all the relevant information in the frame. Although information is necessary it is more important to attract and keep the viewer's attention. This calls for composition where the subject matter receives prominence without distraction from other elements within the frame. In this way composition complements communication. The image should encourage the viewer to explore without complicating the communication and decreasing the importance of the subject matter. The subject should be viewed as a two-dimensional object. This will help the photographer become aware of distractions to the composition that could confuse the communication. Avoid placing the main subject matter in the centre of the image. Use the whole frame in which to compose your image. You are paying for every part of the image, so use it.

Rule of thirds

Rules of composition have been formulated over the centuries to help artists create harmonious images. The most common of these rules are the 'golden section' and the 'rule of thirds'. The golden section, dating back to the time of Ancient Greece, is the name given to the traditional system of dividing the frame into unequal parts.

The rule of thirds

The rule of thirds is the simplified modern equivalent. Visualise the viewfinder as having a grid which divides the frame into three equal segments, both vertically and horizontally. Use these lines and their intersecting points as key positions to place significant elements within the image.

Activity 4

Research examples of photographs that follow the rule of thirds and examples that do not. Discuss whether the same subject matter could be made to work with a different approach to composition and design. Could breaking the rules improve the communication?

Point of view

Working in the studio a photographer has ample time in which to explore the subject in great detail. With the exception of fashion and portraiture the studio photographer is not limited to capturing the precise moment in history that will never occur again. This creates the opportunity to view the subject from all possible angles without the risk of 'losing the shot'. Start with, but do not immediately dismiss, the 'normal' viewpoint. Then look for something different and unusual but still capable of communicating with the viewer. Try different focal length lenses. Try climbing a ladder or lying on the floor. Forget how you would see the subject from a normal vertical position and try to visualise how the camera, which is not subject to any normal viewpoint, might be used to interpret the subject.

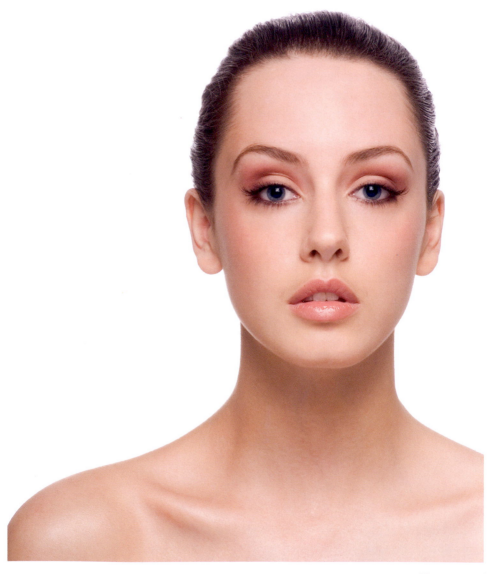

Tomas Friml

Line

Western visual culture has determined the way we look at images. From the moment of our first visual encounter with images and the written word our eye has been conditioned to viewing what is in front of us following certain patterns of perception. We instinctively scan images from top left to bottom right. The same way we read. This element of design is a major factor in the success of the communication. Lines, whether horizontal, vertical or diagonal, lead the viewer around an image. If the flow of the image is easy to follow, and therefore unnoticeable, the intended communication is more likely to succeed. If the flow is interrupted by poor use of line the viewer will lack visual guidance, not understand the communication and possibly disregard the image.

Horizontal lines

The horizontal line is often the dominant line in an image. Everyone is aware that the horizon is level to their normal viewpoint. Horizontal lines within the image will give the viewer a sense of stability and balance when correctly aligned with the edge of the frame. Incorrect alignment may upset this static perception and the image could appear unbalanced.

Vertical lines

Our perception of the vertical line is as strong as that of the horizontal. Its use in composition and design is similar. The horizontal line divides an image from top to bottom, vertical lines divide an image left to right. The horizontal line guides the viewer left to right, the vertical line guides the viewer top to bottom. When correctly aligned to the edge of the frame vertical lines will give a static composition with a sense of strength, power and dominance. When vertical lines are tilted within the frame this perception is reduced and replaced with a sense of imbalance. However, converging vertical lines create perspective and can lead the viewer to an implied horizon and visual stability.

Diagonal lines

Horizontal and vertical lines when correctly aligned to the frame create a sense of stability relative to a normal viewpoint. Diagonal lines are not relative to the normal perception of stability and are therefore viewed as unstable and precarious. Whether actual or perceived the visual tension created by the use of diagonal lines can lead to dynamic composition and a sense of movement within the image.

Curves

Images are viewed from top left to bottom right. A curved line achieves this progression in an unobtrusive and orderly way. Curved lines are soothing to the eye and depending on their degree of curvature unlikely to create visual tension and discord. When placed close to the edge of frame the effect of the curve is greatly enhanced.

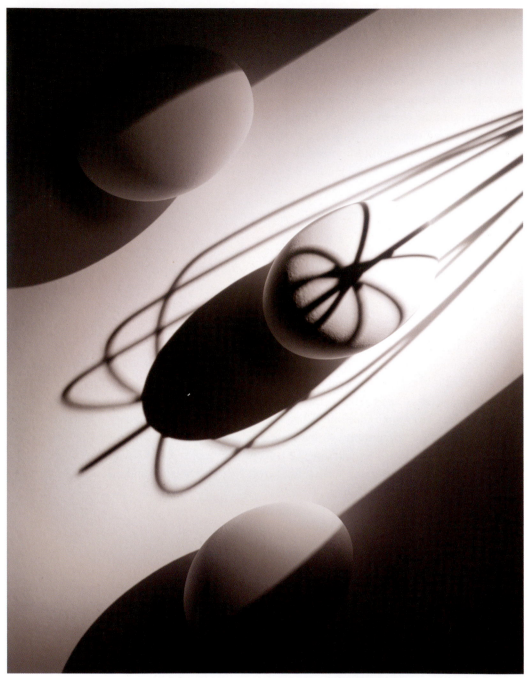

Rodrick Bond

Activity 5

In the example above discuss which elements of design have been used to the best effect. Is one design element stronger than another?

Find examples where the photographer has used horizontal line to create stability and examples where the photographer has used vertical line to create visual dominance.

Depth

A photograph is usually a two-dimensional representation of a three-dimensional subject. To imply a sense of depth within an image a studio photographer can artificially create dimension by placing objects in front of (foreground) and behind (background) the main subject matter. The foreground objects will appear larger than the subject and the background objects will appear smaller. This illusion of depth can be increased by careful use of line, tonality, contrast, color, depth of field and framing. When these elements work successfully the viewer will create the third dimension in their mind.

Natarsha Gleeson

Perspective

Visual perspective is achieved by the creation of depth and distance within a two-dimensional medium. Our perception is that parallel lines converge as they recede towards the horizon and objects diminish in size as the distance between them and the viewer increases. Because the human eye has a fixed focal length this perspective cannot change. Most cameras, however, can be used with lenses of differing focal lengths. This means the photographer can alter perspective by changing the focal length of the lens. A normal lens has a perspective similar to the human eye. A long lens will compress perspective and create the illusion that elements within the frame are close together. A wide angle lens will exaggerate perspective, distort the perception of distance and scale and create the illusion that elements within the frame are further apart. See 'The studio'.

Shannon Pawsey

Martin Reftel

quick cooling ❄

Rodrick Bond

FUJITSU

art direction

precious.

metal.

Rodrick Bond

essential skills

- An understanding of the process of working with an art director, art direction terminology and outcomes.
- An awareness of how photography is influenced by the demands of a layout and the requirements of a client.
- Produce research containing references and visual information relating to the role of art direction.
- Complete a series of activities relevant to the process, terminology and outcomes of photographic illustration and art direction.

Introduction

Unless working exclusively as a portrait photographer, most commercial photographic projects, whether editorial or advertising, still life or fashion, will involve working with art direction. This involves working to a specific set of guidelines set by the art director or designer and for most of the time having that person 'looking over your shoulder'. The art director is responsible for more than just ensuring you take a good photograph.

Working with art direction

Most commercial assignments are at the request of someone else – the client. It is this commissioning process that makes it the photographer's role to supply the client with the photograph they are prepared to pay for. Because they are paying they have a say in how you photograph the subject, whether it be a car, themselves or someone's dog. It is important to take note of their requests and supply a photograph complying with their requirements. The process should be a combination of the skills of all the parties involved.

Editorial assignments have less contrived and predetermined guidelines within which a photographer has to compose and produce a photograph. The brief is usually governed by the number of photographs per page and an outline of the general content of the subject matter in relation to the text.

With an advertising agency or designer, where the role of the art director is very much an integral part of the production of the final photograph, the requirements are far more precise and demanding.

Art directors and designers

Before a photographer is commissioned to illustrate an advertisement, the art director/designer would have submitted countless ideas at numerous creative meetings. These meetings involve the creative team (art director and copywriter), the creative director (leader of all creative teams within an advertising agency) and in the initial and final stages, the client. This process can be long and arduous. Many ideas will be submitted but only one will be accepted by all parties. By the time the surviving idea reaches the photographer the idea and layout have become very refined and precise. It is imperative therefore that the photographer produces exactly what is wanted. In these circumstances photographer and art director/designer work as a team so a result acceptable to a third party (the agency's client) is achieved. Working to an agreed plan, known as a layout, is the blueprint all concerned follow in order to produce an end result acceptable to all.

Activity 1

Using magazines, newspapers and direct mail advertising collect a series of advertisements having varying amounts of art direction and copywriting. A direct mail catalogue will have less art direction per image than an advertisement for an international perfume.

Compile in your Visual Diary advertisements you consider more effective than others.

Layouts

A layout is the format decided by an art director/designer into which the photograph, headline and body copy (text) have to combine to form an integrated whole. It is a guide to ensure that all the elements visually fit together and become a piece of art work that serves, in the case of advertising, the purpose of attracting attention to the product. Rarely does the photographer have the opportunity to take photographs and have the art director incorporate headline and body copy later. It is nearly always the other way around.

The graphic designer and art director's role is to take all the components (photograph, headline, body copy, client logo) and assemble them in a cohesive form. The finished piece of art work must be acceptable to the client and capable of being produced and released to the media on budget.

After the initial briefing at which the photographer is informed of all the requirements of the photograph, most clients will request an estimate of costs to produce the photograph. Upon acceptance of this estimate a period of time (pre-production) is allowed in which to prepare for the shoot. This involves the complete organisation of all the elements required to be in the final photograph. It is at this stage that the photographer should offer information and advice regarding the practicalities of the layout. If it is obvious to the photographer that elements of the layout are not achievable at a practical or financial level it should be mentioned at the briefing or during the pre-production period. Do not leave it until the day of the shoot. Throughout this process it is important to constantly relate back to the layout and the brief. It is better to oversupply equipment and props than to be short on the day when your reputation as a photographer and organiser is on display. Leave nothing to chance. Organise.

Organisation

Do not assume all the equipment will work. Check everything first. Do not limit your choice of lenses and associated equipment. Assume art directors may change their mind or request an adaptation to the original idea as the photograph takes shape. If you suggest changes ensure you can fulfil your idea. If the brief asks for a plate and a water melon make sure there are at least six different plates and a selection of water melons available to choose from. If the brief asks for a black and white image be prepared to adapt when a request is made for color and their inherent larger file sizes. Oversupply and overcompensate. See 'The studio'.

Activity 2

Using current magazines, newspapers and direct mail advertising collect and photocopy a series of advertisements. Cut out each element, headline, body copy, logo and photograph and collate separately in your Visual Diary.

With other students mix and match elements from various advertisements.

Is there a general pattern to photographic illustration when used for advertising?

Does the product sometimes determine the aesthetic photographic approach?

Framing the image

Photographs used in completed pieces of art work are rarely random images. They are images relating to the message the art director is attempting to get across to the public. It is essential to understand fully what the art director is trying to say with this combination of words and pictures. Suggestions by the photographer are usually welcome if there is a genuine attempt to improve on the outcome and communication. To suggest radical changes will meet with resistance. This may not necessarily be because the art director disagrees with you but because any major change would require a resubmission to the agency of any new idea differing from what the client has agreed to pay for. This is valid in any form of commissioned photography. If someone is paying you to photograph their dog in his favourite kennel suggest variations upon this theme but do not be surprised if you meet resistance when you suggest the idea of maybe photographing the dog in a bath full of bubbles. It may seem like a great idea to you but the client may hate how the dog looks when it is wet. Do not feel obliged to make any suggestions if it is obvious that the client has a firm opinion of what they expect from you. Judge each job on its merits.

Format

As well as creative constraints there are physical restrictions to composition. If the layout is a single full page advertisement the camera should be orientated to a portrait format (vertical). A double page spread would see the camera set to landscape (horizontal) and allowance made for the inclusion of a gutter (where the staples go) when composing the photograph. A double page spread should look as if it is one photograph although made up of two separate but connected images. A billboard would be horizontal format, an in-store poster could be either. This is a guide where the rules can change. Once the orientation and format have been decided allowance for areas within the composition must be left for the headline, body copy and the printing process.

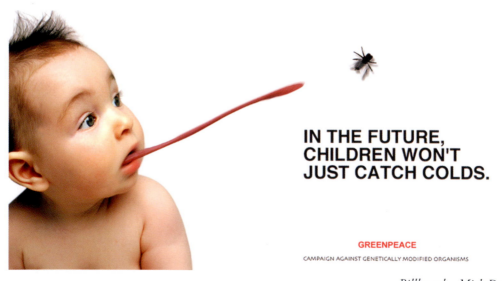

IN THE FUTURE, CHILDREN WON'T JUST CATCH COLDS.

GREENPEACE

CAMPAIGN AGAINST GENETICALLY MODIFIED ORGANISMS

Billboard – Mick Downes

Text and bleed

In a single full page advertisement where the photograph is printed to the edge of the page the text (words) will be printed over the image. The choice of typeface used to print this text is chosen by the art director. The positioning of these various pieces of text (headline, body copy) is known as typography. In a single page advertisement where the photograph is contained within the page the typography will appear on the page and not over the image. These rules also apply to double page spreads, 24 sheet posters (billboard), point of sale (usually close to the product), in-store posters, catalogues and any form of finished art where there is a combination of photography and words.

Bleed is the term that refers to the amount of excess image area allowed around the edges of a photograph that will disappear in the printing process. This is done to eliminate the possibility of white edges appearing when the finished piece of art work is printed. If the art work is slightly greater in size than the paper it is being printed on any chance of the edges of the paper not being printed has been reduced. This is especially important with very large print runs.

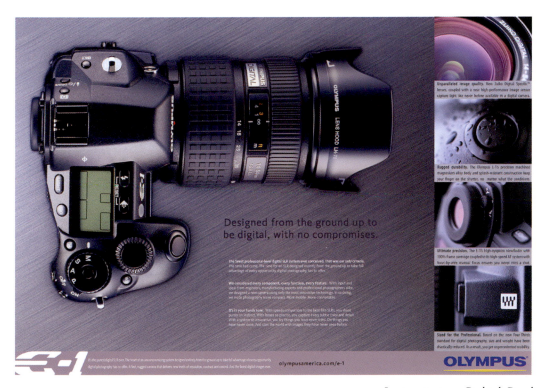

In-store poster – Rodrick Bond

Activity 3

Find examples of the various photographic formats used in magazine and newspaper advertising and examples where different formats have been used for the same advertisement (e.g. single page and billboard).

Discuss, compare and compile in your Visual Diary.

...and the dish ran away with the spoon

Rodrick Bond

COUNTRY ROAD
HOME

Daniel Tückmantel

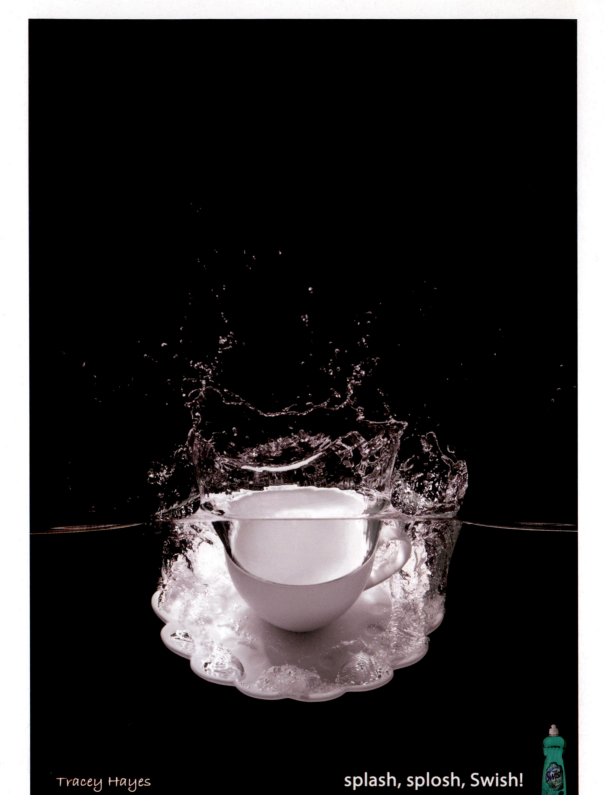

Tracey Hayes

splash, splosh, Swish!

the studio

Abhijit Chattaraj

essential skills

- An understanding of the use of artificial light sources, camera and associated equipment in a studio environment.
- An awareness of the equipment and organisation required for the photographic control of lighting ratios, contrast and exposure.
- The study and observation of the importance of the studio in the production of photographic images.
- The compilation of reference and visual information influencing the approach taken to produce the photographs for each activity.
- To produce photographic images and collate information relevant to the technique and production of each photograph.

Introduction

Studios range in size from small areas surrounded by black curtains to large film stages in Hollywood. The instant photographic booths found in many public areas are miniature studios. They are an area devoid of external light in which there is a controlled light source. This is the basis of any photographic studio. Size is not as important as efficiency. To set up a studio that will function within the requirements of this book need not be a complex or unachievable task.

Size

A floor area for each photographer working with camera, lights and table-top set-up should be approximately 6m x 6m, with a working height of 4 metres. This is an ideal minimum. The reality is sometimes different. Whatever size can be achieved it is important to ensure the area is uncluttered and free of anything that could cause injury. Bear in mind that other than the lit subject the studio area will be in almost total darkness.

Power

After determining size the most important criterion is the supply of power. Ensure it is safe. Have a qualified electrician install sufficient power (amount of current-amps, and number of outlets) for the equipment to be used. An imperative safety factor is the installation of circuit breakers (breaks power circuit at the instant of any electrical fault). Distribution boards (the supply is divided into multiple outlets) with overload switching facilities (breaks delivery of current to the equipment being used) is also recommended as an extra precaution. Also make sure the normal lights within the studio can only be turned on or off from within the studio and there is adequate ventilation.

Darkness

The only light in a studio should be created by the photographer. To achieve this blacken out the entire work area. This can be done with dark heavy curtains over windows and painting the walls and ceiling a dark matte gray. Where possible the floor color should also be dark. The result should be an area with no external light entering and surfaces of minimum reflectance. Work areas within a large studio should be separated from each other by non-reflective curtains so more than one photographer can be working at a time.

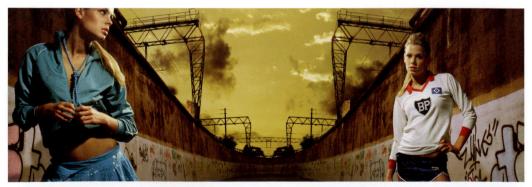

Stuart Wilson

Health and safety

Power supply

It cannot be stressed strongly enough that the lighting equipment and studio power supply be either installed, or checked in the case of existing supply, by a qualified and licensed electrician. Without question working with powered light sources is dangerous. As a photographer it is inevitable that light sources are taken for granted and unfortunately familiarity leads to complacency and poor safety practices. Always observe a few simple rules.

- Electricity is dangerous. It can kill you.
- Never attempt to repair lights or wiring unless you are absolutely confident you know what you are doing.
- Always be cautious when moving or connecting lights.
- Always turn off the power to the flash pack when changing flash head outlets.
- Use heat resistant gloves when handling tungsten lights.
- Always turn off the power and disconnect the cable before changing a globe.
- Never touch any part of a light or cable with wet hands.
- Exercise extreme care when photographing liquids.
- Never use liquids near electricity.
- Wear shoes with rubber soles.
- Ensure you know where and how to use the first aid kit.
- Ensure you know where and how to use the fire extinguisher.
- Ensure you are aware of emergency procedures related to work area.
- Ensure adequate ventilation of the studio area.

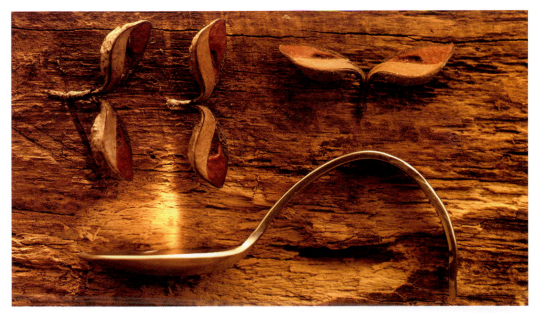

Thomas Berstadht

Equipment

Essentials

- An area devoid of external light sources, preferably a room with no windows or one capable of being darkened by the use of heavy curtains or blinds.
- An AC power supply with circuit breakers, distribution boards and extension cables.
- Camera, lenses, accessories.
- Compatible computer interface.
- AC power adaptor.
- Supply of fully charged Ni-MH batteries.
- Artificial light source (flash or tungsten) and associated stands.
- Heavy duty tripod, preferably with rising central column or arm.
- Hand-held light meter capable of measuring flash and ambient light.
- Memory card.
- 18% gray card.
- First aid kit.
- Appropriate fire extinguisher.
- A system of stands and poles from which to hang background material.
- Stands ('C-stands') to support reflectors, diffusion material, color filtration.
- Table top.
- Preparation or work bench.
- Gaffer tape, tracing paper, reflectors, Stanley knife, heat resistant gloves.

Other essentials

This is equipment you accumulate as you start to take photographs.

- Battery charger.
- Power distribution board with overload switching.
- Viewing/focusing loupe.
- Diffusion material (cheesecloth, netting, etc.).
- Clamps (various sizes).
- Sand or shot bags.
- Make-up mirror with lights.
- Assorted tools.

Darkroom

If choosing to use film a lightproof area is needed for the loading of large format film into double dark slides. A requirement for darkroom facilities in commercial practice is not required as processing and printing is usually contracted ex-studio. Digital image capture, post production, transmission and printing is now commonly accepted as the industry standard and darkroom and processing facilities have been replaced with digital hardware and software.

Camera

Most studio imaging is undertaken using small, medium and to a lesser extent large format cameras. Apart from image size, small and medium format cameras differ little in their use and capabilities. Most have through the lens (TTL) metering with manual over-ride, a preview system for viewing the subject at the exposure aperture, the ability to store image data in transferable memory and a facility to connect to a computer interface. The main difference between small and medium format cameras is the shutter mechanism. In most small and some medium format cameras a focal plane shutter is used. To expose the image two blinds follow each other across the focal plane in a horizontal or vertical movement. However, with fast shutter speeds the second blind begins to close before the first has cleared the frame. This limits the use of synchronised flash and is the reason for the relatively slow shutter speeds used for flash exposures with focal plane cameras. In most medium format and all large format cameras the shutter is between the lens elements. This means as the size of the aperture is all that has to be opened and closed (at f64 this could be the size of a pin head), light and synchronised flash can be instantly transmitted at any shutter speed. Digital camera shutter systems vary. Exposure time is controlled either by switching the image sensors on and off (allowing flash synchronisation at high shutter speeds) or in some cameras by a hybrid system using a focal plane shutter combined with activated image sensors.

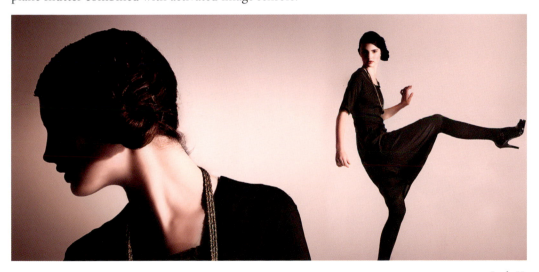

Jeph Ko

Large format cameras, although old in design and technology (except for lens design they have changed little since first used in the 19th century), have many distinct advantages. Their main difference is that the lens (front) and focal plane (back) can be moved independently of each other. In its simplest form this means any magnification of subject size can be obtained, using any lens, by moving the front and back panels away from each other. By changing the front and back of the camera from parallel to non-parallel and at varying angles to each other, distortion can be corrected or created at any subject to camera angle. Maximum depth of field (nearest and furthest points in focus) is obtainable at maximum aperture (lens wide open), and creative use of selective focus can be achieved.

Lenses

Modern cameras have detachable compound lenses enabling photographers to use one camera body with a wide range of lenses. A compound lens is made up of many lens elements which in combination determine its focal length and maximum aperture. The minimum requirement for a student would be a normal, wide and long lens.

Format	Normal	Wide	Long
Small	50mm	24mm	100mm
Medium	80mm	50mm	180mm
Large	150mm	90mm	360mm

A normal lens is the term applied to a lens with a focal length equal to the measurement of the diagonal of the sensor format with which it is being used. This is approximately equivalent to the normal perspective of the human eye. A wide angle lens will give a field of view wider than normal and a long lens will give a field of view narrower than normal. A wide angle lens will appear to increase and distort perspective, a long lens will appear to compress perspective due to closer and further viewpoints respectively.

Wide *Long – Jana Liebenstein*

Activity 1

Light a subject on a neutral background with a diffuse light source (floodlight/soft box).
Photograph the subject with a normal lens.
Without moving the subject or camera position repeat the process with as many lenses as are available (minimum of wide and long).
Keep a record of exposure and the focal length of each lens for each frame exposed.
Correlate the images with the written record.

Focus

With through the lens viewing an understanding of focus is best explained at a practical level. The closer the lens to the subject the greater the distance from the lens elements to the focal plane. The further the lens from the subject the shorter the distance from the lens elements to the focal plane. This means that as the size of the image increases in the viewfinder the distance from the lens elements to the focal plane increases.

Aperture

Within the lens is an adjustable diaphragm used to control the intensity of light entering the camera. This is known as aperture. The numerical measurement of aperture is known as f-stop. F-stops can range from f1.2 to f90 and beyond. When moving from one f-stop to another a series of clicks can be felt. Each stop and half stop has a click. Each full f-stop will halve the amount of light entering the camera when changing from a lower to a higher number. Each full f-stop will double the amount of light entering the camera when changing from a higher to a lower number. With some digital cameras aperture is controlled via the menu; however, the theory and effect are the same. See 'Exposure'.

Time

On most medium and all large format cameras exposure time is controlled by a shutter mechanism fitted between the elements that make up a compound lens. These shutter speeds vary from fractions of a second to any length of time the photographer determines. These periods of exposure time are equally applicable to small format cameras, but the shutter mechanism is at the focal plane and not inside the lens. With some digital cameras time is controlled via the menu; however, the theory and effect are the same. See 'Exposure'.

Accessories

With all cameras it is important to have at least a standard lens hood. Large format cameras require a dark-cloth, a double dark slide and a cable release, digital cameras an AC power adaptor and/or rechargeable batteries. The lens hood will reduce lens flare (direct light from the source entering the lens) and the cable release will eliminate camera vibration during exposure. This is essential when using long exposures. A dark-cloth is required to view the image on the ground glass plate at the back of a large format camera and a double dark slide (cut film holder) is used to place film at the focal plane.

Activity 2

Focus a camera, mounted on a tripod, on a light source. Turn on the light.
Without looking through the camera make an exposure at various angles to the light as you gradually move the camera away from the light source until it is at 90 degrees to the start.
Repeat the procedure using a lens hood on the camera.
Observe the difference (when light flare appears and disappears) between the angle of the camera to the light when using and not using a lens hood.
Correlate the images with the written record.

Light sources

Flash

There are numerous flash equivalents of the two standard artificial light sources, floodlight and spotlight. They have a color temperature of 5500K to 5800K and are balanced to daylight. Despite the names, swimming pool, soft box, fish fryer, honeycomb, etc., they are really only larger or smaller versions of a diffuse light source. The use of an open flash (direct light to subject without diffusion) will give the same effect as a spotlight. Most brands have focusing capabilities and the range of attachments available used to control intensity, quality and shape exist in one form or another for use with either flash or tungsten. The majority of studio flash systems consist of a power pack, flash head and flash head attachments. Tungsten modelling lights built into the flash heads are used to determine the direction and quality of the light prior to exposure. An average flash system with an output of 5000 joules would be suitable for the purposes of this study guide. Compared to tungsten, flash equipment is lightweight and versatile. However, buy the most robust equipment you can afford. Keep a stock of modelling globes and exercise caution when handling the flash heads, power pack and power supply. Never touch the flash head or disconnect the leads unless the power pack is fully discharged and the power supply switched off. See 'Using light'.

Tungsten

There are many variations of the two basic tungsten light sources, floodlight and spotlight. The majority have a color temperature of 3200K to 3400K and are balanced to tungsten. The minimum requirement to teach and learn the use of tungsten light would be a single floodlight and a single spotlight. A simple floodlight would have an output of 500 watts and a spotlight suitable for the purposes of this study guide an output of 650 watts. Purchase the most robust lights and stands you can afford within the output range mentioned above. Keep a stock of spare globes and exercise caution when handling the lights and the power supply. If possible all light stands should have wheels to ensure ease of movement and to reduce vibration when moving a light. Professional spotlights come with barn doors and nets. Barn doors are metal flaps used to control the shape and amount of light falling on the subject. Nets are pieces of wire gauze of varying densities that reduce the output of the light by diffusing the light at its source without greatly affecting the shadows.

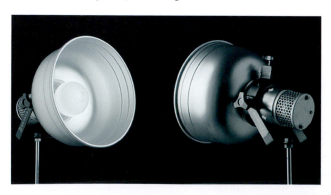

Tungsten floodlight

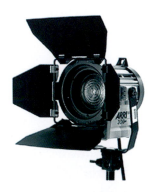

Tungsten spotlight

Equipment detail

Tripod

A large format camera should always be on a tripod. With a small or medium format camera with exposures longer than 1/60 second, it is advisable to use a tripod. It is not necessary to buy an expensive studio tripod. A heavy duty tripod that can be used in the studio as well as on location is sufficient. Avoid the many lightweight tripods on the market as they will not be stable enough for long exposures. If the tripod is heavy and awkward to carry then it will probably be the right one for studio use. As well as adjustable legs, the tripod should have a head that locks firmly into position at any angle, a rising central column and spirit levels for vertical and horizontal alignment.

Light meter

Working in a studio where all light created is from an artificial source it is very important to have a reliable light meter. Next to a camera the light meter is the most important piece of photographic equipment you will own. To understand fully the effect of artificial light and lighting ratios a hand-held meter, capable of measuring both flash and tungsten, with an invercone and reflected light reading attachment is essential. See 'Exposure'.

Digital

Digital images are stored either directly to a computer hard drive or as transferable data on memory cards. There are many different types manufactured but all are defined by their memory size. The greater the memory the more images the card contains. Memory cards are not specific to any color temperature as this can be controlled by adjustment of the white balance to the dominant light source at the time of capture or in post production when capturing Raw images.

Film

The range of film material available to the studio photographer is gradually diminishing as digital capture increases. Film can be divided into two types, negative and reversal (positive). Tungsten film (3200K) should be used with tungsten light. Daylight film (5500K) should be used with flash. Black and white film can be used with either light source. All film should be stored at a constant temperature, as specified by the manufacturer, preferably in a refrigerator. A special back manufactured to fit most cameras has to be attached to the camera in order to use instant film (Polaroid, Fuji). The advantage of this back is that the photograph is taken through the same lens as the final exposure onto film. Using a separate instant film camera may not give the same perspective or focal length.

18% gray card

An 18% gray card is an exposure and color standard introduced by Kodak. It is important to remember all light meters assume the subject to be photographed, in order to give correct exposure, is 18% gray. This is referred to as a mid-tone or reflecting 18% of the light falling on it. See 'Exposure'.

First aid kit

All workplaces must comply with local health and safety regulations. The studio environment is no exception. Ensure you know where the first aid kit is kept and how to use it, especially with relation to burns. It is imperative the kit is accessible at all times.

Fire extinguisher

Fire regulations may vary from state to state and country to country. Ideally a studio should have a heat activated sprinkler system installed. At the very least fire extinguishers should be installed and regularly serviced and maintained. Make sure the extinguisher is appropriate to the risk involved. Ensure you know where it is kept and how to use it.

Support

A system of reliable support mechanisms is essential for the safe operation of a studio. They can be permanent or made from components of the various systems available. These stands are commonly referred to as C-stands and come in varying sizes and stability. They can be used for almost any conceivable purpose to support any kind of material. In combination with gaffer tape and clamps an entire support mechanism can be created.

Daniel Tückmantel

Table top work bench

A ideal surface on which to place most smaller subjects is a table top. Do not interpret this too literally. Any flat, elevated, mobile surface will do.

Tool box

A photographer will acquire so much 'junk' in the process of producing images that some type of storage facility will be required. Personal choice will determine what is used but a tool box is ideally suited to carry around gaffer tape, clamps, Stanley knife, scissors, Blu-tac, stop watch, heat resistant gloves, etc.

Organisation

The key word to efficient studio photography is organisation. Not only does organisation save time but in commercial practice money. Most people at some stage in their photographic career attempt to make money out of photography. To be paid for doing something you enjoy is most people's dream. That dream can become hard work through lack of organisation. Organisation in a studio situation covers everything from the simplest task to the most complex. A well-organised studio will operate more efficiently. A place for everything and everything in its place. Look after and maintain your own equipment. Ensure it works when you most want it to. A tidy, clean studio is also a safer studio. In a studio situation where more than one photographer is working the unexpected will always occur, so be prepared. When working with lights be aware of your position in the studio in relation to others.

Pre-shoot checklist

Prior to any photographic assignment a photographer should carry out a simple checking procedure to ensure everything required to produce the photograph is available.

√ Check availability of studio.
√ Check availability of power to studio.
√ Check camera equipment, lenses, lens hood.
√ Check tripod.
√ Check digital back/camera.
√ Check digital back/camera power source.
√ Check digital memory.
√ Check computer interface and cabling.
√ Check light meter.
√ Check lighting equipment, spare lamps, cabling, distribution boards.
√ Check availability of diffusion material, reflectors, cutters.
√ Check availability of support mechanisms, table, C-stands, clamps, gaffer tape, etc.
√ Check work area safety, fire extinguisher, first aid kit.
√ Check contents of tool box.
√ Check subject matter will be in the right place at the right time.

Activity 3

Compile a list of the requirements you would need to photograph a dog in a studio environment.
Itemise each piece of equipment, the quantity required, its source and availability.
Compare and discuss until a comprehensive checklist has been achieved.

James Newman

Andrew Boyle

Jeph Ko

Rodrick Bond

essential skills

- Knowledge and understanding of how the use of light can create form, dimension and contrast in a studio environment.
- Develop an understanding of the relationship between artificially created lighting situations and the photographic medium.
- The study and observation of the importance of light in the production of photographic images.
- Through research study different studio photographs and the technique employed to achieve the result.
- To produce photographic images through the use of technique, observation and selection demonstrating how the direction, quality and type of light affect the way we view the subject matter.

Introduction

Light is the essence of photography. Without light there is no photography. The major difference between studio photography and any other form is that the studio itself has no ambient or inherent light. This means unlike photography undertaken in daylight, studio light cannot be observed and interpreted because it does not exist. The photographer starts with no light at all and has to previsualise how to light the subject matter and what affect the light will have upon the subject. It is a fact that studio photographers have to previsualise the lighting of the subject rather than observe what already exists that separates this genre from all others. This requires knowledge, craft, observation, organisation and discipline. Good studio photography takes time, lots of time, and patience.

Seeing light

In order to best utilise an artificial light source, we must first be aware of how light acts and reacts in nature. Observation of direct sunlight, diffuse sunlight through cloud and its many variations will develop an understanding of the two main artificial light sources available. A spotlight/open flash imitates the type of light we see from direct sunlight, a hard light with strong shadows and extreme contrast. A floodlight/soft box imitates the type of light we see on an overcast day, a soft diffuse light with minor variations in contrast and few shadows. Light falling on a subject creates a range of tones. These fall into three main categories: highlights, mid-tones and shadows. Each can be described by its level of illumination (how bright, how dark) and their position and distribution within the frame.

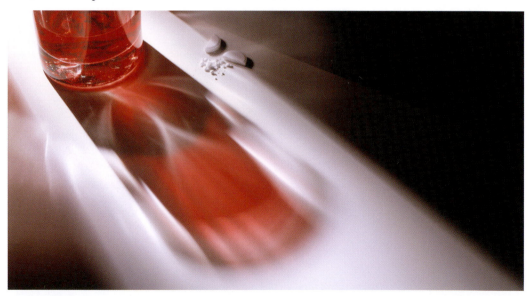

Janette Smith

Activity 1

Describe the image above in terms of highlights, mid-tones and shadows.
Draw a diagram indicating the relative position of the subject, light source and camera.

Artificial light

In a studio situation all forms of light are artificial. All light has to be created by the photographer. An artificial light source can be anything from the largest flash system to a single candle. Artificial studio lighting was originally measured in candle power. Today tungsten light output is measured in watts, flash output is measured in joules. A normal household light bulb is 100 watts. A 20kW tungsten-halogen lamp is 20,000 watts.

Although natural available light is often used for fashion and portraiture, the majority of studio photographs are lit using artificial light sources. These are:

- Flash
- AC discharge
- Tungsten-halogen
- Photoflood

Flash (5500K-5800K)

Flash is a generic term referring to an artificial light source of high intensity and short duration. It will render correct color when balanced to daylight. If using film balanced to tungsten an 85B filter will be required to correct the blue cast these lights emit. There is minimal heat output, and it maintains constant color balance and intensity. Flash is not a continuous light source. It has to recycle (recharge) between flashes and has no light output other than at the instant of exposure. To assess the direction and quality of the light flash heads have built-in modelling lamps. These are tungsten lamps and not color balanced to flash. As the output and intensity of the flash are far greater than that of the modelling lamps, exposure times will be too short for any tungsten exposure to register.

AC discharge (5600K)

Referred to as HMIs, AC discharge lamps have a very high output but emit less heat than tungsten when operating. The design of the light is very similar to the tungsten-halogen spotlight. They are not a continuous light source as the light flickers at very high frequency during operation. This is of no consequence to the stills photographer but must be taken into consideration when exposing moving film. They will maintain correct color balance throughout the life of the globe and will render correct color when balanced to daylight. If using film balanced to tungsten an 85B filter will be required to correct the blue cast these lights emit. AC discharge lamps are used predominantly in the film and TV industry.

Tungsten-halogen (3200K)

Next to flash this is the most commonly used artificial light. Light is emitted when the element inside the glass envelope is heated providing a continuous light source. All tungsten light sources emit heat when operating. Unlike the photoflood lamp the glass will not discolor with age, will maintain correct color balance and will give correct color when balanced to tungsten. If using film balanced to daylight an 80A filter will be required to correct the orange cast these lights emit. These lamps are used predominantly in spotlights.

Photoflood (3400K)

The photoflood is similar in design to the normal domestic lamp. As the name implies this type of lamp is used to create a broad soft light source. It is balanced to tungsten and normally used without correction. As the age of the lamp increases a shift in color balance can occur. This is due to the discoloration of the glass surrounding the element. If the camera is balanced to daylight an orange color cast will be evident. This can be corrected with the use of a blue (80B) filter or capturing as a Raw file and correcting in post production.

Daniel Tückmantel

Characteristics of light

To understand light it is essential to examine its individual characteristics.

- Intensity, reflectance and distance
- Quality, diffusion and reflection
- Color
- Direction
- Contrast

Intensity

In a studio environment the greater the impedance to the light (diffusion, reflection, filtration) the less intense the light falling on the subject. Direct light (no diffusion, reflection, filtration) the more intense the light falling on the subject. A hand-held light meter with a diffuser attachment will give an incident reading of the light falling upon a subject when pointed at the light source from the subject. In this way by separately measuring each light source the lighting ratio (the difference between the intensity of light from each source) can be calculated. This enables the photographer to control image contrast and the tonal range recorded. When referring to lighting ratios the photographer is also referring to lighting contrast. See 'Exposure'.

Reflectance

Regardless of the intensity of the light falling on the subject different levels of light will be reflected from the subject. The amount of light reflecting from a surface is called 'subject reflectance'. The levels of reflectance vary according to the color, texture and angle of the light to the subject. A white shirt will reflect more light than a black dress. A sheet of rusty metal will reflect less light than a mirror. In all cases the level of reflectance is directly proportional to the viewpoint of the camera. If the viewpoint of the camera is equal to the angle of the light to the subject the reflectance level will be greater. The level of reflected light is therefore determined by:

- Reflectance of the subject
- Intensity of the light source
- Angle of viewpoint and light to subject
- Distance of the light source from the subject

Distance

When either the subject or the light increase their relative distance to each other the intensity of the light is reduced. The amount of light falling on a subject decreases to a quarter of its original intensity when the light to subject distance is doubled. This change in illumination is called 'fall-off', and is quantified by the 'inverse square law'. For example, if a light meter reading of f16 is obtained when the light to subject distance is one metre, at two metres the reading would be f8, at four metres the reading would be f4. These rules do not change regardless of the light source.

Quality

Light from a point light source such as a tungsten-halogen spotlight is described as having a 'hard quality'. The light will be directional with well-defined edges and strong dark shadows. Light coming from a diffuse light source such as a softbox is described as having a 'soft quality'. The light will appear to be coming from an indiscriminate source with no edges and soft ill-defined shadows of limited density (detail can be seen in them).

The quality of light, whether hard or soft, can be changed by diffusion and reflection.

Diffusion

Any light source can be diffused by placing certain translucent materials between the light source and the subject. This has the affect of diffusing and spreading the light over a greater area by artificially increasing the size of the source. Relative to its size, the further the diffusion material from the light source the larger the light appears to be. This softens the shadows, increases shadow detail and decreases the measured amount of light falling on the subject. The amount of diffusion is also determined by where the diffusion material is placed in relation to the light source and the subject. The closer the diffusing material to the light source the less diffuse the light. The closer the diffusing material to the subject the more diffuse the light, the softer the edges of the shadows and the greater the shadow detail. There are many diffusion products manufactured specifically for the photographic market. See 'Using light'.

Reflection

Light is reflected off surfaces to varying degrees. More light will be reflected off silver than off black. Reflection is a simple way of changing the quality of light. The amount of light reflected off a surface is directly related to subject contrast. A point source of light (spotlight/open flash) will give hard shadows to the left side of a subject when lit from the right. This is called high contrast as there are only highlights and shadows. To obtain detail in the shadow area light has to be reflected into the shadows. This is called fill light and is achieved by collecting direct light from the light source and redirecting it with a reflector. This will reduce the contrast by raising the detail in the shadows to a level closer to the highlights enabling the photographer to control image contrast and the tonal range recorded. There are many reflective products available manufactured specifically for the photographic market. See 'Using light'.

Activity 2

Photograph a subject with average tones (another person) under many varied light sources.
Set the camera to one color balance (do not auto balance and do not alter color balance).
Include daylight, domestic, street, commercial, industrial and studio lighting.
Record exposure, light source type and where known color temperature.
Observe how the color and quality of the light varies from light source to light source.

Color

The visible spectrum of light consists of a range of wavelengths from 400 nanometres (nm) to 700nm. Below 400nm is UV light and X-rays, and above 700nm is infrared (all capable of being recorded). When the visible spectrum is viewed simultaneously we see 'white light'. This broad spectrum of colors creating white light can be divided into the three primary colors: blue, green and red. The precise mixture of primary colors in white light may vary from different sources. The light is described as cool when predominantly blue, and warm when predominantly red. Human vision adapts to different mixtures of white light and will not pick up the fact that a light source may be cool or warm unless it is compared directly with another in the same location.

White balance and color correction

The light from tungsten-halogen (3200K) and photoflood lamps (3400K) consists predominantly of light towards the red end of the spectrum. The light from AC discharge (5600K) and studio flash (5800K) consists predominantly of light towards the blue end of the spectrum. The color of light is measured by color temperature. Color temperature is described in terms of degrees kelvin (K). This refers to a temperature scale expressed as visual appearance, red is warm, blue is cold. To create images that have correct color most digital cameras use an auto or manual white balance and exposure compensation to correct the color temperature of any light source. For correct color if using film, filtration of lights or camera plus exposure compensation can be used to balance to any lighting situation.

Light source	Color temperature	Balance	Filter	Exposure
Average shade	8000K	Daylight	81EF	+0.65
		Tungsten	85B	+0.65
Flash	5800K	Daylight	None	
		Tungsten	85B	+0.65
AC discharge	5600K	Daylight	None	
		Tungsten	85B	+0.65
Daylight	5500K	Daylight	None	
		Tungsten	85B	+0.65
Photoflood	3400K	Daylight	80B	+1.65
		Tungsten	None	+0.35
Tungsten-halogen	3200K	Daylight	80A	+2.00
		Tungsten	None	
Domestic lamps	2800K	Daylight	80A	+2.00
		Tungsten	82C	+0.6

Direction

Shadows determine the direction of light. They create texture, shape, form and perspective. Without shadows photographs can appear flat and visually dull. A light placed to one side or behind a subject will not only separate the subject from its background but also give it dimension. A front lit subject will disappear into the background and lack form or texture. In nature the most interesting and dramatic lighting occurs early and late in the day. Observing and adapting this approach is a starting point to understanding the basics of studio lighting. In some situations front lighting is the only solution to a particular set of requirements, but time should be spent trying to add side or back lighting to any subject.

Tracey Hayes

Activity 3

Visit the same location at dawn, midday and sunset.

Photograph the effect of the light from the same viewpoint each time.

Using a simple object and trying various lighting combinations attempt to reproduce in the studio the different lighting effects appearing on your images.

Compare the quality of the light and the mood communicated.

Contrast

The human eye registers a wide range of light intensities simultaneously. The difference in the level of light falling on or being reflected by a subject is called contrast. Without contrast photographic images would appear dull and flat. It is contrast within the image that gives dimension, shape and form. Awareness and the ability to understand and control contrast is essential to work successfully in the varied and complex situations arising in studio photography. Contrast can be subdivided into four areas:

- Subject contrast
- Lighting contrast
- Lighting ratios
- Brightness range

Subject contrast

Different surfaces reflect different amounts of light. A white shirt reflects more light than black jeans. The greater the difference in the amount of light reflected the greater the subject contrast. Subject contrast can only be measured when the subject is evenly lit. The difference between the lightest and darkest tones can be measured in f-stops. If the difference between the white shirt and the black jeans is three stops then eight times more light is being reflected by the shirt than by the jeans. A 'high contrast' image is where the ratio between the lightest and darkest elements exceeds 32:1. A 'low contrast' image is where the ratio between the lightest and darkest elements is less than 2:1.

One stop = 2:1, two stops = 4:1, three stops = 8:1, four stops = 16:1.

Rebecca Coghlan

Lighting contrast

Subject contrast or reflectance range only exists once the studio photographer has turned a light on the subject. Prior to this the subject has no contrast. It is therefore possible to control the subject contrast by controlling the amount of light falling on the subject. If a single point source of light is used to light a subject the difference between the highlights and the shadows will be determined by the amount of light they reflect. Overall image contrast is therefore determined by a combination of subject contrast and 'lighting contrast'. If we continue with the example of the white shirt and the black jeans an understanding of the difference between subject contrast and lighting contrast can be achieved. A person wearing these clothes when lit with a large soft diffuse light from the front will have a subject contrast range equal to the reflectance level of the clothes. If you now turn off the front light and light the subject with a point source from the right each item of clothing now reflects different levels of light. The right side of the person is highlighted, the left side of the person is in shadow. When measured this would have a subject contrast range between the lit side of the shirt and the shadow side of the jeans in excess of 32:1 (high contrast). To control these contrast levels a balance of different light sources is used. This balance is called 'lighting ratio'.

Lighting ratio

To reduce the lighting contrast levels in the above example the first diffuse light could be moved to the left side of the subject. This has the effect of reducing the contrast between the left and right sides of the subject. This change in the subject contrast can be measured by the difference in the amount of light falling on each side of the subject. The right light measures f32, the left light f16. This is a difference of two stops. Working on the same scale used to measure subject contrast, this is a lighting ratio of 4:1. Metering for lighting ratios is covered in greater detail in 'Exposure'.

Tim Barker

Brightness range

Subject brightness range is the combined result of subject and lighting contrast. If a subject with a high reflectance range of 32:1 is lit by a combination of light sources creating a lighting ratio of 4:1 the overall subject brightness range (SBR) is 128:1.

Subject Brightness Range (SBR) = Reflectance Range × Lighting Ratio.

Digital image sensors and film are only capable of recording a limited brightness range. The ability to accommodate a brightness range is referred to as 'latitude'. Digital image sensors can accommodate a brightness range of 32:1 or five stops latitude when images are processed in camera and saved as JPEG or TIFF. When saved as Raw a brightness range of 128:1 or seven stops latitude can be achieved. Combined with post production and printing techniques it is possible to extend this range even further. With this knowledge the photographer working in digital capture will understand any highlight three stops brighter or shadow more than three stops darker than a mid-tone will register little detail. The limit of digital image sensor latitude, referred to as 'noise', is evident as poor pixel definition in the shadows and/or highlights. Color transparency film can accommodate a brightness range of 32:1 or five stops latitude. Black and white and color negative film can accommodate a brightness range of 128:1 or seven stops latitude.

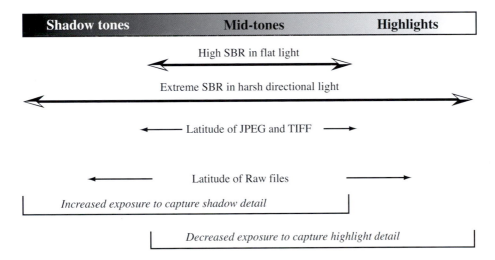

A subject with a high or extreme brightness range can exceed the latitude of the sensor or film

Being aware of subject brightness range and latitude allows the photographer to previsualise the outcome of the final image. When the brightness range exceeds the film/image sensor's latitude the photographer has the option to compensate by varying the lighting ratio and/or by increasing or decreasing exposure to ensure shadow or highlight detail. A subject with a high SBR is said to have 'extreme contrast'.

Extreme contrast

In a studio situation where the subject reflectance, lighting contrast and lighting ratio are all under the control of the photographer, extreme contrast is usually by design rather than by error of judgement. Being aware of image sensor latitude and the photographer's ability to alter lighting ratios, images with extreme contrast can be avoided. However, as the elements causing extreme contrast are controlled by the photographer it can be created and used to great effect. Placing highlights in shadow areas and deep shadows through mid-tones can create interesting images. Exposure is critical. Experience and trial and error are the best ways to achieve reliable results.

Rodrick Bond

Alison Saunders

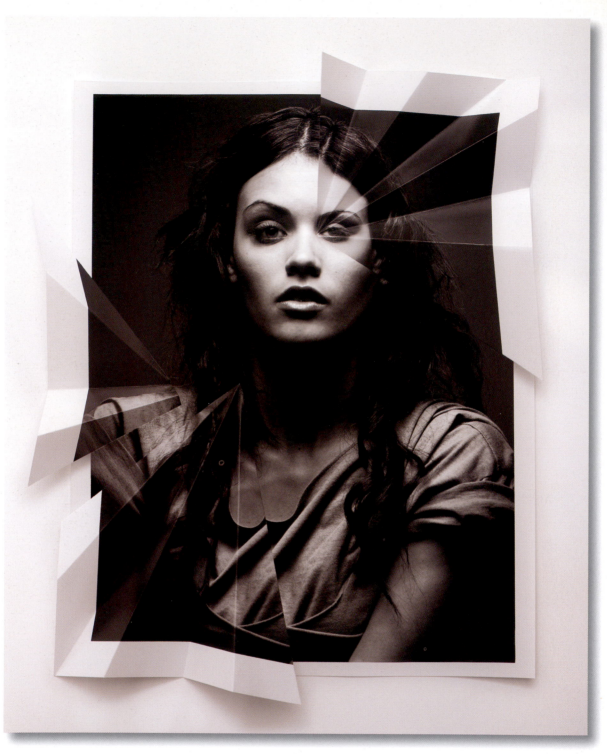

Tracey Hayes

exposure

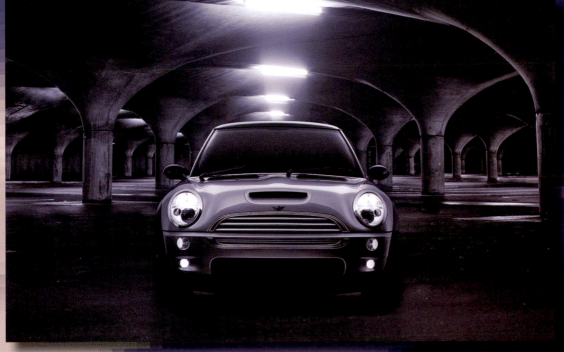

James Newman

essential skills

- A knowledge and understanding of exposure and its relationship to light sensitive surfaces, depth of field and selective focus.
- An understanding of the use of a light meter, the difference between reflected and incident meter readings, and their relationship to lighting ratios and exposure.
- Through research an understanding of the effect of exposure in the creation of photographic images.
- Production of photographic images through close observation and selection that show an understanding of metering techniques and their relationship to exposure, lighting ratios, depth of field and selective focus.

Introduction

Exposure is the amount of light required to correctly expose an image. Exposure is a combination of intensity (the quantity of light determined by the size of the aperture) and duration (the quantity of light determined by the length of the shutter speed). Correct exposure is the interpretation of light meter measurements related to the desired effect and the subject being photographed. Too much light will result in overexposure. Too little light will result in underexposure. It makes no difference whether there is a large or a small amount of light, the same amount of light is still required for correct exposure. Exposure has to be adjusted to compensate for these variations. This is achieved by adjusting either the intensity (aperture) or duration of light (time). An increase in the size of the aperture will give more exposure, a decrease will give less exposure. A decrease in the duration of the shutter speed will reduce exposure, an increase will give more exposure.

Overexposure *Correct exposure* *Underexposure*
– Line Mollerhaug

In order to calculate correct exposure the light has to be measured. The device that measures light is called a light meter. All light meters give the photographer information about the amount of light available to obtain correct exposure in f-stops and shutter speeds. These two pieces of information can be used in any combination, for example an exposure of f11 at 1/125 second = f8 at 1/250 second = f16 at 1/60 second, etc. However, working in a creative medium correct exposure can sometimes be a very subjective opinion.

Exposure is a combination of f-stops and shutter speed – aperture and time.

Activity 1

Find photographs you think are over-, under- and correctly exposed. Why has this occurred? What lighting/exposure situations have you found yourself in where the result has been different to what you expected?

Aperture and time

Aperture

Actual aperture is the size of the diameter of the diaphragm built into the camera lens. The iris is a mechanical copy of the iris existing in the human eye. Aperture controls the intensity of the light entering the camera. In the dark the iris of the eye opens to maximum aperture in order to increase the amount of light reaching the retina. In bright light the iris closes down to minimum aperture in order to reduce the amount of light reaching the retina. In the same way the aperture of the camera lens must also be opened and closed to control the amount of light entering the camera. The right amount of light is required for correct exposure. Too much light and the image will be overexposed, not enough light and the image will be underexposed. As the aperture on a manually operated lens is opened or closed a series of clicks can be felt. These clicks are called f-stops and are numbered. When the value of the f-stop decreases by one stop exactly twice as much light enters the camera as the previous number. When the value of the f-stop increases by one stop half as much light enters the camera as the previous number. The only confusing part is that maximum aperture is the f-stop with the smallest value and minimum aperture is the f-stop with the largest value. The larger the f-stop the smaller the aperture. Easy! With most digital cameras aperture can be controlled via the menu but the theory, effect and result are the same.

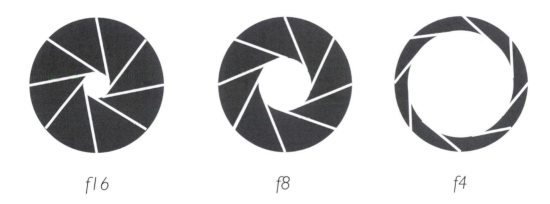

f16 f8 f4

Activity 2

Carefully remove the lens from either a small or medium format camera.
Hold the lens in front of a diffuse light source of low intensity.
Whilst looking through the lens notice how the size of the aperture changes as you alter the f-stop.
Record the relationship between the size of the aperture and the corresponding f-stop number displayed on the lens or in the LCD panel.

Time

The amount of light required to correctly expose an image is controlled by a combination of aperture (f-stop) and time (shutter speed).

Aperture controls intensity, time controls duration.

Until the invention of the focal plane shutter exposure time had been controlled by devices either attached to or within the lens itself. These shutters regulated the length of exposure of the film to light. Early cameras had no shutter and relied upon the photographer removing and replacing a lens cap to facilitate correct exposure times. Other rudimentary shutters, very similar in appearance to miniature roller blinds, were tried but it was not until the invention of a reliable mechanical shutter that exposure times could be relied upon. As film emulsions became faster so did the opportunity to make shorter exposures. Most digital cameras control the duration of the exposure by switching on and off the image sensor for a determined period of time. Others use a hybrid system of digital and focal plane shutters. In a studio situation exposure time related to still life is not a major consideration. Using exposure times of between 1/1000 second and 30 seconds is normal.

1 second *1/8 second* *1/60 second*

When photographing people, or anything likely to move, an exposure of 1/60 second is usually adequate. Shutter speeds slower than this will cause subject movement blur and/or vibration if the camera is hand held and not on a tripod. With the use of flash, exposure times have little effect upon exposure as the flash is of such high intensity and extremely short duration that camera vibration or subject movement is eliminated.

Activity 3

Light an inanimate subject with a diffuse light source.
Set the shutter speed on your camera to 1/125 second and the aperture to what is required for correct exposure.
Hand hold the camera, make two exposures at each shutter speed between 1/125 second and 1 second. Adjust aperture accordingly.
Record and compare the results to see which shutter speed has the least image blur.

Light meter

Working in a studio where all light created is from an artificial source it is important to have a reliable light meter. Unfortunately for photographers the ability of the human eye to compensate for variations in light, shade and contrast is far greater than any of the film emulsions and image sensors at present on the market. It is therefore difficult to understand lighting ratios and their relationship to exposure without the use of a meter. Next to a camera the light meter is the most important piece of photographic equipment you will own. Other than large format, most cameras have built-in metering systems, but these all work on measuring light reflected from the subject back to the camera. In most cases this will give adequate metering for correct exposure of a subject with average tonal range. It will not tell you the difference in the light falling on different areas of the subject. Without a meter only experience would tell you if there is going to be detail in the shadows or highlights when the image is correctly exposed. The human eye would mislead you.

Thuy Vy

To understand fully the effect of artificial lights and lighting ratios a hand-held meter, capable of flash and tungsten readings, is essential. Measuring light for the purpose of exposure can be achieved by taking a reflected or an incident reading of the subject.

> A reflected reading is when the meter is pointed at the subject from the camera and the light reflected from the subject is measured.

> An incident reading is when the meter, with diffuser (invercone) attached, is pointed at the camera from the subject and the light falling on the subject is measured.

This exposure reading is known as 'meter-indicated exposure' or 'MIE'. The meter is calibrated to assume that everything it is pointed at is a mid-tone (gray) regardless of the level of illumination. A meter will therefore give correct exposure for a man in a medium gray flannel suit whether he is in a cellar or sunlight. The mid-tone to which all meters are calibrated is called an '18% gray card' because it reflects 18% of the light falling upon it.

Using the light meter

There are many ways of understanding the information a light meter is giving in relation to exposure. The meter read-out system itself can be confusing. Some photographers refer to EV (exposure value) readings, others t-stops (transmission) and others in zones. All have their merits and it is better to understand one system well than a little about all. In reality they all mean the same. An understanding of exposure is without doubt the most critical part of the photographic process. Of all the variations the most common usage is f-stops. All meters usually default to f-stops and all camera lens apertures are calibrated in f-stops. It is not important to understand what f-stops are, just how they relate to exposure and depth of field.

It is important to understand that if the exposure is increased by one stop, either by time or aperture, the amount of light entering the camera has doubled (2x). If increased by two stops the amount of light has doubled again (4x). If increased by three stops the light doubles again (8x) and so on. This simple law applies with the opposite result to decrease in exposure. It is also important to remember to set the meter to the correct ISO rating (measure of sensitivity to light). See 'Image capture'.

Incident light reading

An incident reading is when the meter, with invercone attached, is pointed at the camera from the subject and the light falling on the subject is measured. The invercone is a white plastic dome that fits over the meter's light sensitive cell. The invercone accepts the light from a wide field of vision (180°) falling on the subject and transmits 18% of that light to the meter's light sensitive cell. The information the meter gives you must then be interpreted into an aperture/time combination.

The meter reading should only be viewed as a guide to exposure. Due to the broad range of tones visible to the human eye it is often necessary to take more than one reading to decide on the most appropriate exposure. If a reading is taken in a highlight area the resulting exposure may underexpose the shadows. If a reading is taken in the shadows the resulting exposure may overexpose the highlights. The photographer must therefore decide whether highlight or shadow detail is the priority or reach a compromise.

Activity 4

Take an incident light reading of a subject in a constant light source.

Note the f-stop at an exposure time of 1 second. Increase the number of the aperture by three f-stops.

Note the change in exposure time.

What would the result be if the duration of time had been increased by a factor of three instead of the aperture?

Which method would be the most appropriate to achieve minimum depth of field?

Collate results in your Record Book.

Reflected light reading

A reflected reading is when the meter is pointed at the subject from the camera and the light reflected from the subject is measured. This is undertaken with the invercone removed. The meter's light sensitive cell has an angle of acceptance approximately equivalent to a normal lens. With a spot meter attachment this angle can be reduced to 5 degrees for precise measurements within the subject. The exposure the meter recommends is an average of the reflected light from the light and dark tones present. When light and dark tones are of equal distribution within the frame this average reading is suitable for exposure. It must be remembered the meter assumes that everything reflects light at the same level as an 18% gray card. If the subject is wearing a medium gray flannel suit a reflected reading from the camera would give an average for correct exposure. However, if the subject is wearing a white shirt and black jeans a reflected reading of the shirt would give an exposure that would make the shirt appear gray. A reflected reading of the jeans would make them appear gray. When light or dark tones dominate the photographer must increase or decrease exposure accordingly.

18% gray card

An 18% gray card is an exposure and color standard introduced by Kodak. It is a tone and color image sensors are meant to truly render at correct exposure. It is important to remember all light meters assume the subject you are about to photograph, in order to give correct exposure, is 18% gray. This is referred to as a mid-tone or reflecting 18% of the light falling on it. If a reflected meter reading is taken of a black card it will assume the card is 18% gray and give an exposure reading rendering the black card gray. This applies equally to a white card. The light meter reading will make the white card gray. This is one reason why snow comes out gray in many snapshots.

Activity 5

Using a diffuse light source take individual reflected light meter readings of three pieces of card, one white, one black and one mid-gray.

The black card should give a reading different by four stops to the reading off the white card. The mid-gray card should be between the two. If the mid-gray card is two stops apart from each, you have a mid-tone the meter sees as the average tone (18% gray).

Make one exposure of each of the three cards using their meter-indicated exposure (MIE). Photograph the white and black cards again using the meter-indicated exposure of the gray card.

Label the results with the meter indicated exposure, the actual exposure and the tone of the card being photographed.

Collate results in your Record Book.

Lighting ratios

A light meter is often incorrectly called an exposure meter. Exposure is only one part of its function. It can also be used for measuring lighting ratios and lighting balance. This is achieved by taking an incident reading of the light source from the subject. The meter is pointed at the light source to measure the amount of light falling on the subject from that specific light. If there is more than one light source each light can be measured independently by ensuring only one light source is on at any one time. In this way the ratios between the light sources can be measured. Understanding and controlling lighting ratios will help ensure the SBR is within the image sensor's latitude. See 'Light' and 'Image capture'. Lighting ratios and their relationship to latitude are best demonstrated and understood at a practical level. Take, for example, a photographer using an image sensor known to have a latitude of five stops. To make use of this information the photographer should try to light the subject to within this range. A five stop latitude would allow a photographer to use a maximum lighting ratio of 32:1 (five stops). This ratio would retain detail in the highlights and the shadows.

Example 1

In a darkened studio a person is lit with a single light source from the right-hand side at 90 degrees to the subject. An incident light meter reading is taken from the right-hand side of the person's face directly towards the light source. The aperture is f45 at 1 second. An incident light meter reading is taken from the left-hand side of the person's face directly towards the opposite side of the studio to where the light is placed. The aperture is f4 at 1 second. This is a lighting ratio of 128:1 (seven stops). To reduce this ratio another light or a reflector (fill) is placed on the left-hand side of the subject. The fill is moved towards or away from the subject until an aperture reading no more than three stops lower (f16) than the main light source is obtained. This is now a lighting ratio of 8:1.

128:1 *8:1*

Example 2

A photographer has to light three sides of a single colored box with a one stop ratio between each of the sides. Pointing a light meter in the general direction of the subject would give an average reading for 'correct' exposure but would not indicate the difference in the light falling on each of the three sides. This would be achieved by taking either a reflected reading of each side or for a more precise measurement taking an incident reading of each of the three light sources. This would give a measure of the actual amount of light falling on the subject. This information can then be used to adjust the balance of the lights to achieve the required lighting ratio.

1. Spotlight

2. Spotlight + floodlight

3. Spotlight + floodlight + reflector

1. A point source (spotlight) is aimed at the top of a neutral gray box from behind the subject. The shadow falls forward of the subject. An incident reading is taken of the light source by pointing the invercone directly at the spotlight. The reading is f16.

2. A diffuse source (floodlight) is aimed at the left side of the box, ensuring no light affects the top or right side of the box. An incident reading is taken of the floodlight (shield the invercone with your hand to prevent light from the spotlight affecting the reading) by pointing the invercone directly at the floodlight. The reading is f11. This is a lighting ratio between the top and left-hand sides of 2:1 (one stop).

3. A piece of white card is used to reflect light back into the right-hand side of the box. The light reflected is gathered from the spotlight and floodlight. With both lights on, an incident reading is taken of the reflected light by pointing the invercone directly at the piece of white card. The reading is f8. This is a lighting ratio between the left and right sides of 2:1 (one stop), and an overall lighting ratio between the top and left-hand side of 4:1 (two stops).
To measure exposure an incident reading is taken by pointing the invercone from the box back towards the camera. It should be f11. This is an average of the lighting ratio.

Interpreting the meter reading

The information given by the light meter after taking a reading is referred to as the 'meter-indicated exposure' (MIE). This is a guide to exposure only. As stated before, all meters assume everything a photographer is about to photograph is a mid-tone and reflects 18% gray. This is hardly ever the case. If you consider interest and visual impact within a photograph are created by the use of lighting and subject contrast (amongst many other things) the chances of all the elements within the frame being a mid-tone are remote. How boring photographs would be if they were. It is up to the photographer to decide the most appropriate exposure to achieve the result required. A photographer with a different idea and outcome may choose to vary the exposure. It is the photographer's ability to interpret and vary the meter-indicated exposure to suit the mood and communication of the image that separates their creative abilities from others.

Average tones

A subject of average reflectance (mid-tone) is placed with equal dark and light tones. All three tones are lit equally by the same diffuse light source.

A reflected reading of the mid-tones will give correct exposure. A reflected reading of the dark tone will make it gray and overexpose the mid and light tones. A reflected reading of the light tone will make it gray and underexpose the mid and dark tones.

An incident reading will give correct exposure regardless of which tone it is held in front of because it measures the light falling on the subject (in this case the light is equal on all three tones) not the light reflected from it.

Dominant dark tones

A subject of average reflectance (mid-tone) is placed with dominant dark tones. All three tones are lit equally by the same diffuse light source. A reflected light meter reading is taken from the camera. The meter will give what it thinks is correct exposure because it has assumed the subject is reflecting 18% gray. This is not the case, however, because dark tones dominate. This 'correct' exposure will result in the dark tones becoming a mid-tone and the mid-tone overexposing. If the subject is to be recorded accurately the exposure must be reduced (less time or less light) from that indicated. The amount of reduction is dictated by the level of dominance of the dark tones.

An incident reading will give correct exposure regardless of which tone it is held in front of because it measures the light falling on the subject (in this case the light is equal on both tones) not the light reflected from it.

Activity 6

In a constant light source take a reflected light reading with a hand-held meter positioned 30cm from an 18% gray card. Note the exposure reading.

Now take an incident reading from the gray card with the invercone pointing back towards where you were standing when you took the reflected reading. Note the exposure reading.

The incident reading will be the same as the reflected. Why?

Collate results in your Record Book.

Dominant light tones

A subject of average reflectance (mid-tone) is placed with dominant light tones. All three tones are lit equally by the same diffuse light source. A reflected light meter reading is taken from the camera. The meter will give what it thinks is correct exposure because it has assumed the subject is reflecting 18% gray. This is not the case, however, because light tones dominate. This 'correct' exposure will result in the light tones becoming a mid-tone and the mid-tone underexposing. If the subject is to be recorded accurately the exposure must be increased (more time or more light) from that indicated. The amount of increase is dictated by the level of dominance of the light tones.

An incident reading will give correct exposure regardless of which tone it is held in front of because it measures the light falling on the subject (in this case the light is equal on both tones) not the light reflected from it.

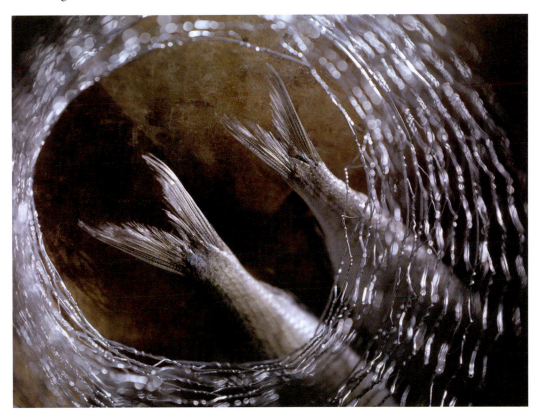

Shivani Tyagi

Average exposure

In most situations where tones are evenly distributed the most appropriate exposure is often the one indicated by the light meter. When the light or dark tones dominate, however, under- or overexposure may occur. It is essential that the photographer understands how the light meter reads light to have full control over exposure.

Exposure compensation

Working in a studio, high or low contrast lighting situations are controlled by the photographer. Exposure compensation would negate the effect the photographer is trying to achieve. When working on location (exterior) the lighting (sunlight) already exists and there is little the photographer can do about it other than exposure compensation. It is this difference that makes high and low contrast situations infinitely more controllable in a studio. Exposure compensation would only be used if the photographer found it impossible to alter either the lighting ratios or subject reflectance range. The amount of compensation necessary will vary depending on the level of contrast present and what the photographer is trying to achieve. Compensation is usually made in half and one stop increments. This is called 'bracketing'. When working with a computer interface 'correct' exposure can be judged subjectively by assessing the monitor image or objectively by interpretation of the histogram.

James Newman

Activity 7

Place a white object next to a black object.

Light with a single light source so the light falling on both is equal.

Take a reflected reading and expose one frame at meter-indicated exposure (MIE).

Bracket in half stop increments for three stops either side of normal.

Repeat process using an incident reading as MIE.

Keep a record of the exposures in your Record Book.

Compare the results with your record of exposures.

What does the meter 'see', and how does the photographer allow for its limitations?

Assessing the degree of compensation

Photographers calculate the amount of compensation from MIE in different ways. The method chosen is one of personal choice. As accuracy is the primary consideration the method chosen is usually the one with which the photographer is confident and has proved from past experience to be the most reliable.

18% gray card Photographers can use a mid-tone of known value from which to take a reflected light meter reading. A mid-tone of 18% reflectance is known as a 'gray card'. The gray card must be at the same distance from the light source as the subject. Care must be taken to ensure the shadow of neither the photographer nor the light meter is cast on the gray card when taking the reading.

The indicated exposure is suitable for an SBR not exceeding 32:1. If highlight or shadow detail is required the exposure must be adjusted accordingly. If saving as Raw files the indicated exposure is suitable for an SBR not exceeding 128:1. If the SBR exceeds 128:1 the exposure can be increased and subsequently optimised in post production.

Caucasian skin A commonly used mid-tone is Caucasian skin. A reflected reading of Caucasian skin placed in the main light source (key light) is approximately one stop lighter than a mid-tone of 18% reflectance. Using this knowledge a photographer can take a reflected reading from their hand and increase the exposure (opening the aperture one stop) to give an exposure equivalent to a reflected reading from an 18% gray card. Further adjustment would be necessary for an SBR exceeding the sensor's latitude.

Bracketing To ensure correct exposure a photographer can bracket the exposures. An incident or reflected reading of a mid-tone is taken. Either side of MIE a photographer can vary the exposure, either by time or aperture, in half stop or one stop increments. The degree of variance does not need to cover the entire SBR.

Digital Correct exposure with digital capture is achieved by interpretation of the histogram, visual assessment of the monitor image, subsequent compensation of exposure and/or lighting ratios where necessary and the use of appropriate post-production software for final output.

Polaroid Although no longer the primary medium by which to assess exposure and composition Polaroid has a similar ISO and comparative contrast range to most films available. To best understand the relationship between Polaroid and film, testing of both is recommended. This will give you the best correlation between how the correct exposure for film would appear on an equivalent Polaroid. Polaroid film holders (backs) fit most medium and large format cameras. Polaroid backs suitable for small format cameras are limited.

Judgement The best technique for exposure compensation is judgement, gained from experience and knowledge. This requires previsualisation of the image and the degree of compensation required to produce the desired effect. This comes with practice and time.

Digital exposure

A 24-bit RGB digital image file is separated into three color 'channels' (8 bits per channel). Each channel can store 256 levels of brightness between black (level 0) and white (level 255). When viewing channels simultaneously each pixel is rendered in any one of 16.7 million colors (256 x 256 x 256). These brightness levels can be displayed as a graph or histogram. The horizontal axis displays the brightness values from left (darkest) to right (lightest). The vertical axis shows how much of the image is found at any particular brightness level. If the subject brightness level exceeds either the latitude of the image sensors or there is either under- or overexposure shadow or highlight detail will be lost.

Thomas Berstadht

Histograms

With digital capture it is possible to check the image sensor's ability to record the tonality and color of the subject. This information can be displayed as a 'histogram' on the LCD screen of high quality digital cameras immediately after capture, or in the scanning software during the scanning process. The histogram displayed shows the brightness range of the subject in relation to the latitude or 'dynamic range' of the image sensor. Most digital cameras claim their sensors have a dynamic range between five and seven stops.

Note > You should attempt to modify the brightness, contrast and color balance at the capture stage to obtain the best possible histogram prior to post production.

Optimising tonality

In a good histogram, where a broad tonal range with full detail in the shadows and highlights is present, the information will extend right across the horizontal axis. The histogram below indicates missing information in the highlights (right) and some loss of information in the shadows (left).

Histograms indicating image is either too light or too dark

Brightness

With overexposure the graph will peak on the right side (level 255) of the histogram. With underexposure the graph will peak on the left side (level 0) of the histogram.

Solution: *Decrease or increase the exposure/lighting ratio.*

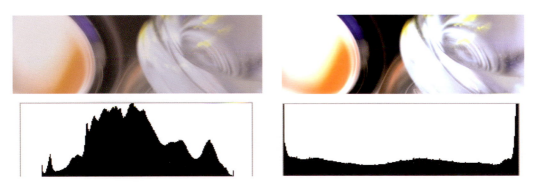

Histograms indicating image has either too much contrast or not enough

Contrast

If image contrast is too low the histogram will not extend to either end on the horizontal axis. If image contrast is too high a peak will be evident at either end of the histogram.

Solution: *Increase or decrease the contrast of the light source or the contrast setting of the capture device. Use diffuse lighting or direct light with reflectors and/or fill for an image with full detail.*

Optimising a histogram after capture

The final histogram should show pixels allocated to most, if not all, of the 256 levels. If the histogram indicates large gaps between the ends of the histogram and the sliders (indicating either a low contrast scan or low contrast subject lit with flat lighting) the subject should be re-photographed, if possible.

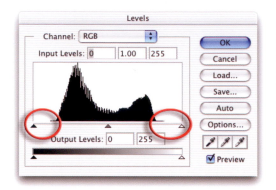 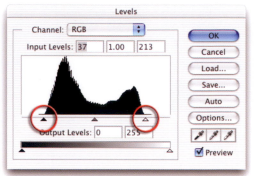

Small gaps at either end of the histogram can be corrected by moving the sliders to the start of the tonal information. Holding down the Alt/Option whilst moving the sliders will indicate if any information is being clipped. Note how the sliders have been moved beyond the thin horizontal line at both ends of the histogram. These low levels of pixel data are often not representative of the broader areas of shadows and highlights within the image and can usually be clipped (moved to 0 or 255).

Moving the 'Gamma' slider can modify the brightness of the mid-tones. If you select a Red, Green or Blue channel (from the channel's pull-down menu) prior to moving the gamma slider you can remove a color cast present in the image. For those unfamiliar with color correction the adjustment feature 'Variations' (Image > Adjustments > Variations) in Photoshop gives a quick and easy solution to the problem. After correcting the tonal range using the sliders click 'OK' in the top right-hand corner of the Levels dialog box.

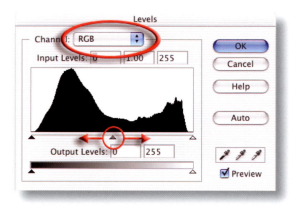

Note > Variations is not available for Photoshop users working in 16 bits/channel.

Color

Neutral tones in the image should appear desaturated on the monitor. If a color cast is present try to remove it at the time of capture or scanning if possible. Correct color casts by using either the white balance in the camera menu or a color conversion filter if using film. See 'Light'.

Summary of exposure compensation

A reflected light meter measures the level of light reflected from the subject. The resulting exposure is an average between the light and dark tones present. When light and dark tones are of equal distribution this average is suitable for exposure. When light or dark tones dominate the photographer must either take a reflected meter reading of a known mid-tone and compensate, or take an incident reading of the light falling on the subject.

Dominant tones

A reflected light meter reading measures the level of light reflected from the subject. An incident light meter reading measures the amount of light falling on the subject. The resulting exposure is an average between the light and dark tones present. When light and dark tones are of equal distribution this average light reading is suitable for exposure. When light or dark tones dominate the photographer must increase or decrease exposure.

Dominant light tones	**increase exposure**	**+**	**Open up**
Dominant dark tones	**decrease exposure**	**−**	**Stop down**

Extreme contrast

Increase highlight detail	**decrease exposure**	**−**	**Stop down**
Increase shadow detail	**increase exposure**	**+**	**Open up**

Orien Harvey

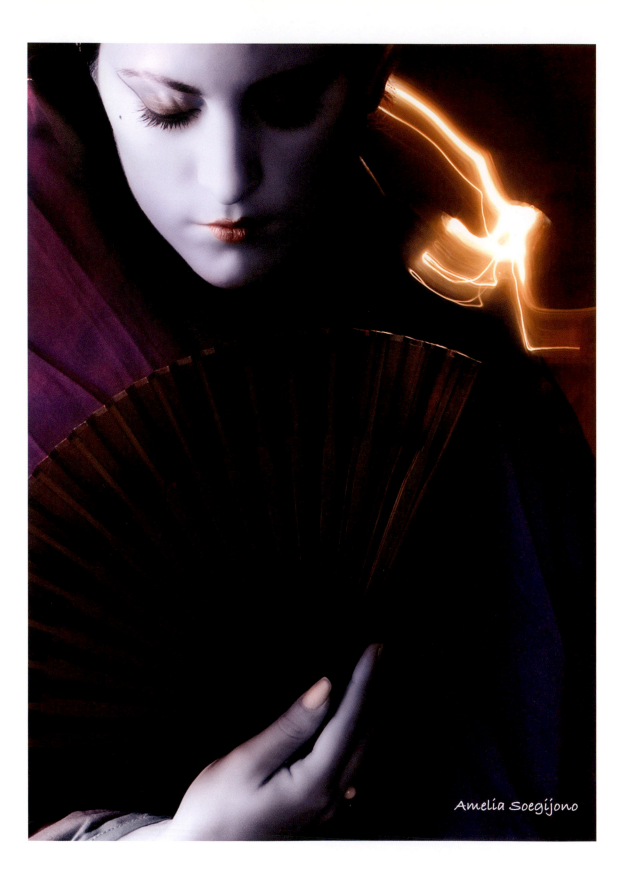

Amelia Soegijono

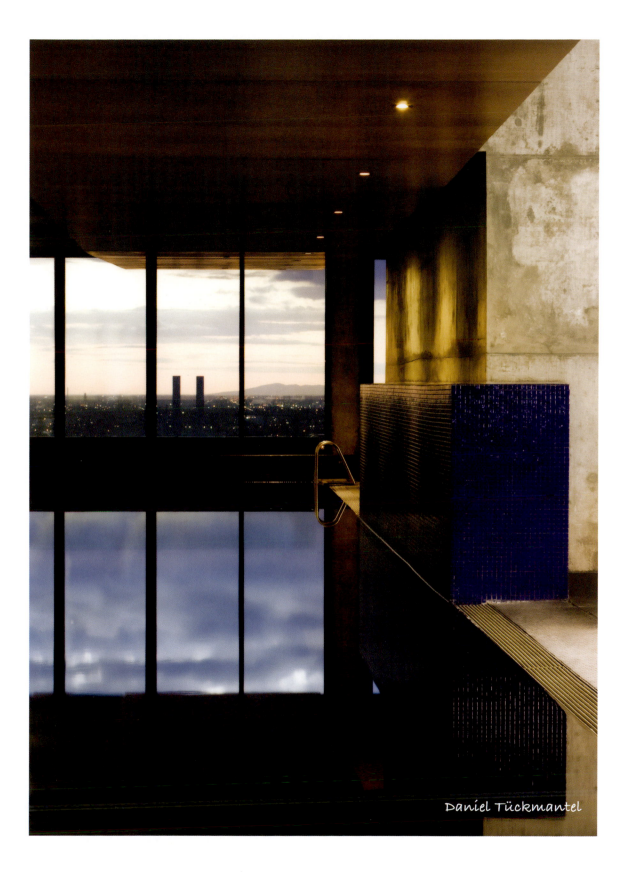

Daniel Tückmantel

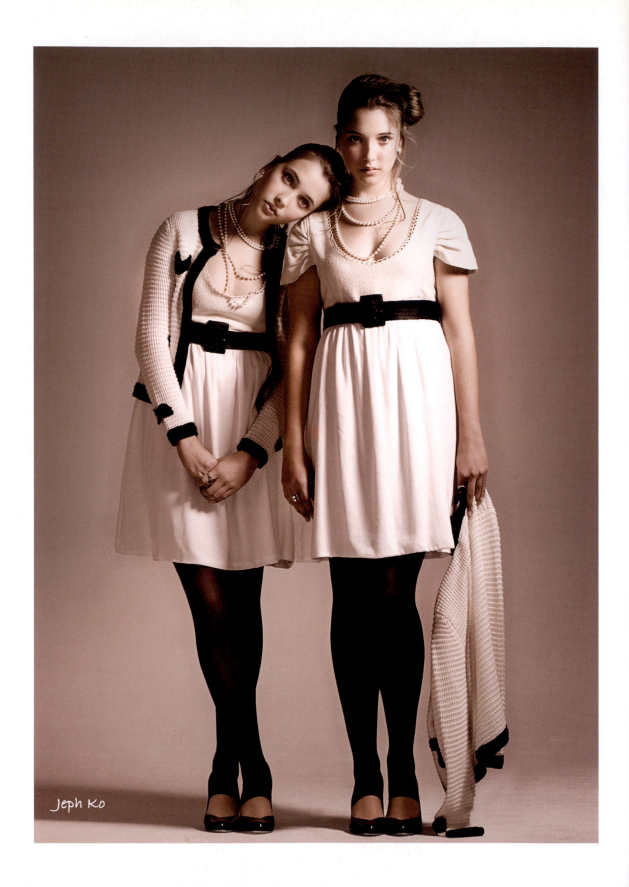
Jeph Ko

studio
image capture

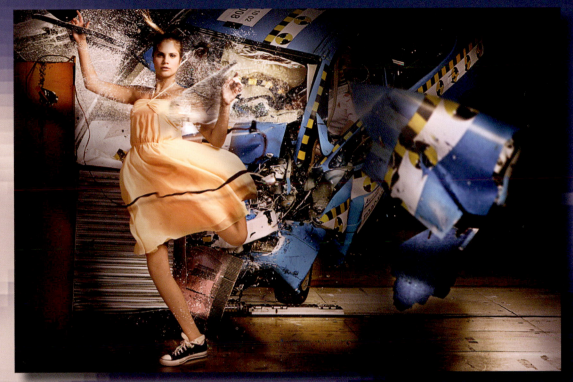

Jeph Ko

essential skills

- A knowledge and understanding of light sensitive surfaces available to the studio photographer.
- An understanding of these materials and devices, their advantages, limitations, processing and output.
- To research several various studio photographs and the image capture techniques used to achieve the result.
- To produce photographic images using technique, observation and selection demonstrating a practical understanding of light sensitive surfaces.

Introduction

There is a wide range of image capture mediums available. These range from an increasing choice of digital image sensors to a decreasing choice of color and black and white films. Choosing the appropriate medium is an essential skill for every photographer.

Capture mediums

Light sensitive surfaces can be divided into four main types:

- Digital image sensors
- Color positive (transparency or slide film)
- Color negative
- Black and white negative

ISO

Film has an ISO (International Standards Organisation) or ASA (American Standards Association) rating. Digital image sensors' degree of sensitivity to light can be altered by changing the ISO in the camera's menu. This rating is a measure of its effective speed (susceptibility to light and contrast).

Tungsten and daylight

Tungsten film (3200K) has limited availability. Daylight film (5500K) is more available. Color film achieves correct color balance when used with the appropriate light source. Correct color for digital images is achieved by choosing auto white balance or matching the light source to the corresponding white balance in the camera's menu or saving as Raw and correcting in post production. Some of the color film still available to the photographer is listed below. However, this choice is becoming more and more limited as the demand for film products decreases.

Tungsten

ISO	FORMAT	PROCESS
64	small, medium, large	E-6
160	small, medium	E-6

Daylight

ISO	FORMAT	PROCESS
100	small, medium, large	E-6
200	small	E-6
400	small, medium	E-6

www.kodak.com

Choosing a capture medium

There has been a progressive move towards digital image capture due to its ability to produce an image requiring no processing. Instead it creates image files, downloaded to a computer, suitable for printing and desktop publishing. A limiting factor has been the high cost of digital cameras capable of providing the image quality suitable for commercial illustration, but for those photographers who require lower resolution images coupled with quick turnaround and output digital offers an economically viable alternative (see *Digital Photography: Essential Skills*). Commercial photography reproduced in magazines has traditionally been produced using positive or reversal (transparency) film because it is a one-step process to achieve a positive image. However, this is changing rapidly as digital technology creates sensors with more and more pixels recording more image data. Used commercially to a lesser extent negative film creates, within its limitations, an image the opposite of what is viewed through the camera. Only when it is printed does it become a positive image. The advantage of using negative film is its greater 'latitude' and ability to handle higher subject contrast levels.

Image processing

When capturing images as JPEG or TIFF image processing is carried out in the camera. This removes most of the flexibility that post production offers. To maintain control of the final outcome capturing a digital negative or Raw file gives the photographer maximum opportunity to post produce the image. The commercial illustration industry favours Apple Macintosh computers using Adobe Photoshop. Using this software unprocessed Raw data can be converted into a usable image file where white balance, brightness, saturation and sharpness can be manipulated. Using these image editing facilities enables the photographer to achieve a higher quality outcome (see *Photoshop CS3* or *CS4: Essential Skills*).

If choosing to use film it is recommended color processing be undertaken by a professional laboratory. Although it is still possible to purchase chemicals to process color film the money saved may well be a false economy when considering the experience and equipment required to produce consistent and accurate color. The number of black and white processing systems is as varied as the number of films available. Although not covered in this book it is recommended that all photographers develop a thorough understanding of black and white processing. It is relatively simple technology (it has changed little since its introduction) and easy to learn.

Appropriate exposure

Assessing correct image exposure can be achieved by examining a histogram of the digital image file or by viewing the film on a light box. It takes practice to be precise about the subtleties of underexposure and overexposure but there is a simple starting point. If there is little or no image detail something is wrong.

If when viewing a digital image a large peak is apparent at one or both ends of the histogram then detail (recorded data) due to incorrect exposure or excessive subject contrast may be missing.

If negative film appears 'dense' (transmits very little light) with no visible detail it is probably overexposed. If positive film appears 'dense' it is probably underexposed.

If negative film appears 'thin' (transmits nearly all light) with no visible detail it is probably underexposed. If positive film appears 'thin' it is probably overexposed.

Digital capture

The image sensor of a digital camera turns the image viewed into 12 bits of memory dedicated to each of the three color channels (RGB). Most digital cameras save in the following file formats: JPEG, TIFF and Raw (see *Photoshop CS3* or *CS4: Essential Skills*).

JPEG files are created when the image data is processed in-camera. This data, at 8 bits per channel (256 levels per channel), is the smallest file size of the three formats and by compression enables many images to be stored on the camera's memory card. This format is suitable if minimum post production is anticipated, the output is to monitor display, the print size no greater than A4 and a large number of images are required. Its limitation is that the higher the compression rate, the greater the loss of quality of the final image.

TIFF format uses 'lossless' compression to process the data to 8 bits per channel (256 levels per channel) and is the accepted standard for high quality images and desktop publication (dtp). At present this format creates the largest processed file size the camera is able to output. However, fewer images can be stored on the memory card.

Raw format is the unprocessed image data (usually 12 bits per channel) recorded by the camera's image sensor. This is referred to as a 'digital negative' and offers the potential for the highest quality image when processed using designated imaging software. In many ways a Raw file contains similar information to an exposed but unprocessed frame of film. It not only enables the photographer to save an unprocessed version of the image but unlike film can be processed and manipulated as many times and in as many ways as the software allows.

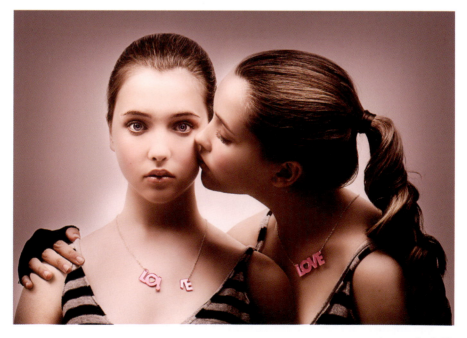

Jeph Ko

Latitude

Latitude is a measure of the ability or inability to record detail in subjects with extreme contrast and variation from correct exposure. It is accepted that most image sensors have an approximately five to seven stops latitude, although this will increase as manufacturers develop technology. This means if you underexposed an 18% gray card by three stops it would appear black on the processed file. If you overexposed it by three stops it would appear white. The human eye has almost limitless latitude because of its ability to compensate for changes in contrast and light levels. Film or image sensors are incapable of doing this due to their limited latitude. Raw files, black and white and color negative film have a latitude of seven stops and can handle a contrast ratio of 128:1. JPEG, TIFF and color transparency have five stops latitude and can handle a contrast ratio of 32:1. The human eye is capable of adjusting to a ratio in excess of 1000:1.

Daniel Willmott

Activity 1

Light a gray card with a diffuse light source.

Make sure the card fills the frame.

Defocus the camera.

Take a reflected or incident meter reading.

Either side of correct exposure, over- and underexpose in sequence one to five stops.

Evaluate the results and determine the point at which detail above and below correct exposure (latitude) is missing.

Limitations of film capture

Expiry date

All film products have an expiry date printed on their packaging. Do not use film past this date as the manufacturer will not guarantee correct color. Store unexposed film at a constant temperature, preferably in a refrigerator, but do not freeze.

Color temperature

It is not important to understand fully the theory of color temperature other than to know that capturing color images requires the correct match between capture medium and light source to avoid excessive color casts. Black and white film is relatively unaffected by color temperature although a small increase in exposure (as indicated by the MIE reading) is often required when using tungsten lights.

Tungsten film is rated at 3200K and used with tungsten lighting.

Daylight film is rated at 5500K and used with flash and daylight.

To render correct color, the use of 'white balance' when using digital capture or filtration of the camera and/or lights when using film can be used to color balance any lighting situation. The filtration required for film is listed in the specifications packaged with the film. See 'Light'.

Kata Bayer

Reciprocity

Reciprocity, more correctly referred to as reciprocity failure, is a measure of the film's ability or inability to handle extreme exposure times. Reciprocity takes effect when shutter speeds are greater than 1 second when using daylight color film, greater than 30 seconds when using tungsten color film and 1 second when using black and white. Without going into the causes of reciprocity the remedy is to reduce shutter speed (time) and compensate by increasing aperture (intensity). Increasing exposure by increasing time will only compound the problem. The results of not compensating for reciprocity is an underexposed image, varying shifts in color rendition and unpredictable results.

Push and pull

In the unlikely event of digital meltdown and film is the only capture medium available, a safety net photographers can use is the manipulation of film processing after exposure. Despite the precision of the camera and metering systems used, human and equipment error can still occur when taking a photograph. If the situation allows, bracketing (exposure one and two stops either side of and including normal) is a way of ensuring correct exposure. When there is not the opportunity to bracket and all exposures are meter-indicated exposure (MIE) it is advisable to clip test the film.

Clip test

Clip testing is a method of removing the first few frames from an exposed roll of film and processing as normal (i.e. to manufacturer's specifications). If these frames appear underexposed, a push process (overprocessing the film) may improve or compensate for any error in exposure. If overexposure is evident a pull process (underprocessing) may correct the result. The amount of pushing or pulling required to produce an acceptable result is generally quantified in stops. If an image appears underexposed by one stop push the film one stop. If an image appears overexposed one stop pull the film one stop.

Push processing color transparency having correct exposure is also an option. It has the affect of cleaning up the highlights and giving an appearance of a slight increase in contrast. Pushing in excess of what would be required to achieve this can be an interesting exercise. The results can be unpredictably dramatic. Most professional film processing laboratories offer this service.

Normal process

One stop push
– Fabio Sarraff

Activity 2

Deliberately underexpose by one and two stops subjects with average contrast.

If possible save the images in the formats JPEG, TIFF and Raw.

Assess the results.

Process in post production to achieve a consistent result with all formats.

Cross processing

Cross processing in post production is based upon a similar effect achieved when processing film in chemicals different to that suggested by the manufacturer. If a transparency film normally processed E-6 is instead processed C-41 (color negative) the result is a transparency with negative colors and tones and unpredictable detail in the highlights and shadows. Using the adjustment layers in Adobe Photoshop it is possible to create a visual equivalent of cross processing using digital editing techniques. The images below were created using a Curves adjustment layer, shifting the color values and then increasing the color saturation using a hue/saturation adjustment layer (see *Photoshop CS3* or *CS4: Essential Skills*).

If the choice is made to cross process using film it is important to note film speed will change. As a general rule transparency film should be underexposed by one stop when processing in C-41, and negative film overexposed by one stop. This is only a guide and variations in film speed and processing should be tested to obtain the result you want. Matching a film to an incorrect process can be done in any combination but the results can vary from amazing to very disappointing, but well worth the experimentation.

Normal process

Cross process
– Michael Wennrich

Activity 3

Photograph subjects of varying SBR.
Bracket the exposures and keep a record of aperture and time.
Use Adobe Photoshop to create the cross processing effect.
Label the results for reference, comparison and discussion.

Image preview

Since its introduction in 1946 instant film has become a common tool in the assessment of exposure, contrast, composition and design. To most people, whether it be you, a lecturer, an art director or someone wanting a family portrait, it is the first evidence of the photographic process and an indicator of where improvements can be made. Instant film images are 'the rough drawings' on the way to the final photograph. All instant film, color or black and white, will give a positive image. In some cases a negative, as well as a positive, will be produced that can be printed at a later date.

When using this type of film closely follow the instructions relating to film speed (ISO or ASA) and observe the processing times relating to room temperature. It is important that processing times are followed carefully. When assessing an image for exposure relative to another film type it should be realised that more detail will be seen in a correctly exposed color transparency than will be seen in the instant film's positive reflective print. This is because transparencies are viewed by transmitted light and prints by reflective light. The instant image will appear 'thin' if it is overexposed and 'dense' if it is underexposed. Types of instant film available at present are listed below.

Tungsten

TYPE	ISO	FORMAT
54 (b/w)	100	Large
55 (b/w–negative)	50	Large
59 (color)	80	Large
64 (color–tungsten)	64	Large
664 (b/w)	100	Medium
665 (b/w–negative)	80	Medium
690 (color)	100	Medium

www.polaroid.com

Digital display

Digital capture supersedes the use of instant film as the image can be seen immediately on the camera's LCD screen or downloaded to a suitable computer. The computer must have a monitor and software capable of displaying the digital file at high resolution together with a histogram of the image levels.

Activity 4

Using a diffuse light source light a person's hand.

Preview the image using an appropriate camera to computer interface or correctly expose by incident reading onto Polaroid.

Using either medium determine 'correct' exposure and composition.

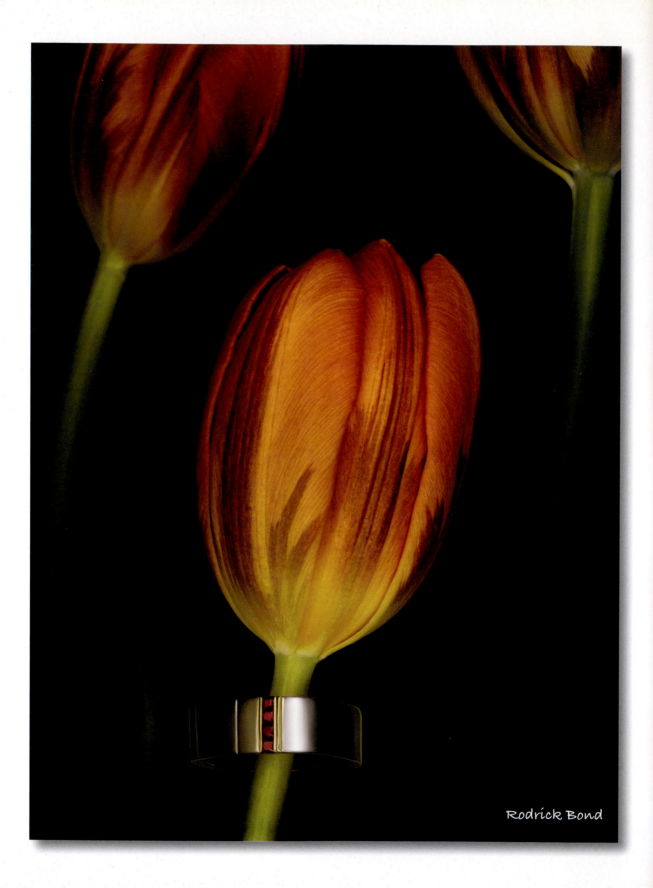

Rodrick Bond

creative controls

Daniel Tückmantel

essential skills

- Increase knowledge and understanding of aperture, shutter speed and focal length and their combined effect on visual communication.
- Increase familiarity and fluency of operating camera equipment.
- Through research study and observe the use of creative controls in the creation of photographic images.
- Produce photographic images demonstrating a practical knowledge of depth of field, timed exposures and perspective.

Introduction

The choice, arrangement and design of a subject within the frame determines the effectiveness of its communication. Communication can be increased by having a better understanding of the camera and its controls. Careful consideration is advised when using technical effects, so the resulting images are about communication and content and not predominantly about technique. Technique should never dominate the image. Some of the main techniques (other than lighting) employed by photographers to increase the communication of an image are:

- Focus
- Duration of exposure
- Perspective

James Newman

Familiarity

Owning the latest equipment will not necessarily make you a better photographer. Familiarity with a simple camera used over a period of time can be of far more value. Using the camera must become second nature to the point where it can be operated with the minimum of fuss. The equipment must not interfere with the function of seeing. The camera is the tool used to communicate the photographer's vision. Creative photography is about observation, interpretation and communication of this preconceived vision.

Focus

'Focus' is the point at which an image is sharp or is the 'centre of interest'. When framing an image the lens is focused on the point of interest to the photographer. The viewer of an image is instinctively drawn to this point of sharp focus. This is the 'point of focus' of the image. In this way the photographer 'guides' the viewer to the same point of focus and thereby the same point of interest visualised in the original composition.

Jo Harkin

Limitations

Everything at the same distance as the focal point of the image will be equally sharp. Subjects nearer or further away are progressively less sharp. Focus on most small and medium format cameras can be graduated between two points to achieve focus. As the camera moves closer to the subject a point is reached where the subject can no longer be focused. This is the 'closest' point of focus, and the lens will be at its greatest physical length. As the camera moves away from the subject the focal point of the image will change until it reaches a point where almost everything within the frame will be in focus. At this point the limit of the lens's ability to focus will have been reached and it will be at its shortest physical length. This distance is called 'infinity' and is marked on most lenses by the symbol ∞ . The closest point of focus and infinity varies between lenses.

Activity 1

Using the closest focusing distance of each of your lenses photograph the same object from the same viewpoint. Record the closest focusing distances. If using a zoom lens record the closest focusing distance at the shortest and longest focal length.

Depth of field

Aperture not only controls exposure, it also controls depth of field. Depth of field is the distance between the nearest and furthest points in focus at a chosen aperture. At maximum aperture the depth of field is said to be narrow (shallow focus). At minimum aperture the depth of field is said to be wide (deep focus). The greatest depth of field is achieved at minimum aperture. If exposure time has to remain constant due to subject limitations then aperture has to be altered to achieve correct exposure. Changing aperture will increase or decrease depth of field depending upon the f-stop used. The larger the number of the f-stop the greater the depth of field. The smaller the number of the f-stop the smaller the depth of field. Depth of field is, however, relevant to the point of focus. A general rule of thumb is depth of field increases 1/3 forward and 2/3 behind the point of focus as you decrease the size of the aperture (increase the f-number).

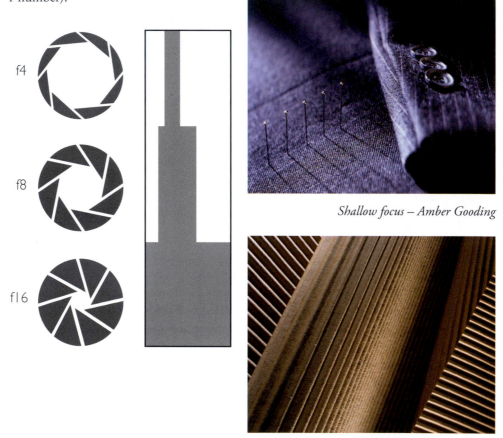

Shallow focus – Amber Gooding

Deep focus – Rodrick Bond

Activity 2

Find examples of photographs where depth of field has been used as a creative tool in the composition of the image.

Retain copies for future reference in your Visual Diary.

Factors

Depth of field is determined by the distance from the camera to the subject, the focal length of the lens and the size of the aperture.

Distance

As the camera moves closer to the subject the depth of field decreases (shallow focus). As the camera moves away from the subject the depth of field increases (deep focus).

Focal length

As the focal length of the lens increases (long lens) the depth of field becomes narrower. As the focal length of the lens decreases (wide angle lens) the depth of field becomes wider.

> The least depth of field is achieved using the minimum focusing distance at maximum aperture on a long lens. The greatest depth of field is achieved using the maximum focusing distance at minimum aperture on a wide angle lens.

Point of focus

In most cases depth of field extends unequally in front of and behind the point of focus. Focus increases in the proportion of ⅓ forward of the point of focus and ⅔ behind.

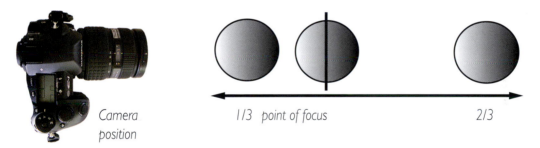

Camera position 1/3 point of focus 2/3

Depth of field

Practical application

All factors affecting depth of field are working simultaneously. Aperture is the main control over depth of field. In combination with framing, composition, lens choice and the distance of the camera from the subject the focal point of the image can be precisely controlled. Using any combination of these techniques can isolate or integrate that part of the subject within the frame determined to be the focal point of the image.

Activity 3

Compile in your Record Book the depth of field distances as indicated on your lenses. Correlate distances with f-stops from the depth of field scale and retain for future reference. On which lens does depth of field increase at the greatest rate?

Selective focus

Aperture places limitations upon a photographer that can become a creative advantage with the use of selective focus. This does not mean the camera is focused at a single point. When aperture is increased or decreased the depth of field changes. This changes the area of sharp focus to a greater or lesser extent. It is the conscious decision made by a photographer to use a combination of focus and aperture to create a selective field of focus that draws the observers' viewpoint to one area or selected areas of the image.

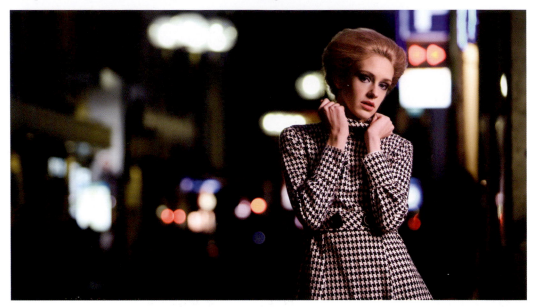

Tracey Hayes

Shallow focus is obtained at maximum aperture (iris wide open) and deep focus is obtained at minimum aperture (iris closed down). Having this information enables the photographer to use this technique to create well-defined areas of focus and attention. See 'Exposure'.

In practical terms, this means if a point of focus is chosen and maximum aperture is used for exposure, all areas other than the point in focus will remain out of focus when the camera makes that exposure. As depth of field increases selective focus decreases. The effect of aperture on depth of field and its use in deciding upon an area of selective focus can be seen prior to exposure by the use of the camera's preview mechanism.

Activity 4

Place two objects one behind the other approximately one metre apart.

Focus with a normal lens on the front object at maximum aperture and make an exposure at every f-stop until you reach minimum aperture.

Focus on the rear object and repeat the sequence.

Compare results and retain for future reference in your Record Book.

Preview

Most cameras or their associated lenses have the facility to preview an image at the chosen aperture prior to exposure. In one form or another this is achieved by closing down the lens (reducing the size of the iris) in order to preview the image using the exposure aperture. Most cameras view images at maximum aperture. Even though the f-stop setting on the lens may not be at maximum aperture the viewing system overrides this. This allows the photographer to compose the photograph with the brightest image available. This can only be obtained by having the lens at maximum aperture whilst viewing and automatically stopping down to chosen aperture at the instant of exposure. This gives the advantage of bright viewfinder images but does not give a true picture of what will be in or out of focus other than the point at which the camera is focused. Previewing depth of field and its effect upon selective focus is a skill photographers often use. If the image has been previewed then there can be no surprises when the results are viewed.

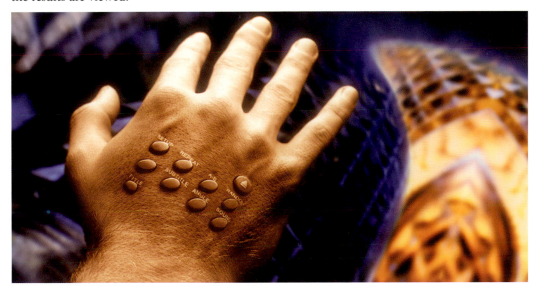

Stuart Wilson

On most cameras it is possible to change aperture, and see the effect upon depth of field, during preview. With large format cameras there is no preview button. Viewing the effect of aperture upon depth of field is undertaken by progressively closing down the f-stop from maximum to minimum aperture whilst looking through the back of the camera. In all cameras as you close down the aperture in preview mode the image will become darker, halving in intensity every f-stop.

Activity 5

Practise using the preview mode on your camera.
Take note of how the image becomes darker as you move through maximum to minimum aperture and the effect it has upon an area of selective focus.
Observe the difference between depth of field and selective focus.

Duration of exposure

All photographs are time exposures of either shorter or longer duration. In a studio situation the majority of subjects being photographed will be relatively inanimate. The longer exposure times required for tungsten lighting compared to exterior daylight or flash are usually not a problem. If the photograph is a studied portrait or recreation of a 'period look' the use of an aperture at or close to maximum will give acceptable results and complement the overall design. By choosing long exposures moving objects will record as blurs. This effect is used to convey the impression or feeling of motion. However, much of the subject information is sacrificed to effect. See 'Using light'.

Fast shutter speed

In a studio fast shutter speeds would be required when photographing moving subjects or subjects likely to move. Animals and children, for example. A shutter speed faster than 1/125 second would be required to freeze their action in order to obtain a sharp image. This does not refer to focus but to image blur. Exposures this fast are most easily achieved using a flash light source of high intensity and short duration. See 'Using light'.

Slow shutter speed

When using tungsten light and a shutter speed slower than 1/30 second movement is recorded as a streak of light. This is called movement blur (when using flash the subject is frozen at any shutter speed). With the camera on a tripod the moving subject will blur but the background will remain sharp. If the camera is panned (camera follows the subject) the subject blur will be reduced and the background will blur in the direction of the pan.

Camera shake

Image blur caused by camera movement can be eliminated by mounting the camera on a tripod and using a cable release to activate the shutter. This is imperative with the longer exposure times required for tungsten light. When using flash, camera vibration is not an issue as the duration of the flash is shorter than the fastest shutter speed on the camera.

Tim Barker

Creative exposure compensation

Exposure compensation is primarily used to achieve correct exposure. However, the creative process of photography sometimes requires an exposure that is not correct to produce the desired result. The degree of compensation is only limited by the photographer's imagination. Interesting results can be achieved by purposely under- or overexposing regardless of SBR.

Color saturation

Decreasing exposure by 1/3 or 2/3 of a stop will increase color saturation. This works especially well if using color transparency film as the image is viewed by transmitted light. Care should be taken when recording tones of known value.

Back lighting

A subject is back lit when the dominant light is from behind the subject. To take a reflected reading of the area viewed by the camera would give an incorrect exposure. A reflected reading of the subject only or an incident reading from the subject to the camera would give correct exposure. In this way the dominance of the back light can be controlled.

Halos

With subjects having extreme contrast either as a result of SBR or lighting ratios, exposing for the shadow areas will create the effect of massively overexposing the highlights. On its own, or combined with lens filtration (soft filter) or post production techniques, the result especially when using a strong back light is a halo effect around the subject.

Silhouettes

A silhouette is the shadow or outline of the subject against a lighter background. It can be created by back lighting and reducing the exposure to remove detail from the subject. Reducing the subject exposure by three stops is sufficient to record the subject as black.

Daniel Tückmantel

Perspective

Visual perspective is the relationship between objects within the frame and their place within the composition. It is this relationship that gives a sense of depth in a two-dimensional photograph. 'Diminishing perspective' is when objects reduce in size as the distance from the camera to that object increases. 'Converging perspective' is when lines that in real life are parallel appear to converge as they recede towards the horizon. The human eye has a fixed focal length and a perspective determined by viewpoint. Photographic perspective can be altered by changing the distance of the camera from the subject.

Steep perspective

A wide angle lens apparently distorts distance and scale, creating 'steep perspective'. A subject close to the lens will look disproportionately large compared to its surroundings. Objects behind and to the side of the main subject will appear much further away from the camera due to the closer viewpoint often associated with a wide angle lens.

Steep perspective – Stuart Wilson

Compressed perspective

The distant viewpoint of a long lens condenses distance and scale, creating 'compressed perspective'. A subject close to the lens will look similar in size to other subject matter. Objects behind and to the side of the main subject will appear closer together than reality.

Compressed perspective – Stuart Wilson

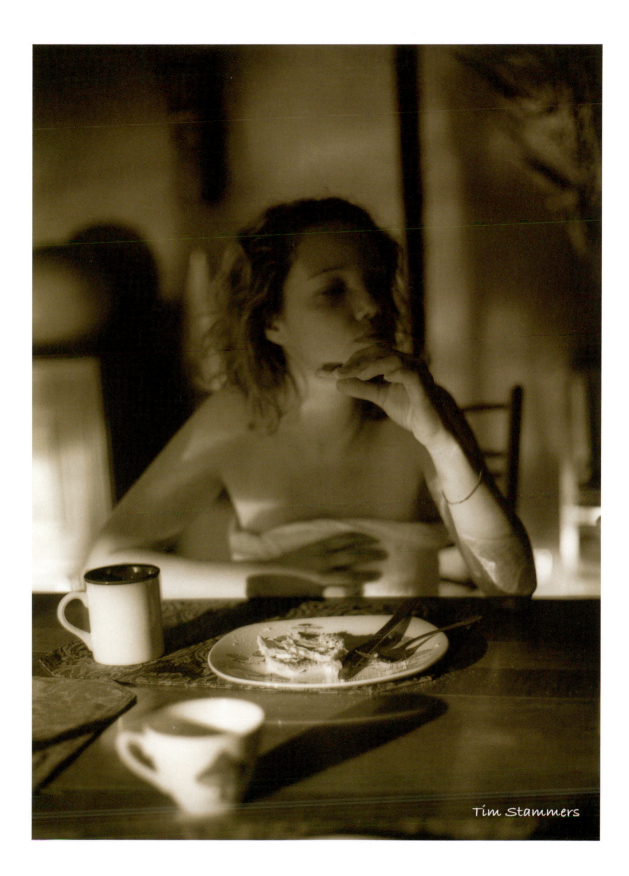

Tim Stammers

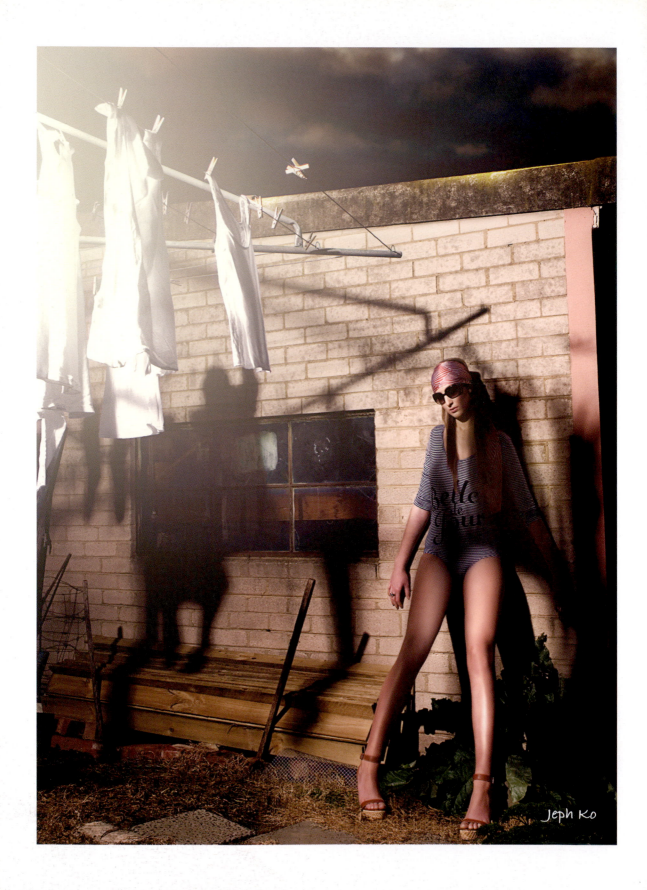

Jeph Ko

using light

Rodrick Bond

essential skills

- A knowledge and understanding of the use of artificial light sources, camera and associated equipment in a studio environment.
- An awareness of the effect of artificial light in the creation and control of lighting ratios, tonal range, contrast and exposure.
- Through research the study and observation of the use of light in the production of photographic images.
- The production of photographic images demonstrating a practical knowledge of the use of light.
- Record information relevant to the technique and production of each photograph.

Introduction

This study guide should be used as a practical source of information to understanding the use of artificial light sources in a studio environment. The explanation of how to use the light sources (diffuse and direct) is directly related to providing practical lighting solutions to the assignments in 'Lighting still life' and 'Assignments'. Completion of the activities will provide a basis for an understanding of the recommended approach to each assignment. It is advisable the technique and lighting approach suggested in each activity be initially followed and then adapted to individual subject matter.

Shaun Guest

Approach

The sun, the dominant light source in the world outside the studio, is the starting point to understanding studio lighting. As you progress through your photographic career other approaches will inevitably influence you but an understanding of how to use a single light source to achieve many varied results is a discipline worth mastering. Try not to attempt too much too soon. Set yourself goals you know you can achieve within your limitations. Aspiring photographers may never have enough time or money but admirably they are exploding with ideas. It is making these ideas work within these constraints and abilities that will give successful results. Set out to achieve what you know is possible, take as much time as is available and exercise patience. If you allow three hours to produce an image use the full three hours. When you have completed the photograph experiment with variations. Every time you move a light or alter its quality you will learn something. You will never take the perfect photograph. If you ever think you have, change careers because photographically the learning process has ceased.

Working with studio lights

Common rules

Common rules of physics apply to the use of artificial light sources. When sunlight passes through greater amounts of particles in the atmosphere at dawn or sunset, exposure times increase compared to a reading taken at noon. This applies to clear and overcast days. Exposure times will obviously be shorter on a clear day. Applying these rules to a studio situation, the greater the impedance to the light (diffusion, reflection, filtration) the longer the exposure. The less impedance to the light (no diffusion, reflection, filtration) the shorter the exposure.

Another simple rule. The amount of light falling on a subject decreases to 1/4 of its original intensity when the light to subject distance is doubled, and increases by four times when the light to subject distance is halved. For example, if a reading of f16 is obtained when the light to subject distance is one metre, at two metres the reading would be f8, at four metres f4. These rules do not change regardless of the light source. It is also important to remember contrast in a studio situation is created not only by the reflectance level of the subject matter (SBR) but also by lighting ratios. When referring to lighting ratios the photographer is also referring to lighting contrast. See 'Light'.

Key light one metre from subject

Key light two metres from subject – Fabio Sarraff

Activity 1

In a darkened studio place a light one metre from the studio wall and take an incident reading, with the light on, of the light falling upon the wall. Note the reading and move the light on the same axis another one metre, making a total of two metres, away from the wall. Note the reading. Double the distance once more, making a total of four metres. The final reading will be four stops less than the first. What will the distance of the light from the wall have to be to achieve a meter reading of three stops less than the first?

Flash

Flash is a generic term referring to an artificial light source of high intensity and short duration. It has a color temperature of 5500K to 5800K and is balanced to daylight. Unlike tungsten it is not a continuous source of light. Between flashes it has to recycle (recharge) to maximum output before it can be used. A large tungsten lamp has an output 100 times greater than the average household light bulb. With a film or image sensor rated at ISO 100 this will give exposures of around 1/60 second at f4. A modest studio flash with an output of 5000 joules (measurement of output) at the same distance from the subject will give exposures of around 1/500 second at f11. This is six stops faster or a ratio of 64:1. Its advantage with subject matter that moves becomes obvious.

Tracey Hayes

The advantage of modern flash is its lightweight construction and versatility. Most studio flash systems consist of the power pack, flash heads and flash head attachments. The power pack is usually a separate unit where the power output is stored until the instant of exposure. After exposure the power pack recharges ready for the next exposure. Recycling times vary from seconds to fractions of a second. The faster the recharge to full power the more expensive the unit. The flash heads are the actual light source. The basis of their design is to produce a light quality similar to that produced by floodlights and spotlights. The way in which this is achieved ranges from varying sizes of reflector bowls similar in design to a floodlight, to a focusing spotlight equivalent to its tungsten counterpart. The choice of flash head attachments manufactured to achieve this is extensive and varied. A large percentage of the images in this book were lit using studio flash. This is not to underestimate the importance of tungsten in a studio situation. Flash, being a non-continuous light source, is confined to 'still' photography whereas tungsten lighting is used almost exclusively in 'moving' photography (film, video and TV). However, the lessons learned with one light source apply equally to any other.

Floodlight

Despite the manufacturers' names, swimming pool, soft box, fish fryer, honeycomb and many others, these are really only larger or smaller variations of a floodlight. In some the light source is placed inside and to the rear of a collapsible tent with direct light transmitted through a diffuse front surface. In others the light is reflected off a white or silver surface before it is transmitted through a diffuse front surface. These types of light sources give a very soft diffuse light with minimum shadows. Another source of soft diffuse light is created when flash is used in conjunction with a collapsible umbrella. With umbrellas having a white or silver (inside) surface, diffuse light with no shadows can be directed into the umbrella and reflected back onto the subject. With umbrellas having a semi-transparent surface, diffuse light with soft shadows can be directed at the subject through the umbrella.

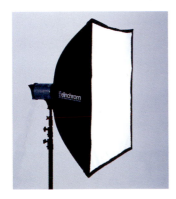 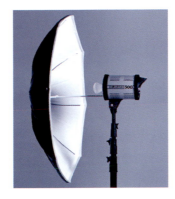 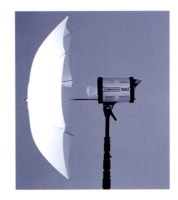

Soft box *Reflected umbrella* *Diffuse umbrella*

Spotlight

The use of an open flash (direct light to subject without diffusion or reflection) will give the same effect as a spotlight. Some brands have focusing capabilities closely imitating Fresnel spotlights. The light will be hard with no shadow detail. Barn doors, nets and filtration of the light is approached in the same way with either artificial light source.

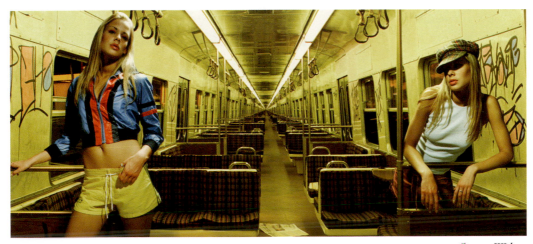

Stuart Wilson

Tungsten

Vacuum tungsten lamps and their derivatives are widely used forms of artificial photographic lighting in photography, film and television. They have a color temperature between 3200K and 3400K and are compatible with correctly balanced image sensors, tungsten color film and black and white film. See 'Image capture'. Despite the extensive use of flash in a commercial studio, prior to any flash exposure the way a subject is lit is usually determined by the use of tungsten modelling lamps built into the flash heads. Flash gives a much shorter exposure time with a similar quality of light to the same subject having been lit by an appropriate tungsten light source. However, compared to flash, tungsten is relatively simple technology. It should be taken into account when learning the use of tungsten lighting that all film and television lighting is tungsten based. There are many variations to the lighting sources available but in general terms they all fall into the two major categories, floodlight and spotlight.

Floodlight

A floodlight produces a wide flood of light across a subject. The light from the lamp bounces off the reflector in which it sits and travels forward as a broad light source. This diffuse light gives 'soft' edges to the shadows and some shadow detail. The quality of the light is similar to sunlight through light cloud.

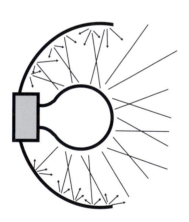

Floodlight

Activity 2

In a darkened studio place a diffuse flash or tungsten floodlight four metres in front of a person standing against the wall. Turn on the light. Note the lack of shadow detail.
Without moving the light get the person to move one metre away from the wall. Note the increase in shadow detail and softening of the shadows' edges.
Repeat in one metre increments until the subject is almost in front of the light.
What is happening to the shadows and why?
Compile results in your Record Book.

Spotlight

A spotlight, by use of a focusing (Fresnel) lens, can concentrate light at a certain point. The light from the lamp is directed forward by a spherical reflector and focused to a point by the glass Fresnel lens. The light will have 'hard' edges to the shadows and no detail in the shadow areas. The quality of the light is similar to direct sunlight. Spotlights can be 'flooded' to give a more diffuse quality comparable to the spread of a floodlight but with less shadow detail. This change from spot to flood is achieved by moving the lamp and the reflector inside the lamp housing away from (spot) or closer to (flood) the lens at the front of the light. On 'full spot' shadows are harsh with no detail, on 'full flood' shadows are softer with some detail.

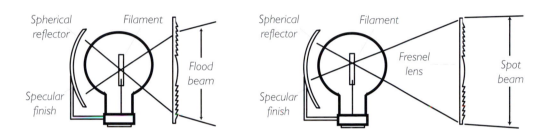

Full flood/full spot

Most spotlights are supplied with barn doors and nets. Barn doors are four metal flaps attached to the front of the light and used to control the shape and amount of light falling on the subject. Narrowing the doors will not only reduce the amount of light but also control the shape of the light falling on the subject. Once shaped the barn doors can be rotated independently of the main light housing. Nets are pieces of wire gauze of varying densities that reduce the output of the light by diffusing the light at its source without greatly affecting the shadows. They are manufactured in half, one and two stop increments.

Activity 3

In a darkened studio light a subject (a person) with a diffuse flash or tungsten floodlight from the right-hand side.
Record with correct exposure for the lit side of the face.
Turn off the light and relight the same subject from the same direction with an open flash or tungsten spotlight on 'full spot'.
Record with correct exposure for the lit side of the face.
Observe the results and determine the difference in the intensity and detail in the shadows.
Which light would you use for no shadow detail and which light for limited shadow detail?
Compile results in your Record Book.

Diffusion

Long before the invention of photography painters had been diffusing light. Light passing through certain materials created a light with soft shadows sympathetic to their subjects. Early writings and drawings of Michelangelo show his studio had a type of cheesecloth hung over the windows. This diffused the harsh sunlight and filled the studio with a soft light more suitable to painting. Any light source can be diffused by placing certain translucent materials between the light source and the subject. This has the effect of diffusing and spreading the light over a greater area by altering the direction of the light waves. Diffusion softens the edges of the shadows and increases shadow detail. At the same time the measured amount of light falling on the subject is decreased. The amount of diffusion is also determined by where the diffusion material is placed in relation to the light source and the subject. The closer the diffusing material to the light source the less diffuse the light. The closer the diffusing material to the subject the more diffuse the light, the softer the edges of the shadows and the greater the shadow detail. There are many diffusion products manufactured specifically for the photographic market. These are products such as scrim, nets and silks. Other suitable materials are tracing paper, cheesecloth and window netting provided they are non-flammable or heatproof.

Diffuse light – Itti Karuson

Activity 4

In a darkened studio light a semi-reflective object (e.g. a tomato) with an open flash or tungsten spotlight. Place the light approximately 1.5 metres from the subject.
Observe the source of light reflected in the object and lack of shadow detail.
Diffuse the light source with tracing paper (60cm x 60cm) 50cm from the light.
Observe the apparent increase in the size and diffusion of the light source as reflected in the subject, diffusion of the shadows and increase in shadow detail.
Without moving the light place the tracing paper as close to the subject as possible.
The light source has now become the size of the piece of tracing paper. There will be a soft spread of light over most of the subject with the shadow being almost nonexistent.

Reflection

Reflected light is most often used as a way of lighting areas the dominant light source (key light) cannot reach. An example is the strong shadow created by a spotlight when it is to one side of the subject. To obtain detail in the shadow area light has to be reflected into the shadows. This is called fill light and is achieved by collecting direct light from the light source and redirecting it with a reflector. Reflectors can be any size, from a very small mirror to large polystyrene sheets measuring 3m x 1.5m. Reflected light can also be used as the key light. When photographing a reflective object, or a very diffuse (soft) lighting effect is required, the light source can be directed into a reflector. The reflector becomes the light source and no direct light from the light source is directed at or reflected in the subject. When photographing cars in an exterior situation the car is usually positioned so sunrise or sunset is behind the car. With the sun below the horizon, the sky above and in front of the car is acting as a giant reflector. This is one approach to lighting cars and reflective objects in a studio. There are many reflective products manufactured specifically for the photographic market. More readily available materials are, white card, gray card, colored card, silver foil, aluminium foil and mirrors.

Reflector as light source – Daniel Tückmantel

Activity 5

Light a person's face with open flash or tungsten spotlight from behind and to one side.
Observe the deep shadows falling across most of the face.
Using a reflector (white card 1m x 1m) redirect the light into the shadow areas.
Observe how the intensity of the light changes as the reflector is moved closer to and further away from the face.
Expose image at the desired intensity of fill.
Cover the reflector with aluminium foil and repeat the above activity.
Label and keep results for future reference.
Compile results in your Record Book.

Filtration

Filters alter the quality of light by selectively transmitting certain colors or by changing the way light is transmitted. A red filter only transmits red light. A blue filter only transmits blue light and so on. A soft focus filter changes the direction of the light waves in the same way as diffusion material softens a light source. Correction filters alter the color temperature of the light. Neutral density filters reduce the amount of light, and therefore exposure, from a light source without affecting its color temperature. Glass, plastic and gelatin filters are used for filtration of the camera lens but gelatin filters are used more often in the filtration of the light source. The advantage of filtering the light source is that different filters can be used on each of the lights whereas with filtering the camera all light entering the lens will be subjected to a common filter. Filters used upon a light source are made of heat resistant colored gels manufactured to specific safety requirements and color balance. The effect of filtration is obvious and immediate. When working with correctly color balanced gels, appropriately balanced camera and correct exposure 'what you see is what you get'. Filtration of the camera is normally used for color correction or enhancement of the entire image. This may be caused by the light source not being balanced to the camera or the removal of an excess of one color inherent in the light source. However, when capturing Raw file images it is possible to undertake color correction in post production. See 'Image capture'.

Polarising filters are valuable in the control of unwanted reflections and increased color saturation. This is because of their ability to selectively transmit certain wavelengths as they are rotated in front of the camera lens or light source. A wide range of 'effect filters' such as graduated and star burst are also available for on-camera use and post-production software. They can produce some interesting results but should not be used as a substitute for the lack of an original idea or solution to a photographic problem. Camera filtration will require a degree of exposure compensation.

Post-produced filtration – Stuart Wilson

Mixed light sources

Any source of light can be combined with another to create interesting lighting effects and shifts in color balance. In a studio situation this can go beyond mixing tungsten with flash and is limited only by one's imagination. Normal domestic lamps are often used as supplementary and practical sources of light. Candles give a warm glow and very soft shadows. Torch light can be used to great effect when painting with light. When working in color do not be afraid to change the color of the light by the use of colored gels on the lights or on the camera, or incorrect white balance. If it gives off light, try using it!

Mixed flash and tungsten – Amelia Soegijono

Activity 6

Place a camera on a tripod. Focus on a coin placed on a dark background. Set the shutter speed to T (the aperture opens when activated and will not close until activated for the second time). Set the aperture to maximum aperture. Darken the studio and open the lens. Using a small torch move its light over the coin as if painting with a brush (large broad strokes) for approximately 10 seconds. This should be done from the camera position.

Bracket your exposures by one stop either side of normal (5 seconds and 20 seconds).

Repeat this procedure at every f-stop. Record results and observations.

Illusion of movement

Closely associated with an understanding of the use of light is the use of the camera to create the illusion of movement. By combining the movement of either the camera, subject, or lights the illusion of movement within a still frame can be created. Using tungsten light in a darkened studio and with the camera lens open, walking slowly through frame (the camera's field of view) will result in a blurred image where you were moving and still image where you stopped. Another way to create movement is to increase exposure time to the longest possible with the light source you are using and move the camera during all or part of the exposure. This is easily achieved with a zoom lens, but also achievable by panning or tilting the camera mounted on a tripod. There are other advantages to using a slow shutter speed when using a combination of flash and tungsten. If the output of the modelling lamps, or supplementary tungsten lighting, is high enough to equal the exposure aperture of the flash output a slower exposure time can be used for the tungsten light than required for the flash. This would allow correct exposure of the flash (which is regulated by aperture and not time) and correct exposure of the tungsten (which is regulated by a combination of aperture and time). This would give the effect when balanced to daylight of a warm after-glow to any object moving before or after the flash exposure.

Studio camera movement – Itti Karuson

Activity 7

From the camera position light a person with a broad diffuse tungsten light source.

Set the camera shutter to the longest exposure possible relative to the aperture.

In a darkened studio with the lens open get the subject to walk around in frame.

Vary the speed and rhythm of the movement.

Process and compile results and observations in your Record Book.

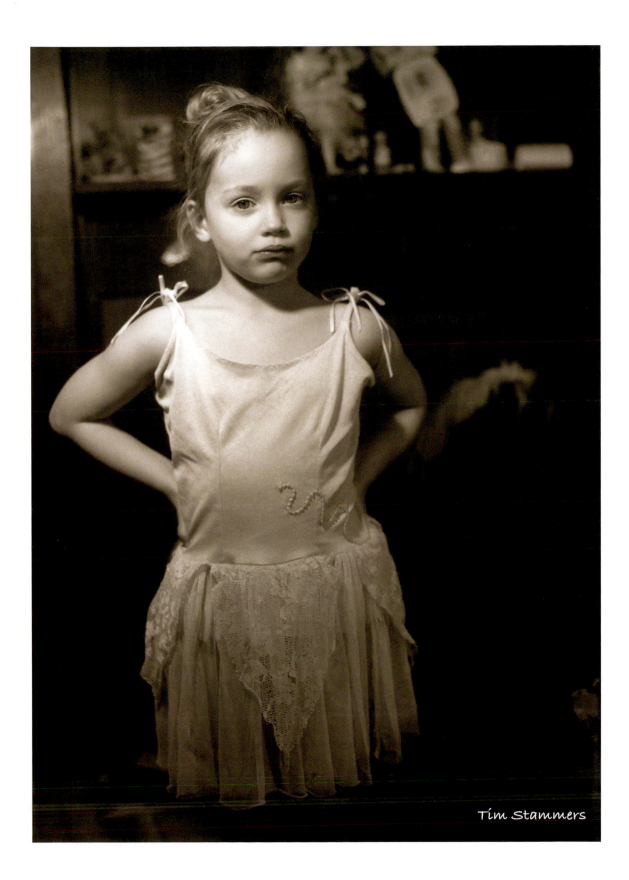

Tim Stammers

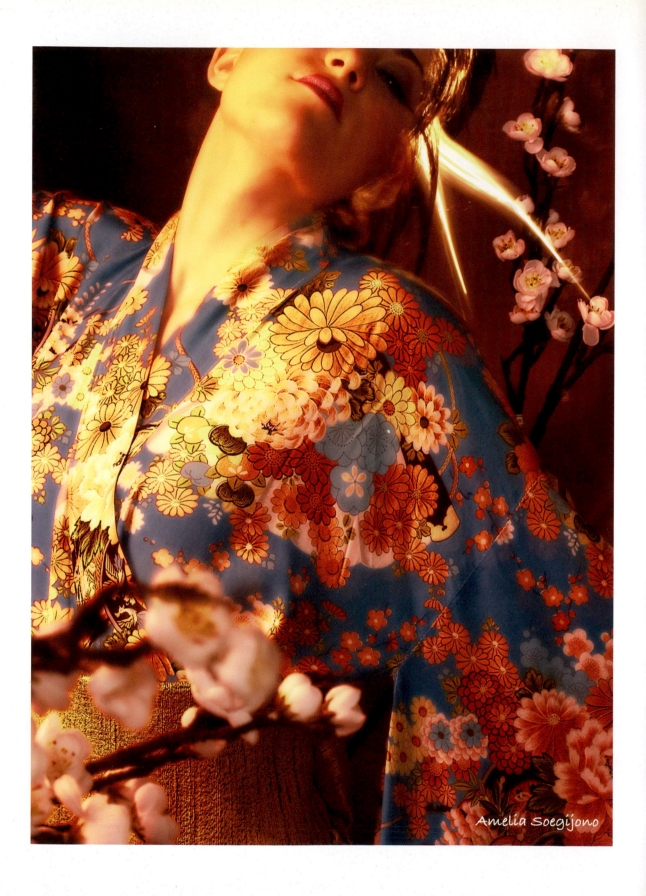

Amelia Soegijono

lighting still life

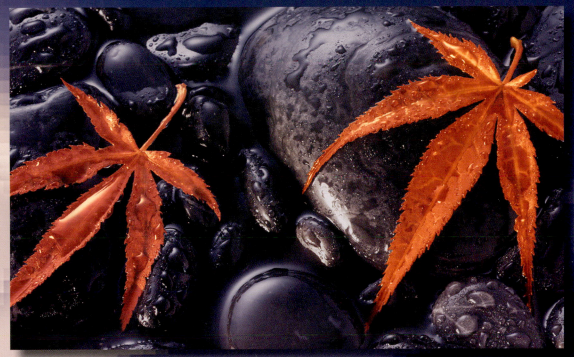

Rodrick Bond

essential skills

- A knowledge and understanding of the application of studio lighting to still life subjects.
- An understanding of the practical use of light to create contrast, dimension and mood.
- Through study, observation and pre-production an understanding of the resources and skills required to produce photographic images.
- To develop ideas and produce references containing visual information gathered in completing the assignments.
- To produce color images to the highest standard.

Introduction

The assignments are written with the assumption that the aspiring photographer has a limited knowledge of the practical application of studio lighting. It is important the assignments are completed in the order in which they are written. Each lesson learnt from one applies to the assignment that follows. To attempt to produce the assignments out of sequence will mean certain information relating to lighting development and metering techniques will be missed. The criteria set out in each assignment should be followed as closely as possible as it forms a major part of the practical learning process. Where possible it is advisable that each assignment be workshopped at a group level with guidance and direction. Individuals should then attempt to complete their own interpretation of the brief within a specified period. The assignment brief is itemised into specific requirements. These requirements must be successfully completed as a basis for any assessment of the completed image. Interpretation of the brief beyond these requirements is encouraged but not at the expense of the basic criteria. All information relevant to the completion of each assignment should be compiled in the Record Book.

Criteria

Lighting This is a description of the minimum lighting requirements to complete the assignment. The recommended light source is indicated (floodlight, spotlight, fill, etc.) along with its purpose and effect (e.g. to create tonal difference). If using studio flash substitute open flash for spotlight and diffuse flash (soft box, umbrella, etc.) for floodlight.

Props This is a recommendation of other objects that could be used within the image area to enhance the composition and design of the photograph. The use of props is a personal choice dependent upon previsualisation of the image.

Background In the first two assignments the background color is specifically related to the criteria of the brief. It is difficult to create a foreground shadow of the box on a black background. With the ball assignment it is difficult at this stage of the learning process to control strong backlighting on a white background. In the other assignments the choice of background is limited only by your imagination.

Exposure To develop an understanding of metering techniques follow the method specified in the brief. In the earlier assignments lighting ratios between lights will be asked for (ratio of 2:1 between key light and fill). Lighting ratios are measured with your light meter. See 'Exposure'.

Technique Technique is the use of all the elements the photographer controls in order to produce the specific requirements laid down in the assignments. This covers the use of the camera, lighting, exposure and composition to create an image that fulfils the brief and complements the photographer's previsualisation.

Lighting diagrams

A lighting diagram is a graphic means of illustrating the lighting and camera position in relation to the subject. Measurements are not shown as these will vary according to the output of the lights being used and the size of your subject. It is important, however, to attempt to reproduce the direction and quality of the light. The diagrams are therefore a starting point from which to experiment and build your knowledge. Lighting diagrams should form a major component of your Record Book.

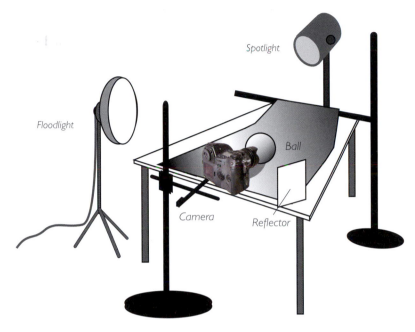

Progress

A series of progressive images will show the way in which an answer to the individual lighting solutions posed by each assignment is solved. Cost is always a factor in photography, no more so than when learning, so the choice of whether to shoot progressive images as a way of judging exposure and composition is left to the individual. The cost can, however, be far less than having to reshoot the assignment due to an error that may have been obvious on a progress image.

Assignment 1 'Box'

Criteria

Lighting Direct spotlight and floodlight, plus reflector to create tonal difference between the three sides of the box.

Props Optional.

Background White.

Exposure Incident light meter reading. Lighting ratio of 2:1 between spotlight and floodlight and 2:1 between floodlight and reflector.

Technique Create an image of a single colored box with a foreground shadow and three sides with separate tonal ranges.

Image 1

Place a single colored box on a white background. Place the camera on a tripod in front of and 30 degrees above the subject. Fit a lens hood to the camera. Using a normal lens at maximum aperture focus 1/3 of the way into the top of the box. From behind the subject aim a spotlight on full spot into the centre of the top of the box. With the light correctly centred turn the spotlight to full flood and move the light so the shadow falls directly in front of the subject. Ensure only the top of the box is lit by the spotlight. Check for lens flare (direct light into the lens). Take an incident reading of the light source from the subject. Set ISO and note the aperture.

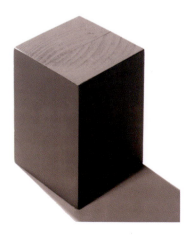

Image 2

Turn off the spotlight. As viewed from the camera, place a floodlight on the left of the box and at the same distance from the box as the spotlight. Turn on the light and ensure light from the floodlight only lights the camera left side of the box. Take an incident reading of the light from the subject. Note the aperture and adjust the floodlight by moving it closer to or further away from the subject until an aperture of exactly one stop less light than the spotlight is achieved. This will be a lighting ratio of 2:1 between the spotlight and the floodlight.

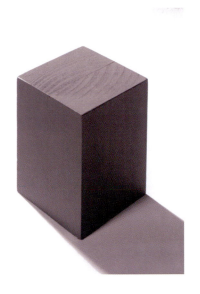

Michael Wennrich

Image 3

Turn on both lights. As viewed from the camera place a reflector (piece of white card) on the right-hand side of the box approximately half the distance of the floodlight from the subject. Whilst shielding the invercone with your hand take an incident reading from the subject of the light being reflected from the white card. Move the card closer to or further away from the subject until a reading one stop less than the floodlight is achieved. This will be a lighting ratio of 2:1 between the left and right sides of the box. After checking the lighting ratios take an incident reading from the front of the box directly back to the camera. This will be an average of all the readings and 'correct' exposure. Check focus and select an f-stop (using preview mechanism) giving sharp focus from the front to the back of the box (depth of field). Make a final check for lens flare before making an exposure.

Lighting diagram

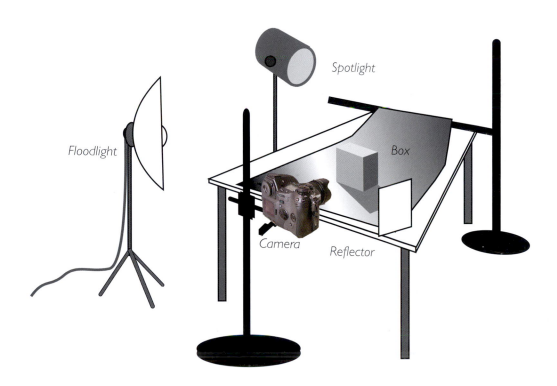

Spotlight

Floodlight

Box

Camera

Reflector

Assignment 2 'Ball'

Criteria

Lighting Direct spotlight and floodlight, plus fill.

Props Optional.

Background Black.

Exposure Incident light meter reading. Measured lighting ratio of 3:1 between backlight and fill light and 2:1 between fill light and reflector.

Technique Using light to create dimension and 'roundness' across the surface of the ball.

Image 1

Place a non-reflective ball on a black background. Place the camera on a tripod in front of and slightly above the ball. Fit a lens hood to the camera. Using a long lens at maximum aperture focus 1/3 of the way into the ball. From behind and above the subject aim a spotlight on full spot at the centre of the back of the ball. This will give a rim of back light around the edge of the ball. Move the spotlight so the shadow falls forward of the ball. Ensure only the edges of the ball are lit by the backlight. Reposition the light if lens flare becomes a problem. Take an incident reading of the light source from the subject. Set ISO and note the aperture.

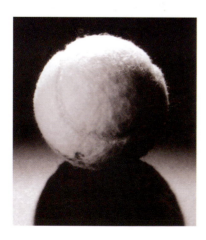

Image 2

Observe the left side of the ball where the front of the ball falls into shadow. Leave the back light on. Place a floodlight on the left of the ball at the same distance from the ball as the back light. Turn on the light and aim the centre of the light at the line that denotes the change from light to shadow. Pan the light to the right. Observe how the light begins to creep across the front of the ball creating visual curvature. Turn off the backlight. Take an incident reading of the fill light. Move the light until an aperture one and a half stops less light than the back light is achieved. This will be a lighting ratio of 3:1.

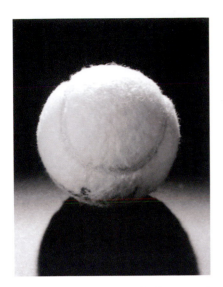

Michael Wennrich

Image 3

Turn on both lights. As viewed from the camera place a reflector (piece of white card) on the right-hand side of the ball approximately half the distance of the fill light from the subject. Whilst shielding the invercone with your hand take an incident reading from the subject of the light being reflected from the white card. Move the card closer to or further away from the subject until a reading one stop less than the floodlight is achieved. This will be a lighting ratio of 2:1 between the left and right sides of the ball. After checking the lighting ratios take an incident reading from the front of the ball directly back to the camera. This will be an average of all the readings and 'correct' exposure. Check focus and select an f-stop (using preview mechanism) giving sharp focus from the front to the back of the ball. Make a final check for lens flare before making an exposure.

Lighting diagram

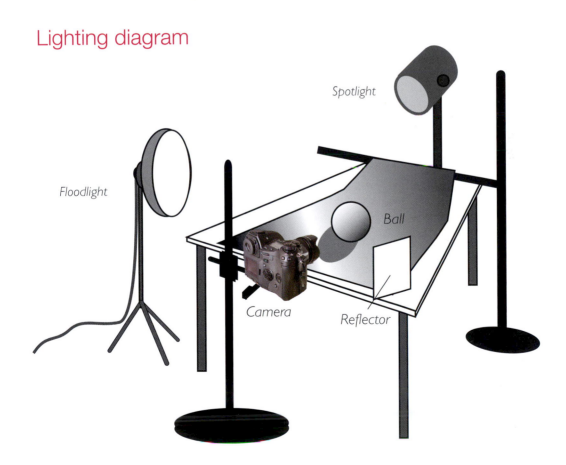

Spotlight

Floodlight

Ball

Camera

Reflector

Assignment 3 'Texture'

Criteria

Lighting	Direct spotlight at low angle to subject, plus fill. Diffused back light.
Props	Minimal.
Background	Predominantly the subject or an unobtrusive color or tone.
Exposure	Incident light meter reading. Subjective choice of lighting ratio.
Technique	Using lighting contrast to emphasise subject texture and to retain detail in the shadows.

Image 1

Support corrugated cardboard in front of a dark background to form multiple 'S' shapes. Place a spotlight above, behind and to the right side of the cardboard with the centre of the light at the centre of the 'S' shapes to create strong shadows falling forward from the top to the bottom of the image. Place an amber heat resistant gel in front of the light. Position suitable support material to form an acceptable composition. Take an incident light meter reading of the light falling on the corrugated cardboard. Note this exposure.

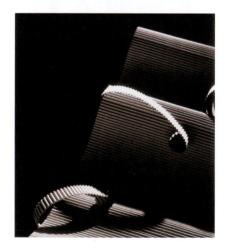

Image 2

From the camera position place a diffuse light above and to the left of the subject. Aim the light at the corrugated cardboard to fill the shadows created by the spotlight. Vary the amount of diffusion and distance of the light from the subject to achieve the desired effect. Turn off the backlight (spotlight) and take an incident reading of the diffuse light falling on the subject. Adjust the light to achieve a lighting intensity one stop less than the exposure calculated for the backlight. This will give a ratio of 2:1 between the back light and the front light.

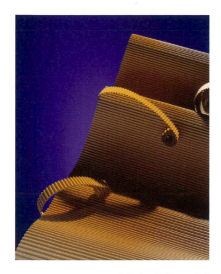

Michael Wennrich

Image 3

Turn off both front and back lights. Aim a second spotlight from left of frame at the background. Position the light to achieve a circle of light directly behind the cardboard. Place a blue heat resistant gel in front of the light. Alternate between full spot and full flood to achieve the desired degree of graduation. Take an incident light meter reading of the light falling on the background. Adjust light to match the calculated exposure for the front light. Turn on the front and back lights. Make final adjustments to composition, lighting and exposure. Reduce any extreme highlights. To maintain maximum density in the shadows this is best achieved by repositioning the subject and not by diffusing the light. Check for lens flare.

Lighting diagram

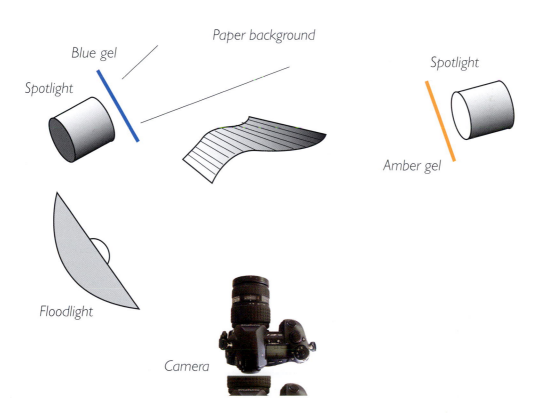

Paper background

Blue gel

Spotlight

Spotlight

Amber gel

Floodlight

Camera

Assignment 4 'Flowers'

Criteria

Lighting Diffuse key light plus back light to separate subject from background.

Props Minimal and complementary to subject matter.

Background Unobtrusive color or tone, lit separately to subject.

Exposure Incident light meter reading. Lighting ratio sympathetic to subject.

Technique Subject in focus. Background out of focus and back lit separately to foreground subject matter.

Image 1

Place one flower behind a sheet of white tracing paper. Place two flowers in front of the tracing paper (these remain unlit). Using a spotlight light the single flower from behind to cast a shadow onto the front surface of the tracing paper. Centre the light behind the head of the flower. Place overlapped green and yellow heat resistant gels in front of the light. Adjust the light until the desired spread of light around the flower is achieved. The background will appear white at the centre graduating to various shades of green and yellow towards the edges. Take a reflected reading of the centre of the light. Increase this exposure by two stops to give a tone that is almost white (e.g. f22 to f11).

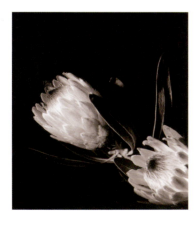

Image 2

Turn off the background light. As viewed from the camera place a spotlight slightly above and to the left of the two front flowers. Between the spotlight and the flower hang a large sheet of tracing paper. Move the tracing paper closer to or further away from the flower until the desired effect is achieved (the light on the subject will be more diffuse the further the tracing paper is from light source). Take an incident reading from the flower of the light falling on the subject. Move the spotlight until a reading the same as the calculated exposure for the background is achieved. This will render the flower as an average mid-tone and the centre of the background almost white.

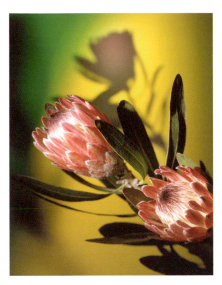

Michael Wennrich

Image 3

Turn on the background light. Check the lighting ratio between the background and subject has not changed. Take an incident reading from the flower, back to the camera, of the light falling on the subject. If the flower is of an average mid-tone this will be correct exposure. If the flower is lighter or darker adjust the exposure accordingly, but remember to retain the same lighting ratio between subject and background, two stops or 4:1. Choose an exposure aperture with sufficient depth of field to retain focus on the flower but not on the background.

Lighting diagram

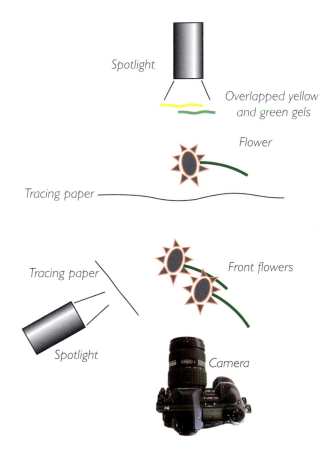

Spotlight

Overlapped yellow and green gels

Flower

Tracing paper

Tracing paper

Front flowers

Spotlight

Camera

Assignment 5 'Metal'

Criteria

Lighting	Diffuse/reflected lighting, plus selective fill.
Props	Subject related.
Background	Coarse and heavily textured.
Exposure	Adjusted incident or reflected meter reading of the highlights.
Technique	Using light and contrast to enforce the harshness of the subject, whilst retaining maximum detail in the highlights and some detail in the shadows.

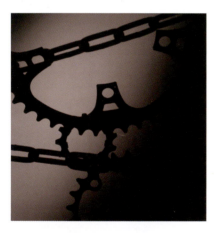

Image 1

Suspend various cogs and chains approximately two metres in front of a tracing paper background. From behind aim a spotlight on full spot into the tracing paper. Position the centre of the spot directly behind the cogs and chains to achieve the desired composition and effect. Turn the light to full flood. This will graduate the light over the background. Place a blue heat resistant gel in front of the light.

Image 2

Turn off the back light. As viewed from the camera position aim a second spotlight, on full spot, from the left side towards the metal cogs. Adjust the direction of the light until the maximum reflectance of the light appears as extreme highlights on the metal surfaces. Ensure no light falls on the background. Place a sheet of tracing paper between this light and the subject. Adjust the angle to and distance between the light and the trace to the subject until the desired reflectance level in the cogs and chains is achieved. Place an orange heat resistant gel in front of the light.

Michael Wennrich

Image 3

As viewed from the camera position aim a third spotlight from the right side at the teeth of the cogs. Place a sheet of tracing paper or other suitable diffusion material close to the light. Move the tracing paper closer to or further away from the subject to reduce the extreme highlights on the metal surfaces. Place a pink heat resistant gel in front of the light. Experiment until the desired effect is achieved. Turn on the back light. To check the subject brightness range take a reflected reading of the highlights and the shadows. If the ratio is less than 32:1 (five stops) some detail will be recorded in both. For exposure take either an incident reading of an area of average illumination or take a reflected reading of an area reflecting approximately 18% gray. Adjust this reading within the 32:1 ratio to achieve the desired result (expose for either the shadows or the highlights).

Lighting diagram

Reflector

Blue gel

Tracing paper

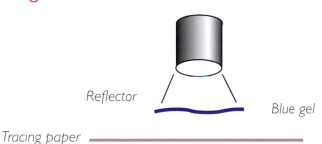

Tracing paper

Cogs

Tracing paper

Orange gel

Pink gel

Spotlight

Spotlight

Camera

Assignment 6 'Desk'

Criteria

Lighting — Interpretive use of light as observed in 'real life', e.g. late afternoon sunlight mixed with ambient room light.

Props — Self-explanatory.

Background — The subject matter itself.

Exposure — Incident light meter reading of keylight area.

Technique — Related to your vision of your desk 'correct' subjective exposure of the keylight and detail in the ambient areas. The selective use of aperture and focus together with filtration of the light source or camera to complement image composition and quality of light.

Image 1

Place subject on an appropriate surface. Position the camera to achieve an approximate composition. As viewed from the camera, position a spotlight in front, above and to the right of the subject. Turn on the light and centre the light on full spot on the focal point of the composition (e.g. bridge of the violin). Flood and move the light until the desired shadow effect and direction are obtained. Record an incident reading of the light from the subject.

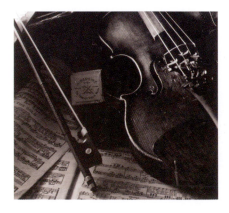

Image 2

Turn off spotlight. As viewed from the camera, position a floodlight to the left of the subject. Place a large sheet of tracing paper between the light source and the subject. Make vertical cuts in the tracing paper so small highlights of direct light appear across the surface of the subject. The intensity of the highlights can be controlled by moving the tracing paper closer to or further away from the light source or increasing the width of the cuts. Experiment until the desired effect is achieved.

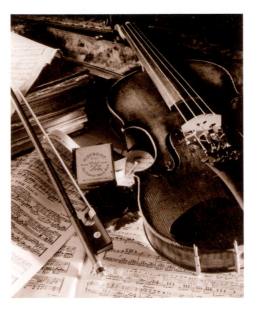

Felicity O'Mara

Image 3

Turn on the right-hand spotlight. Observe the difference in the intensity of the light falling on the subject between the diffuse (traced) and direct (non-traced) areas. Adjust camera and subject matter for final composition. Take an incident meter reading of the direct and diffuse areas. Adjust the exposure dependent upon how the highlights and shadows would best enhance the design and balance of the image. Exposure for the direct light will produce underexposed shadows. Exposure of the diffuse light will produce overexposed highlights. Start with an average of the two readings and bracket the exposure. Choose an exposure aperture that will concentrate the viewers' interest on the focal point of the image. Interpret results to gain a better understanding of exposure and latitude.

Lighting diagram

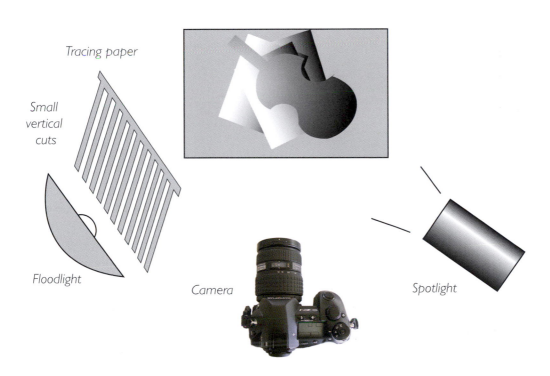

Tracing paper

Small vertical cuts

Floodlight

Camera

Spotlight

Assignment 7 'Rust'

Criteria

Lighting Direct spotlights, plus selective fill.

Props Weathered, well worn and textured.

Background Use of light to create interest and separation of the subject from the background.

Exposure Adjusted reflected light meter reading of key light area.

Technique To enhance the degradation and degeneration of the subject by the use of sharp focus and lighting/subject contrast to create texture and age.

Image 1

Place weathered and rusty textured items next to a sheet of old corrugated iron. From behind and to the right side aim a spotlight at low angle across the surface of the rusty items. Adjust the angle and intensity of the light to achieve maximum texture. Ensure light falls only on the back edges of the subject matter and not across the surface of the corrugated iron. Take a reflected light meter reading of the light falling on an area reflecting almost the same amount of light as an 18% gray card.

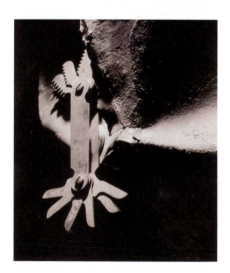

Image 2

Turn off the first spotlight. Using a second spotlight from the front left side, also at a low angle, light the surface of the corrugated iron and the rusty items in such a way as to create long shadows and detailed texture. Adjust the angle, direction and intensity to achieve the most effective design and composition. Take a reflected light meter reading from an area reflecting approximately the same amount of light as an 18% gray card. Compare this reading with Image 1.

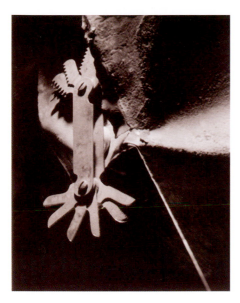

Image 3

Turn on the first spotlight. To increase the illusion of contrast and depth within the image adjust the amount of light from the back light to approximately half to one stop more light than the front light. Making 'correct' exposure for the front light will record the backlit areas as highlights with minimal detail in the shadows and a full range of tones in the areas lit by the front light.

Emily Abay

Lighting diagram

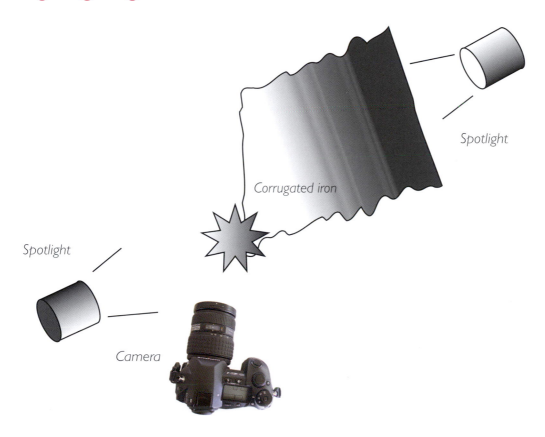

Spotlight

Corrugated iron

Spotlight

Camera

Assignment 8 'Black and white'

Criteria

Lighting Diffuse or reflected light with minimal shadows. Direct spotlight with some degree of diffusion for detail in black subject matter.

Props Black and white.

Background Black and/or white, possibly created by the use of light.

Exposure Interpretation of reflected meter reading from black and white subject.

Technique To render true black and white on color emulsion, with maximum detail in both.

Image 1

Place selected props on a flat table top surface. Position to form an acceptable composition. As viewed from the camera place a spotlight behind and to the right of the subject. Centre the light on full spot on the top surface of the iron. Adjust the direction and intensity (flood or spot) to achieve maximum texture across the surface of the shirt and shadows with almost no detail forward of the iron. This will give detail across the top surface of the iron but make the shirt look very coarse.

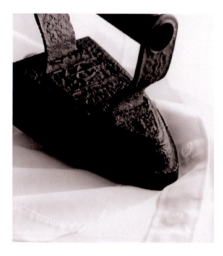

Image 2

Support a piece of tracing paper or other suitable diffusion material between the spotlight and the subject from just above the camera to the back edge of the framed area as seen in the viewfinder. This will reduce the intensity of the shadow forward of the iron and create a 'softer' look to the shirt material. Experiment with moving the tracing paper closer to or further away from the subject to achieve the desired degree of texture and shadow detail. This will have the effect of creating the quality of light suitable for the shirt but at the cost of losing some detail across the top of the iron. Turn off the first spotlight.

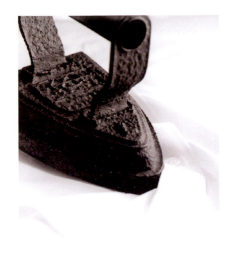

Sophie Takach

Image 3

Place a second spotlight slightly forward and directly above the iron. Position as close as possible to the tracing paper, switch on and turn to full spot. Reduce the amount of light spreading across the shirt by closing the barn doors until the concentration of light is falling on the top surface and leading side of the iron. This increases detail in the iron without greatly affecting the shirt. Take and note an incident reading, from the subject, of the second spotlight. Turn off the second light and turn on the first. Take an incident reading, from the subject, of the first light. Adjust so the first light is one stop less than the second. Turn on the second light and take a reflected reading of the shirt. Depending on the actual shade of white increase the exposure by two stops to render the shirt white.

Lighting diagram

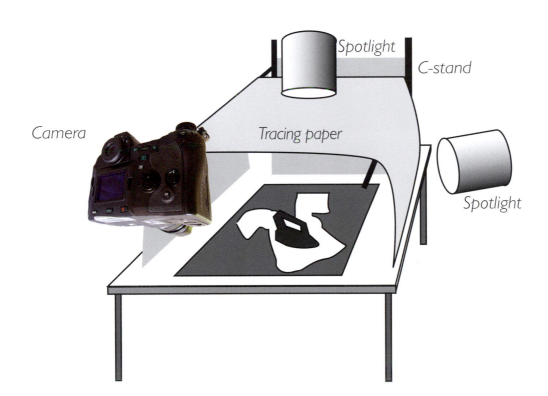

Spotlight

C-stand

Camera

Tracing paper

Spotlight

Assignment 9 'Cutlery'

Criteria

Lighting Graduated diffuse lighting.

Props Reflective and metallic.

Background Complementary tonal range.

Exposure Incident or reflected light meter reading of 18% gray card.

Technique To reflect graduated light into the subject to form shape, and to reduce imperfections in reflective metal surfaces.

Image 1

Place cutlery on a piece of translucent white Perspex. Position subject and camera to obtain a satisfactory composition. Attach a large piece of tracing paper to the back edge of the Perspex and to a C-stand above the front of the camera. This will create a 'tent' of tracing paper completely covering the subject. Place a spotlight from behind and above the tracing paper. Centre the light on full spot in the centre of the paper. Moving the centre of the spot towards the front of the trace will create a graduation of light reflecting in the subject from white in the foreground through gray to almost black in the background. Moving the centre of the spot towards the back of the trace will achieve the opposite effect. Experiment with position and intensity (full spot through to full flood) until the desired effect is achieved.

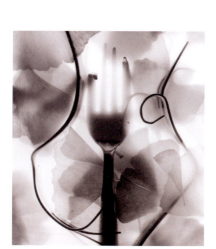

Image 2

Turn off the top light. Place a floodlight underneath the Perspex. Position the light so the Perspex is evenly lit. Take a reflected meter reading of the surface and increase the aperture by three stops (e.g. f22 to f8) to render the surface white. Record this calculated exposure.

Image 3

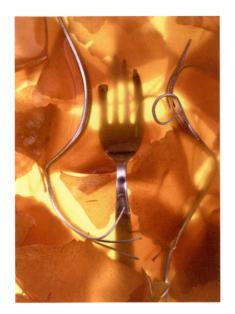

Turn on the top light. Place a strip of black paper approximately 3cm wide by the length of the tracing paper on top of the tracing paper from front to back. Position the black paper to create a reflective black edge along one side of the cutlery. Place an 18% gray card on top of the cutlery and take a reflected reading of its surface. Depending upon the reflective values of the subject adjust your exposure accordingly. Choose an aperture giving sharp focus over the cutlery and ensure the lighting ratio between the top light and the back light remains at 8:1. This can be achieved by increasing the lights in relation to each other or by the separate exposure of each light source at different exposure times.

Rachel Dere

Lighting diagram

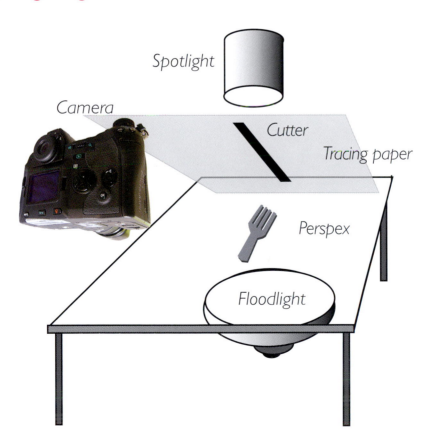

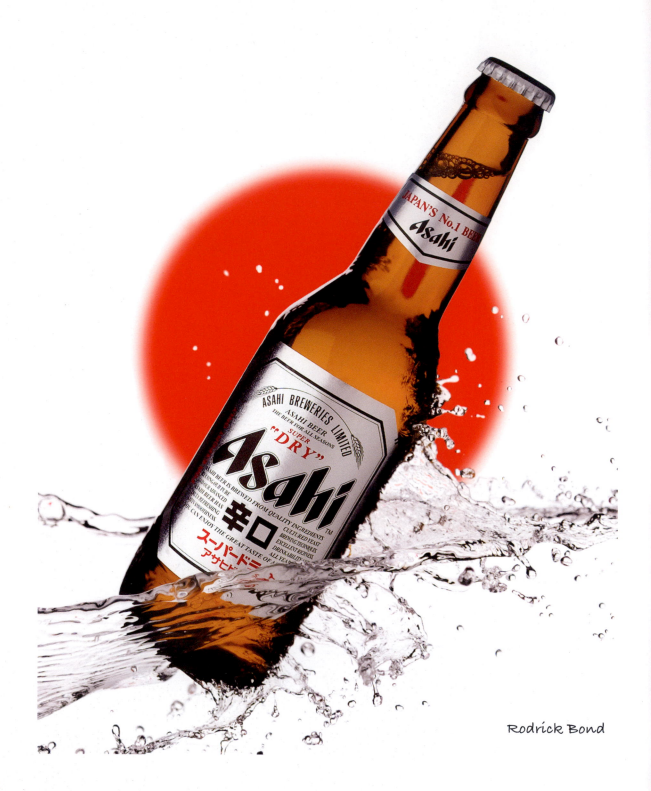

Rodrick Bond

studio
lighting people

Tracey Hayes

essential skills

- A knowledge and understanding of the application of studio lighting when photographing people.
- An understanding of the practical use of light to create tonality, dimension and mood.
- Through study, observation and pre-production an understanding of the resources and skills required to produce photographic images.
- To develop ideas and produce references containing visual information gathered in completing the assignments.
- To produce photographic images to the highest standard fulfilling the criteria in the assignment information.

Introduction

Many different styles of portraiture lighting have evolved since the invention of photography. The approach taken to portraiture, in fact to any genre of photography, is limited only by your imagination. The technical boundaries to photography are at the point of being almost nonexistent. When learning portraiture lighting it is important to understand people and how to light the human form, particularly the face. Portraiture relies heavily on the rapport built up, sometimes in a very short period of time, between the photographer and the subject. Whether the photograph is successful or not depends entirely on the photographer being able to capture the essence of the person in front of the camera. It is therefore essential that the photographer has a thorough understanding of technique and lighting to make it seem to the subject that the actual photographic process is a very minor part of the whole experience. Nothing will alienate the subject more than being confronted with equipment they are not used to and a photographer who appears not to have the situation under control. Confidence in your abilities and a thorough understanding of your technique are ways to inspire and relax the subject of your portrait.

High Key – Daniel Tückmantel

There are three 'classical' approaches to portraiture, high key, low key and mid key. Portraiture in these categories is recognised by the difference in the variation and extremes of the tonal range throughout the image. In its simplest form the difference between the three categories is best understood by comparing the style of portraiture to exposure. In a subject with average reflectance ratios, a mid key could be compared to correct exposure, low key to underexposure and high key to overexposure. It is important to remember this is not how the result is achieved. With this visual in mind it is easier to create the lighting required using lighting ratios and exposure interpretation.

High key

In high key images light tones dominate. Dark tones are eliminated or reduced by careful selection of the tonal and subject brightness range of the subject matter. Soft diffused lighting from broad light sources is used to reduce all shadows. Backgrounds should be flooded with light and overexposed to reduce detail. Increasing exposure beyond 'correct' by up to two stops will ensure all tones are predominantly light. Hard edges and fine detail can be reduced by the use of a soft focus filter. If using black and white film skin imperfections can be reduced by using an orange or red filter. A bright background placed close to the subject will also soften their outline. Even though the quantity of light used to create high key is large the actual lighting ratio is small (1:1).

Low key

In a low key image dark tones dominate. Bright highlights punctuate the shadow areas creating the characteristic mood of a low key image. The position of the key light source for a typical low key image is behind the subject (or behind and to one side). This creates deep shadows. The strong back light creates specular highlights around the rim of the subject. Selective fill light is then used to increase the subject brightness range to a level giving average exposure. The decision concerning appropriate exposure usually centres around how far the exposure can be reduced before the highlights appear dull (underexposed). The shadow areas are usually devoid of detail when this action is taken unless a certain amount of fill is provided. The lighting ratio is relatively high compared to high key (8:1).

Mid key

In a mid key image there is no dominant tone. They are all relatively equal. There are no deep shadows and no extreme highlights. The lighting used is a mixture of both high key and low key (direct and diffuse). Back lighting can be used to create rim light around the subject and fill light to reduce and control shadow areas. An increase in 'correct' exposure of one stop more light would usually be required to achieve a mid key result. The lighting ratio is less than low key (4:1).

Activity 1

Through research of personal, library and www. resources locate the following images.

'E. Gordon Craig'. 1913. Eduard J. Steichen.
'Portrait of Mother'. 1924. Alexander Rodchenko.
'Churchill'. 1941. Yousuf Karsh.
'Piet Mondrian'. 1942. Arnold Newman.
'Mother and Daughter, Cuzco, Peru'. 1948. Irving Penn.
Categorise these portraits into low and mid key.
Find an example from these sources of a high key portrait.
Study the images and draw a considered lighting diagram for each.
Photocopy these and other examples and compile in your Visual Diary.

Assignment 1 'High key'

Image with a predominance of light tones. The result is achieved using a combination of diffuse even lighting, overexposure, selective filtration and some diffusion. This technique is artificially created and is often used in glamour, fashion and child portraiture. The lighting technique creates a shadowless, soft rendering of the face. The final image will primarily consist of dominant whites, some defining grays and a few deep shadows. Make-up is used to retain detail in the lips and eyes and filtration to reduce skin imperfections.

Image 1

Place the subject approximately two metres from a white background. Soft diffuse light sources (reflective flash umbrellas) are placed on either side of the subject. Place large white reflectors next to each light at 90 degrees to the subject. This will reflect all light from the two front light sources back onto the subject. Take and record an incident meter reading from the subject of each light source ensuring there is a half stop difference between them. Viewed from camera the left light should read f11, the right f8.5 at 1/250 second.

Image 2

Place two soft diffuse light sources (reflective flash umbrellas) in front of the white background, behind and to the side of the subject. Angle the lights at 45 degrees to the background. Place black cutters between the lights and the subject to reduce lens flare and to eliminate any direct light falling on the subject. Take and record an incident light meter reading of each light source from the white background ensuring that they are equal. The reading should be f11 at 1/250 second. This gives a lighting ratio of 1:1 between the foreground and the background.

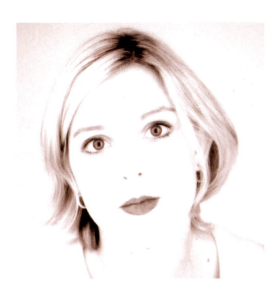

Image 3

Place a white reflector underneath the face of the subject. This will reduce any shadows under the chin, nose and eyebrows. Apply make-up to the eyes (eye liner), lips (dark red lipstick) and foundation to the face. Attach a diffusion filter to the lens. Take an incident meter reading from the subject to the camera and overexpose by two stops. This will give an exposure of f5.6 at 1/250 second. A red filter (plus appropriate exposure compensation) can be added at this stage if using black and white film.

Lighting diagram

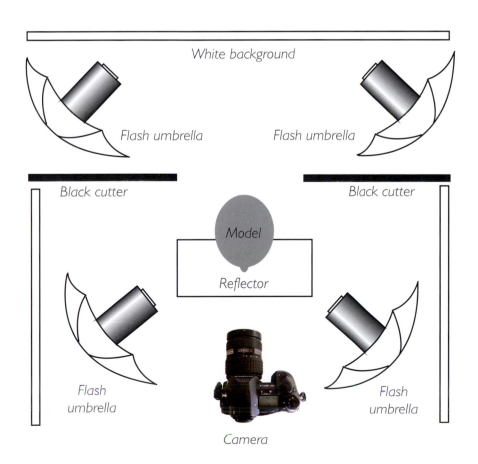

White background

Flash umbrella Flash umbrella

Black cutter Black cutter

Model

Reflector

Flash
umbrella Flash
 umbrella

Camera

Assignment 2 'Low key'

Image with a predominance of rich dark tones with selected specular highlight areas. The result is achieved by a progressive build-up of light across the face to maximise texture, tonality and drama. This requires predominantly direct specular light sources. The nature and quality of this light must be precisely set and varies for each subject, dependent on face shape and form. The spotlights must be placed in relation to camera and subject position so the angle of incidence equals the angle of reflection in order to achieve specular highlights across areas of the face.

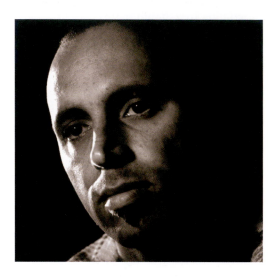

Image 1

Place the subject approximately two metres from a black background. As viewed from the camera, position a spotlight behind and to the left side of the subject. Adjust the spotlight to achieve an incident meter reading of the light from the subject of f8 at 1/30 second. Position a floodlight in front of and to the left side of the subject. Adjust the floodlight to achieve an incident meter reading of the light from the subject to equal that of the spotlight. Place a black cutter between the two lights to reduce lens flare. Record incident light meter readings.

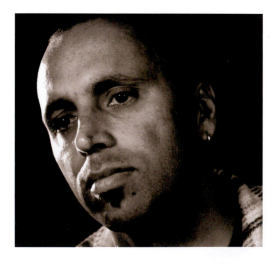

Image 2

Place a second floodlight in front of and to the right side of the subject. Adjust the floodlight until an incident light meter reading of the light from the subject of f5.6 at 1/30 second is obtained. This will provide fill light to the camera right side of the face and reduce nose and chin shadows. This will be a lighting ratio of 2:1 between the left and right sides of the face. Record incident light meter reading.

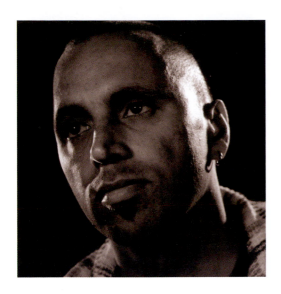

Image 3

Position a second spotlight behind and to the camera right side of the subject. Adjust the light to achieve maximum specular reflection to the camera right side of the face. Take an incident light meter reading of the spotlight from the subject to achieve a reading of f8 at 1/30 second. Place a black cutter between the lights on the right side of the subject to reduce lens flare. Take a reflected light meter reading of the camera left side of the face ensuring that no light from the rear spot lights affects the reading. This reading will be 'correct' for exposure.

Lighting diagram

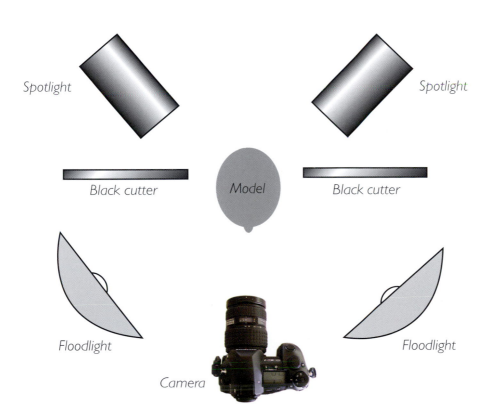

Spotlight

Spotlight

Black cutter

Model

Black cutter

Floodlight

Floodlight

Camera

Assignment 3 'Mid key'

Image with a predominance of average tones, with no extreme of highlights or shadows. The result is achieved using large, soft, very diffuse even lighting, selective fill and over exposure by one stop to obtain correct skin tones. This is by far the most commonly used form of portraiture lighting. It is relatively simple to set up compared to high and low key lighting and will produce good results with most subjects. It does, however, lack drama and mood and would not enhance subjects with great physical character or delicacy of form.

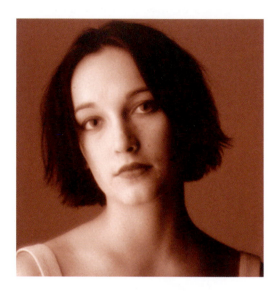

Image 1

Place the subject approximately two metres from a large diffusion screen (background). As viewed from the camera place a soft diffuse light source (flash soft box) in front of and to the left of the subject. Place a diffusion screen larger than the light source between the light source and the subject. The screen should be approximately one-third of the distance from the light to the subject. Take an incident light meter reading from the subject to the camera. A typical reading would be f11 at 1/250 second. The background remains unlit.

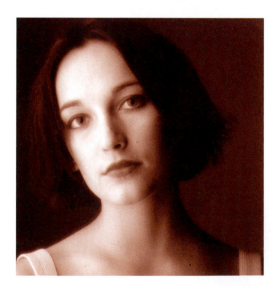

Image 2

Place a large (2m × 3m) white reflector in front of and to the camera right side of the subject. This will reflect light from the key light source back onto the right side of the subject. Adjust the distance of the reflector from the subject until an incident light meter reading from the subject to the reflector is one stop less than the key light. This should be f8 at 1/250 second. This is a lighting ratio of 2:1 between the left and right sides of the face and when used for exposure will overexpose the left side of the face to reduce any skin imperfections.

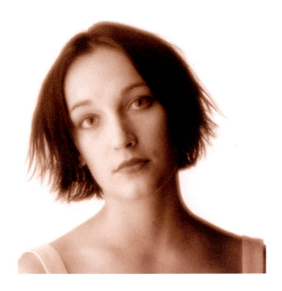

Image 3

Place behind the large diffusion screen in the background a large diffuse light source (flash soft box). Direct the light through the diffusion screen straight back at the camera. Adjust the light source so an incident light meter reading taken from the subject to the diffusion screen in the background is two stops more than the incident reading of the subject to camera (f8 at 1/250 second). This background reading should be f16 at 1/250 second. If the subject exposure is set to f8 at 1/250 second the background will appear white.

Lighting diagram

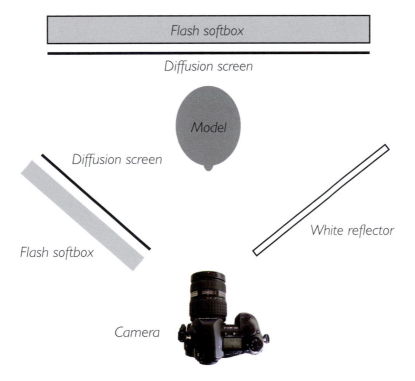

Flash softbox

Diffusion screen

Model

Diffusion screen

Flash softbox

White reflector

Camera

Pose

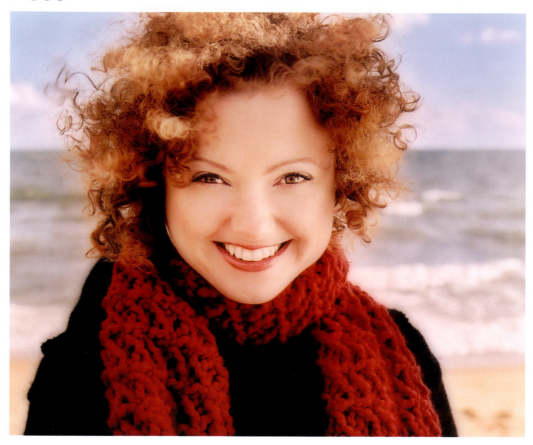

Jo Harkin

Making people look at ease in front of the camera is as much a skill to be learnt as the skill required to light and correctly expose. For some photographers the skill is acquired easily. For most it will take time and patience. It is important not only to make the subject feel at ease but also to be relaxed and confident. There are defined and classical approaches to 'compositional pose' that have evolved throughout the history of painting and photography. These are well documented and not difficult to reproduce. It is much harder to make people look 'real'. The best equipment and lighting will not make the subject come alive. Only the rapport between the photographer and their subject can make that happen. If the subject looks awkward or ill at ease, wait. Walk away from the camera but continue to talk to your subject. Attach a remote firing device to the camera. This will enable you to make exposures away from the camera and in mid conversation. The camera is often intimidating enough without the photographer standing behind it. Being relaxed can be infectious. Start with photographing people you know. As your confidence grows photograph people you don't know. Professional 'models' perform easily for the camera. Subjects with little or no experience will have greater difficulty.

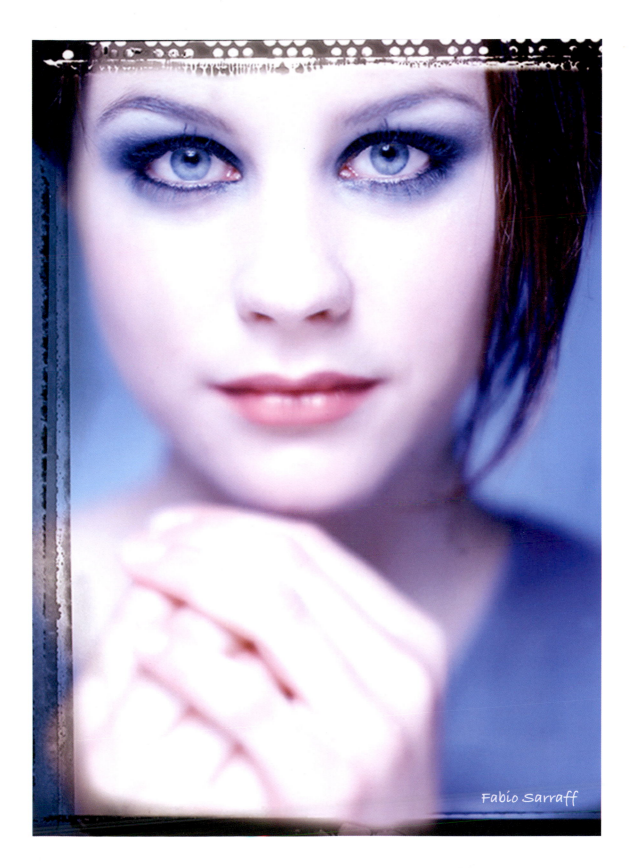

Fabio Sarraff

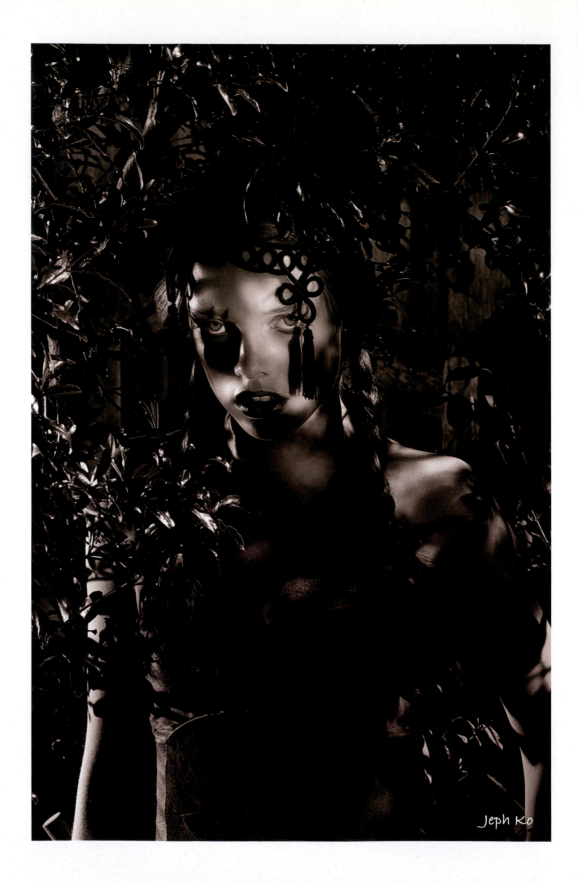

Jeph Ko

lighting on location

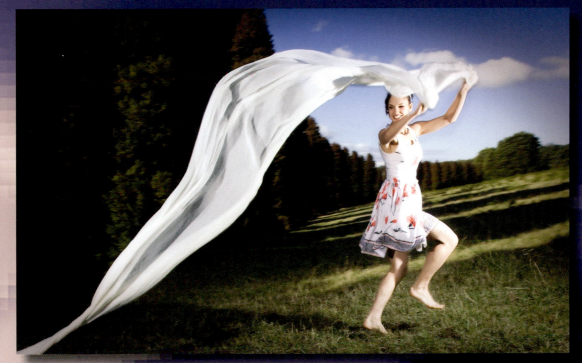

Daniel Tückmantel

essential skills

- Develop knowledge and understanding of the use of artificial light sources, camera and associated equipment on location.
- Develop an awareness of the effect of artificial light in the creation and control of lighting ratios, shade, contrast and exposure.
- Observe the importance of lighting in the production of photographic images.
- Produce photographs demonstrating a practical knowledge of the use of light.
- Compile information relevant to the technique and production of each image.

On location

Studio lights need not be limited to the studio. They can be used on location in conjunction with ambient and existing daylight. With color correction of the light source or camera most light sources can produce acceptable and interesting results. Raw file images can be color corrected in post production. See 'Light' and 'Image capture'.

Exterior location

Common examples of studio lighting used on location are the images seen in film and television. The same approach can be taken to still images. Artificial light, whether flash or tungsten, is normally used to supplement the existing light present, usually daylight. In this situation correct color is achieved by balancing to daylight (5500K) and filtering the tungsten light source/sources (3200K) with an 80A lighting gel. When using studio flash on location no filtration is required as the color temperature of the flash is equal to average daylight (5500K to 5800K).

Mixed light

Mixing the color temperature of the light sources can give a more 'natural' look. Although the human eye corrects all light sources to what appears to be white light, it is visually accepted, and in most cases to great effect; when we view images created using mixed light sources there should be a difference in the color temperature of the various sources of light within the frame.

Mixed light sources – Itti Karuson

Example 1

A photographer has been commissioned to photograph the exterior of a restaurant complex situated in a vineyard. The client has requested there be equal interior and exterior detail. As the building is in constant use the client does not want any introduced lighting placed in the restaurant that may cause health and safety issues for his customers. To achieve this result the photographer decides to create the image by making two exposures, one for the exterior another for the interior. The camera is balanced to daylight. This will record the practical interior lighting, predominantly commercial tungsten (orange/red) and fluorescent lighting (green), as a different color temperature to the exterior daylight.

Exterior ambient light – incident – exposure MIE less 1/2 stop

Total darkness – interior lights on – reflected – exposure average highlights and shadows

Combination exposure – John Hay

Interior location

There can be many different light sources with varying color temperatures confronting the photographer on location. This can range from industrial lighting to the glow from a TV. The possibilities and variations are many but the problems they pose can be either corrected with filtration or white balance adjustment to render 'correct' color, or ignored and the differences in color temperature exploited and used to effect.

Daylight balance

In an exterior location all light sources are balanced to the predominance of daylight (5500K). With an interior location (for example, a furnished room with large windows) there can be a mixture of various light sources. Balancing to daylight (5500K) without filtration of the tungsten light sources (3200K) would make the image appear quite different. Daylight in the image would appear 'correct' but any tungsten light source whether artificially introduced (studio) or practical (normal domestic lighting, desk lamps, candles, etc.) would create a warm glow at its source and on subject matter predominantly lit by it. The overall effect would be of white light through the windows, and depending upon the lighting ratio created between the tungsten light and the ambient daylight an overall warm cast to the image.

Tungsten balance

If the camera is balanced to tungsten (3200K) without filtration of either the daylight (5500K) or the tungsten light sources (3200K) the result would appear different again. Daylight in the image would appear to have a blue cast and any tungsten light source would appear 'correct'. The overall effect would be of blue light through the windows, and depending upon the lighting ratio created between the tungsten light and the ambient daylight, a balance of 'correct' color within the room. It should be remembered filtration of the camera to match the dominant light source would also produce similar results. However, filtration of the camera removes the possibility of selectively filtering the various light sources and color temperatures available to the photographer to create an interesting mix of colors within the frame.

Commercial tungsten light and daylight – Daniel Tückmantel

Example 2

A designer commissions a photograph of a kitchen. As it is in a residential building the owner has requested the minimum amount of disturbance. The client has requested the lighting enhances the space and balances ambient interior and exterior daylight. The photographer decides upon one exposure, balancing the exterior, interior and introduced lighting. The camera is balanced to daylight. Exterior daylight will be overexposed to reduce the orange/red color cast of domestic tungsten lighting.

Ambient light – daylight and tungsten – incident – one second at f8.5

Umbrella flash in hallway balanced to f8.5

Fill flash off ceiling balanced to f8 – John Hay

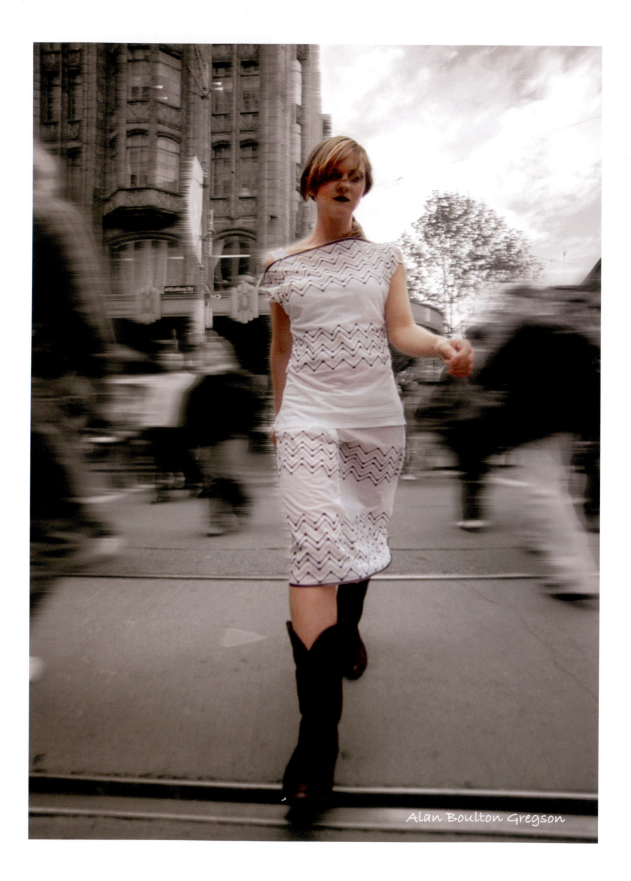

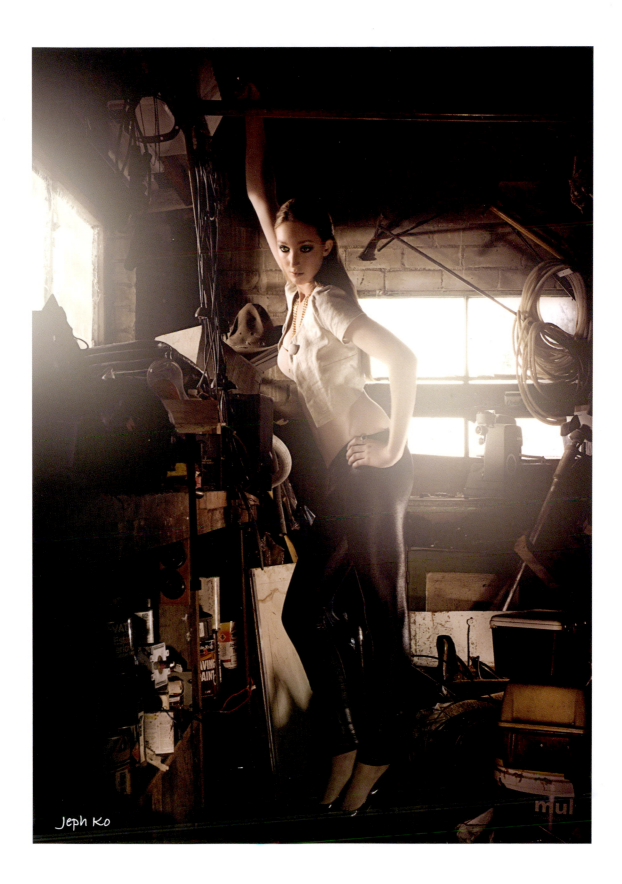

Jeph Ko

mul

Stuart Wilson

composites

Jeph Ko

essential skills

- Develop a knowledge and understanding of the methods and techniques used to create composite images.
- Develop skills in controlling lighting to achieve the requirements of composite images.
- Observe the use of post-production techniques in the production of composite images.
- Produce composite images demonstrating a practical understanding of creative lighting techniques.

Composite images

Since the early days of photography photographers have been producing composite images. The work of Henry Peach Robinson (1830-1901) is one of the first competent, and by the acceptance standards of the day almost convincing, attempts at combining various photographic elements to create a single narrative image. Today digital capture combined with digital post production can achieve the seemingly impossible, from the complex effects contained in most movies to the simplicity of a studio product shot. A situation or subject that a few years ago may have required many hours of intricate lighting can now be achieved with far greater economy of effort and cost by lighting the different elements to their best effect and combining in post production to achieve the desired result.

Jeph Ko

Composite lighting

Combing all the components to create the final montage can be achieved more efficiently if the photographer captures the individual subject matter in such a way as to ensure it has sharp edges that contrast with the background tone or color. White backgrounds lit to level 255 and black backgrounds maintained at level 0 make using the Photoshop 'Screen' and 'Multiply' blend modes easier for montage. Backlit subjects against white will create a silhouette effect and capture detail in translucent artwork. Side lighting subjects against a black background will result in sharp edge detail and create highlights if required. If shadows are a component they must be captured falling on a smooth surface or one with a similar texture to that previsualised in the completed montage. If using Adobe After Effects blue or green screens backgrounds can be used to create an ideal matte (most movie effects are created using this process). A simple rule to remember when creating a blue/green screen image is the blue/green screen should be two stops under the exposure of the subject key light. Also a back light aimed at the back of the subject (creating a rim light) and filtered to the complementary color of the blue/green screen should be one stop under the subject key light. This will reduce fringing around the subject from background light spill.

Back light

Back/Front light

Side light

Magdalene Bors

Paulina Hyrniewiecka

Composite techniques

In the world of commercial reality photographers are often asked to produce the ultimate image in the shortest time for the least cost. Prior to the wonders of digital capture and post-production software this would have meant a certain degree of compromise. In the example below the lighting to create a shadow is a point light source, the lighting to create curvature and minimal reflections on the bottle is a broad diffuse light source. A difficult result to achieve on film which would have required two images, one for the shadow, one for the bottle and precise pin registration of the two images. Now the solution is remarkably simple and very cost effective. By lighting, exposing, digitally capturing each element separately, maintaining lighting direction (even though the shadow is created by a point light source it must look as though it has originated from the same direction as the diffuse light source lighting the bottle) and combining in post production the impossible can seem to be achieved.

1. Images 1 and 2 are placed in the same Photoshop document image by dragging the background thumbnail (in the Layers palette) from the wine image into the shadow image. Shift-click both layers to select them. Select Auto-Align Layers from the Edit menu and select the Reposition Only option before selecting OK.

2. Check the alignment by temporarily setting the blend mode of the wine layer to Difference. If the layers have not been aligned using the Auto-Align Layers command (thin white lines along edges may be apparent, indicating misalignment), select the Move Tool and nudge them into position using the arrows on the keyboard. Return the blend mode to 'Normal' when alignment has been achieved. Make a path around the bottle using the Path Tool. Save the Work Path and then hold down the Command key (Mac) or Ctrl key (PC) and click on the Path thumbnail to load it as a selection.

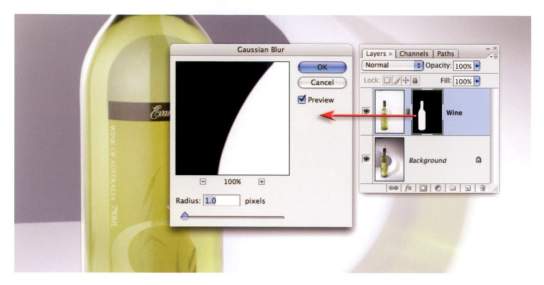

3. In the Layers palette select the Wine layer and click on the 'Add layer mask' icon. Soften the edge of this layer mask by going to Filter > Blur > Gaussian Blur. A one-pixel radius should be chosen to give this bottle a smooth edge.

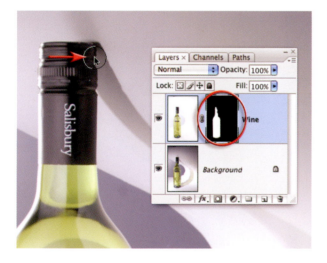

4. The lighting on the bottle has been refined by masking some of the top layer. This has been achieved by selecting the Brush Tool from the Tools palette and choosing black as the foreground color. A soft-edged brush set to 30% Opacity has been used to darken the right side of the bottle cap by painting in the layer mask to reveal the underlying layer. A second path around the label of the bottle has been created and saved as a 'Work Path'. The path has been loaded as a selection by holding down the Command key (Mac) or Ctrl key (PC) and clicking on the Path thumbnail.

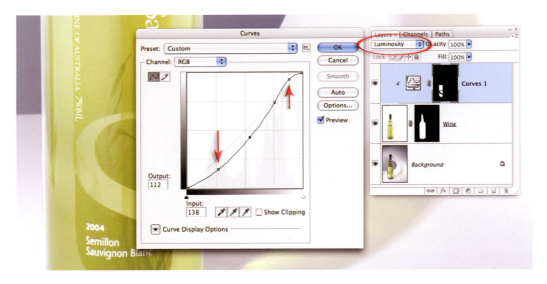

5. The wine and the label can now be modified independently using an adjustment layer. Hold down the Alt/Option key and select a Curves adjustment layer from the 'Create new fill or adjustment layer' icon in the Layers palette. In the New Layer dialog box select the Use Previous Layer to Create Clipping Mask checkbox and set the mode to Luminosity. Select OK to open the Curves dialog box. Adjust the brightness and shadows to optimise the tonality for the label and select OK. Apply a 0.5-pixel Gaussian Blur filter to the mask (Filter > Blur > Gaussian Blur).

6. It is possible to straighten the converging verticals of the bottle caused by non-matching camera angles. To perform this task you will need to stamp the visible elements of the layers into a new layer. The keyboard shortcut for this is to hold down the Ctrl + Alt + Shift keys and type E (for PC) or to hold down the Command + Option + Shift keys and type E (for Mac). With this composite layer on top of the layers stack use the Free Transform command (Command + T or Ctrl + T) and click on the Warp icon in the Options bar. Access the rulers (Ctrl + R or Command + R) and drag some guides into the edges of the bottle and label. The guides will provide feedback to achieve correct alignment. Push gently at the sides of the bottle to make the bottle fit within the guides you have created.

Composite solutions

Photoshop is mostly used by photographers to adjust and enhance an image after the instant of exposure. However, in the hands of a skilled operator images can be created that cannot be captured in a single exposure. The component images of the montage below illustrate that the photographer has spent a great deal of time in pre-production previsualising and assessing the most expedient and effective way to assemble the final image in post production. Part of this process is to fully understand that continuity of lighting direction and lighting quality is the most important key to successful combination of all the components. To create this 'illusion of reality' the photographer has not only lit all the components from a common direction but introduced the light emitted by the fairy by placing a practical light globe in the glass jar. The model and the jar have also been photographed against a black background to enable a higher quality extraction. These components can then be seamlessly placed in the composite image (black, when placed in the 'Screen' blend mode in Photoshop, is neutral or 'invisible'). Other factors to be taken into consideration are continuity of perspective, depth of field (each component image may require a different aperture to maintain the illusion) and a precise approach to all aspects of the process.

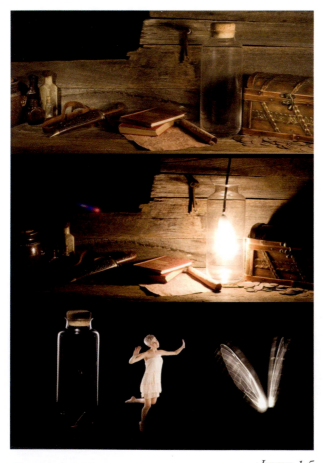

Images 1-5

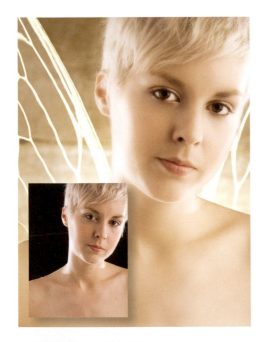

The professional montage and retouching techniques, outlined in these activities, are explained in greater detail in Photoshop CS3: Essential Skills *and* Adobe Photoshop Elements Maximum Performance. *These books come with all of the images used in the projects together with supporting movie tutorials.*

Daniel Tückmantel

Rodrick Bond

assignments

Amber Gooding

essential skills

- To develop and extend your knowledge and understanding of the application of studio lighting and camera technique.
- To develop and extend your understanding of the practical use of light to create contrast, dimension, mood and to increase your creative ability to interpret a written brief with specific guidelines.
- Through further study, observation and pre-production understand the resources and skills required to produce photographic images.
- To develop ideas and produce references containing visual information gathered in completing the assignments.
- Produce color images to the highest standard fulfilling the assignment criteria plus personal creative interpretation.

Introduction

The assignments should only be attempted after successful completion of all the assignments in 'Lighting still life', 'Lighting people' and 'Lighting on location'. They are intended to test and understand the application of the lighting and camera techniques learned. Creative interpretation of the written brief is strongly encouraged. Assignments should be completed at an individual level in any order. Allowance should be made for the fact that each assignment may need photographing more than once before a satisfactory result is achieved. Where possible group tutorials should be the forum where technique and creative interpretation are discussed. Special attention should be taken of the medium in which the photograph is to be used. This will determine image format and in some cases composition. See 'Art direction'.

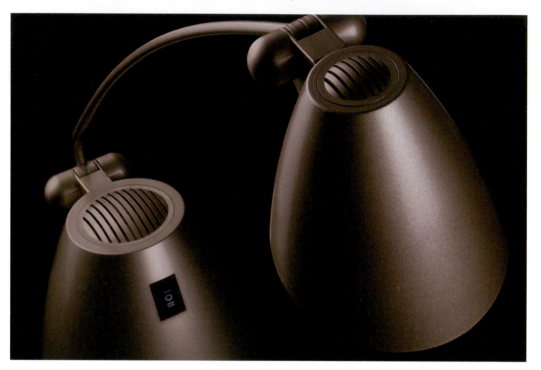

Michael Downes

It is important that the images portray an understanding of what lighting and camera technique can achieve in changing the photographer's perception of the subject and previsualisation of the image. At this stage it is no longer acceptable to place a subject on a background, take a normal viewpoint and perspective and light for correct exposure. This is no different to documentation of the subject. As creative photographic illustrators much more is required. Experiment with viewpoint and lighting. Do not let reality get in the way of creative composition. Perspective, depth, dimension can all be altered to suit the design of the image. The camera will 'see' and record anything you want it to. This does not have to relate to normal human perception. Separate subjects from the background. Dispense with the concept of backgrounds altogether. The area behind and around the subject is only limited by your imagination. Previsualise, experiment and create.

1. Breakfast cereal

To illustrate the health giving and nutritional value of a cereal product, an advertising agency requires a photographic image for a full page magazine ad. The approach should be in a contemporary style, with emphasis given to the premise there is a healthy 'reward' for eating their cereal product. The packaging must be strongly featured, showing three sides and product name and logo clearly visible.

2. Clothing

A large clothing retailer requires a photograph for an in-store 'point of sale' poster. The photograph should be aimed at the youth market with the emphasis on 'lifestyle'. The image must have a point of view of 45 degrees to the subject. Use should be made of selective focus to highlight detail and production identification.

3. Quality control

For the purpose of quality control, a large manufacturer requires a photograph depicting a close-up detail from their product range. The photograph should specifically show detail of manufacturing quality and/or design detail. The image must have sharp focus throughout.

4. Paint

A quality paint manufacturer requires a photograph to launch a 'new' brand of paint. The brief is to show all or part of the packaging, with brand name and type of paint clearly visible. The manufacturer wants to show, however, some of the various colors available. The art director suggests this could best be illustrated by using various colored paint swatches within the composition. The choice of colors to be used is to be determined by the photographer, taking into account the inability of the photographic process to sometimes faithfully record true color. This is a critical element of the image.

5. Childhood memories

A weekend color supplement requires an editorial photograph for a double page spread to complement an article on 'Childhood Memories'. The image has to evoke nostalgia, warmth, security, tenderness and the fun of childhood days spent playing and enjoying treasured possessions. The result depends greatly on the interpretive use of light.

6. Strong flat white

A city coffee shop requires a series of images for their web page. The client wants to reflect their position within the CBD and the inviting and exciting environment they have created. The coffee shop is only available during normal working hours so the use of supplementary lighting is limited due to health and safety concerns.

7. Glass

An international glass manufacturer requires a photographic image for the cover of its annual report. It has been suggested a limited product range (various colors and sizes) be shown on a white background. As they have had a successful year one of their clear glass products, filled with paper money, should be featured in the foreground. The manufacturer (who has limited understanding of the photographic process) is emphatic there are no specular highlights on the glass, the background be pure white, and the money is clearly visible through the foreground product.

8. Industrial plastic

An industrial plastic manufacturer requires a photographic image to be reproduced as a large mural for its head office reception area. Its main area of output is for the telecommunications industry. The client has requested an abstract approach be taken to this large-scale visual. However, emphasis should be placed on telephones and/or their related ancillary equipment.

9. Music

A record manufacturer has requested submissions to produce a photographic image for a CD cover. The photographer has been supplied with a demo CD so they may have a full understanding of the type of music involved (i.e. your choice). Props to be used at the photographer's discretion. As music is an emotional medium, the manufacturer has decided that any submission must attempt to portray the emotions felt by the photographer whilst listening to the music. At the same time it should be obvious the type of music it is (i.e. not a totally obscure image). This is an open brief, the only limitation being that there is movement during exposure of either objects and/or light and/or camera.

10. Food

A publisher requires a double page photographic image for an editorial article on a major processed food corporation. The product to be featured is from its line of packaged cheese. The concept is that cheese has been a basic food source throughout history and will remain so into the future. The photographic approach should have strong appetite appeal and through the use of light and props convey a visual sense of the past or the future.

11. Animal house

A local veterinary practice has requested a series of images to advertise their boarding kennels. The emphasis is on the luxurious conditions under which the boarded animals are kept. The client has suggested a collection of 'happy' animal portraits.

12. www.dot.com

A national internet service provider requires a collection of images to supplement their online promotion of a new satellite voice facility. The target market is rural and remote broadband users who may wish to replace their existing landline system with a more efficient satellite connection.

Daniel Willmott

Daniel Tückmantel

revision exercises

Stuart Wilson

essential skills

- Understand various methods and techniques used to create studio images.
- Be aware of how photography can change our perception of the world.
- Understand the history and development of the various genres of photography.
- Understand how a photograph is a two-dimensional composition of lines, patterns and shapes.
- Understand the process of working with an art director, art direction terminology and outcomes.
- Gain knowledge and understanding of the use of artificial light sources, camera and associated equipment used in the studio and on location.
- Gain knowledge and awareness of the effect of artificial light in the creation and control of lighting ratios, shade, contrast and exposure.

Genres

Q1. The first photograph falls into which genre?

(a) Fashion
(b) Portraiture
(c) Still life

Q2. What invention enabled photographers to reproduce copies from an original photograph?

(a) Polaroid
(b) Calotype
(c) Ambrotype

Q3. Which photographer is recognised as inventing the celebrity pin-up?

(a) Ansel Adams
(b) André Disdéri
(c) Richard Avedon

Q4. One product above all others has changed the public's approach to photography. When was it first put on the market?

(a) 1888
(b) 1826
(c) 1854

Q5. During the 1960s which photographer is recognised as challenging the traditional perception of portraiture?

(a) Julia Margaret Cameron
(b) Sarah Moon
(c) Diane Arbus

Q6. Two magazines were instrumental in the reproduction of fashion photographs. In which period did this start?

(a) 1870s
(b) 1880s
(c) 1890s

Communication and design

Q1. How can a viewer be encouraged to make an objective opinion of an image?

(a) Using simple content
(b) Using complex content
(c) Using neither

Q2. We instinctively follow a pattern of visual perception when looking at an image. What is that pattern?

(a) Bottom left to top right
(b) Top right to bottom left
(c) Top left to bottom right

Q3. Where can a curved line be placed within a composition to greatly increase its effect?

(a) Edge of frame
(b) Centre of frame
(c) Top of frame

Q4. A horizontal image would best be suited to which image format?

(a) Portrait
(b) Landscape
(c) 35mm

Q5. Which camera format would best be suited to an A4 layout?

(a) 6 x 6cm
(b) 35mm
(c) 6 x 9cm

Q6. Horizontal lines create a sense of stability. What type of line creates tension?

(a) Vertical
(b) Diagonal
(c) Curved

Art direction

Q1. When referring to typography an art director is talking about which element of the art work?

(a) Image
(b) Logo
(c) Copy

Q2. What is the name given to the guideline to which the photographer has to work?

(a) Layout
(b) Script
(c) Estimate

Q3. In a double page spread allowance should be made for what part of the printing process?

(a) Bleed
(b) Color
(c) Gutter

Q4. The camera should be orientated to which format when taking a photograph for a single full page advertisement?

(a) Landscape
(b) Portrait
(c) Horizontal

Q5. The art director is responsible for the overall look of the advertisement. Who writes the text?

(a) Account director
(b) Client
(c) Copywriter

Q6. As a photographer commissioned to take a photograph your responsibility is to whom?

(a) Bank manager
(b) Client
(c) Subject

The studio

Q1. What is the most important thing to exclude from a studio?

(a) Heat
(b) External light
(c) People

Q2. What is meant by a compound lens?

(a) Lens with a single element
(b) Lens with more than one focal length
(c) Lens with more than one element

Q3. How do you estimate what is a normal focal length lens when working with different format cameras?

(a) Measure the diagonal of the image format
(b) Call the manufacturer
(c) Guess

Q4. Compared to a normal lens a long lens will give what field of view?

(a) Wider
(b) The same
(c) Narrower

Q5. What device can be used to control the spread of light from a tungsten light source?

(a) Diffusion screen
(b) Barn door
(c) Filter

Q6. What piece of equipment can be used to reduce lens flare?

(a) Filter
(b) C-stand
(c) Lens hood

Light

Q1. A subject two metres from a light source is correctly exposed at 1/60 second at f5.6. The light is moved a further two metres away. If the output of the light is constant, what would the new exposure time be if the aperture remains at f5.6?

(a) 1/30 second
(b) 1/15 second
(c) 1/4 second

Q2. A subject two metres from a light source and camera is correctly exposed at 1/30 second at f8. If the subject to light distance remains constant but the subject to camera distance is doubled, what will the exposure aperture be at 1/30 second?

(a) f8
(b) f5.6
(c) f11

Q3. What filter is required when using daylight film with a tungsten-halogen light source?

(a) 85B
(b) None
(c) 80A

Q4. If the reflectance range of a subject is four stops or 16:1 and the lighting ratio is two stops or 4:1 what will be the subject brightness range (SBR)?

(a) 64:1
(b) 20:1
(c) 12:1

Q5. Two lights are used to light a subject. The first light (spotlight) is three metres from the subject and measures f16. The second light (floodlight) is two metres from the subject and measures f8. What is the lighting ratio between the lights?

(a) 2:1
(b) 8:1
(c) 4:1

Q6. Of the four main types of artificial light used in a studio, which has a color temperature closest to noon on a clear day?

(a) Photoflood
(b) Flash
(c) Tungsten-halogen

Exposure

Q1. A subject two metres from a single light source is correctly exposed at 1/60 second at f5.6. The light is moved to a new position four metres from the subject. What is the new exposure if time remains constant?

(a) f8
(b) f4
(c) f2.8

Q2. Changing exposure from f4 at 1/60 second to f11 at 1/60 second has increased or decreased the amount of light entering the camera by how many times?

(a) Plus 3x
(b) Minus 8x
(c) Minus 6x

Q3. What does an incident reading measure?

(a) Light falling on a subject
(b) Light reflected from a subject
(c) Both

Q4. When using Caucasian skin to establish an exposure reading, what adjustment should be made to the MIE to correctly expose for a mid-tone?

(a) Plus one stop
(b) None
(c) Minus one stop

Q5. What is the lighting ratio of a subject measuring f16 in the highlights and f5.6 in the shadows?

(a) 6:1
(b) 3:1
(c) 8:1

Q6. Correct exposure is f8 at 1/30 second. What would be the aperture at 1/4 second?

(a) f22
(b) f4
(c) f32

Image capture

Q1. A camera balanced to tungsten will give correct color when used with which light
 source?

 (a) Flash
 (b) Photoflood
 (c) Daylight

Q2. What is the color temperature of that light source?

 (a) 5800K
 (b) 8000K
 (c) 3200K

Q3. The exposure at ISO 100 is 1/15 second at f8. What will the exposure be at ISO 400 if
 aperture remains constant?

 (a) 1/60 second
 (b) 1/30 second
 (c) 1/8 second

Q4. Processing reversal film in a negative process will give what result?

 (a) No color
 (b) Positive image
 (c) Negative color

Q5. Which image file format uses the least amount of memory per image?

 (a) TIFF
 (b) Raw
 (c) JPEG

Q6. Which has the greater latitude?

 (a) JPEG
 (b) Color reversal film
 (c) Raw

Creative controls

Q1. How far into a subject would a photographer focus to maximise depth of field?

(a) 1/2
(b) 1/3
(c) 2/3

Q2. What camera mechanism allows a photographer to judge depth of field at exposure aperture?

(a) Cable release
(b) Shutter
(c) Preview button

Q3. What would be the slowest shutter speed recommended to stop image blur when using a tungsten light source?

(a) 1/30 second
(b) 1/60 second
(c) 1/125 second

Q4. When using a slow shutter speed how can a photographer eliminate camera shake?

(a) Use a small format camera
(b) Use a cable release
(c) Use a tripod

Q5. The closest point of focus is achieved when the lens is at its:

(a) longest physical length?
(b) shortest physical length?
(c) any physical length?

Q6. Selective focus is best achieved at:

(a) maximum aperture?
(b) fastest shutter speed?
(c) minimum aperture?

Using light

Q1. An incident meter reading of a subject with average SBR two metres from a light source is f11 at 1/60 second. What will the aperture be at 1/30 second if the light is moved another two metres further away from the subject?

(a) f5.6
(b) f8
(c) f4

Q2. What affect does the color temperature of tungsten light have upon black and white film?

(a) Increases exposure
(b) Increases contrast
(c) Decreases exposure

Q3. What is the name given to the shaped piece of optical glass used to bring a spotlight to focus?

(a) Focusing lens
(b) Panchromatic lens
(c) Fresnel lens

Q4. Barn doors can control the shape of a light source. What attachment can control the intensity of the light?

(a) Color correction filter
(b) Net
(c) Power pack

Q5. Diffusion of the light source will have what effect upon exposure?

(a) None
(b) Increase exposure time
(c) Decrease exposure time

Q6. A polarising filter will have what affect?

(a) Alter color temperature
(b) Alter color saturation
(c) None

Museum Entry

AIATSIS

Michael Downes

Jo Harkin

Glossary

1K	1000 watts, measure of light output.
2K	2000 watts, measure of light output.
5K	5000 watts, measure of light output.
10K	10,000 watts, measure of light output.
12K	12,000 watts, measure of light output.
120	Film format.
2¼	2¼ x 2¼″. Camera format.
35mm	Camera and film format (24 x 36mm).
500W	500 watts, measure of light output.
5 x 4	5 x 4″, camera and film format.
6 x 4.5	6 x 4.5cm camera format.
6 x 6	6 x 6cm camera format.
6 x 7	6 x 7cm camera format.
6 x 8	6 x 8cm camera format.
6 x 9	6 x 9cm camera format.
10 x 8	10 x 8 inches camera and film format.
80A	Conversion filter, daylight film to 3200K light source.
80B	Conversion filter, daylight film to 3400K light source.
85B	Conversion filter, tungsten film to daylight.
ACR	Adobe Camera Raw.
AC discharge	5600K continuous light source.
Adobe RGB	A color space that is appropriate for images destined for print output devices that have a larger gamut than sRGB.
Ambient	Available or existing light.
Analyse	To examine in detail.
Aperture	Lens opening controlling intensity of light entering camera.
Arri 650W	Arriflex 650 watt light source (3200K).
ASA	Film speed rating – American Standards Association.
Aspect ratio	The ratio of height to width.
Auto focus	Automatic focusing system, mainly small-format cameras.
Available	Ambient or existing light.
B	Shutter speed setting for exposures in excess of one second.
B/g	Background.
Background	Area behind main subject matter.
Backlight	Light source directed at the subject from behind.
Backlit	A subject illuminated from behind.
Balance	A harmonious relationship between elements within the frame.
Banding	Visible steps of tone or color in the final image due to a lack of tonal information in a digital image file.
Barn doors	Metal shutters attached to light source.

Bellows	Lightproof material between front and rear standards.
Bellows extension	When length of bellows exceeds focal length of lens.
Bellows formula	Mathematical process to allow for loss of light.
Bit depth	Number of bits (memory) assigned to recording color or tonal information.
Blurred	Unsharp image, caused by inaccurate focus, shallow depth of field, slow shutter speed, camera vibration or subject movement.
Bounce	Reflected light.
Bracketing	Overexposure and underexposure either side of MIE.
C-stands	Vertical stand with adjustable arm.
C-41	Negative film process.
Cable release	Device to release shutter, reduces camera vibration.
Calibration	Adjusting a device such as a computer monitor to a known and repeatable state that is considered standard within the industry.
Camera	Image capturing device.
Camera Raw	Unprocessed image data from a camera's image sensor.
Camera shake	Blurred image caused by camera vibration during exposure.
CCD	Charged Coupled Device. A solid state image pick-up device (sensor or chip) used in digital capture.
Clipping	Loss of detail due to overexposure, underexposure or excessive saturation.
Close down	Decrease in aperture size.
Closest point of focus	Minimum distance at which sharp focus is obtained.
CMOS	Complementary Metal Oxide Semiconductor. A type of image sensor.
Color balance	Photoshop adjustment feature for correcting a color cast in a digital image file.
ColorChecker	A reference card of colors and tones manufactured by Gretag Macbeth.
Color conversion	Use of filtration to balance film to light source.
Color correction	Use of filtration to balance film to light source.
Color management	The process of maintaining the accuracy of colors from the capture device to the output device.
Color profile	Information that describes the unique color characteristics of a device such as a scanner, camera, monitor or printer.
Color space	An accurately defined range of colors which may be a smaller portion of the human vision.
Color temperature	Measure of the relationship between light source and film.
Compensation	Variation in exposure from MIE to obtain appropriate exposure.
Complementary	Color – *see* 'Primary' and 'Secondary'.
Compound	In lens design, indicating use of multiple optical elements.
Compression	Underdevelopment allowing a high-contrast subject brightness range to be recorded on film.
Concept	Idea or meaning.
Context	Circumstances relevant to subject under consideration.
Continuous tone	A smooth transition of color or tone without visible dots or bands.

Contrast	The difference in brightness between the darkest and lightest areas of the image or subject.
Cord	Electrical lead.
Covering power	Ability of a lens to cover film format with an image.
CPU	Central processing unit of a camera used to compute exposure.
Cropping	Alter image format to enhance composition.
Cut-off	Loss of image due to camera aberrations.
Cutter	Device used to control spread and direction of light.
Cyclorama	Visually seamless studio.
Darkcloth	Material used to give a clearer image on ground glass.
Dark slide	Cut film holder.
Daylight	5500K.
Dedicated flash	Flash regulated by camera's exposure meter.
Dense	Overexposed negative, underexposed positive.
Density	Measure of the opacity of tone on a negative.
Depth of field	Area of sharpness variable by aperture or focal length.
Depth of focus	Distance through which the film plane moves without losing focus.
Design	Basis of visual composition.
Diagonal	A line neither horizontal nor vertical.
Diaphragm	Aperture.
Differential focusing	Use of focus to highlight subject areas.
Diffuse	Dispersion of light (spread out) and not focused.
Diffuser	Material used to disperse light.
Digital	Images recorded in the form of binary numbers.
Digital image	Computer generated image created with pixels, not film.
Digital Negative	Adobe's open source Raw file format.
DIN	Film speed rating – Deutsche Industrie Norm.
Dioptres	Close-up lenses.
Direct light	Light direct from source to subject without interference.
Distortion	Lens aberration or apparent change in perspective.
DNG	Adobe's Digital Negative format.
Double dark slide	Cut film holder.
Dynamic	Visual energy.
DX coding	Bar coded film rating.
E-6	Transparency film process.
Ecu	Extreme close-up.
Electronic flash	Mobile 5800K light source of high intensity and short duration.
Emulsion	Light-sensitive coating on film or paper.
Equivalent	Combinations of aperture and time producing equal exposure.
EV	Numerical values used in exposure evaluation without reference to aperture or time.
Evaluate	Estimate the value or quality of a piece of work.

Expansion	Manipulating the separation of zones in B & W processing.
Exposing right	Increasing exposure when using a digital camera to increase the quality of shadow information.
Exposure	Combined effect of intensity and duration of light on light sensitive material.
Exposure compensation	The action increasing or decreasing exposure from a meter-indicated exposure to obtain an appropriate exposure.
Exposure factor	Indication of the increase in light required to obtain correct exposure.
Exposure meter	Device for the measurement of light.
Exposure value	Numerical values used in exposure evaluation without reference to aperture or time.
Extreme contrast	Subject brightness range that exceeds the film or sensor's ability to record all detail.
F-stop	Numerical system indicating aperture diameter.
Fall	A movement on large-format camera front and rear standards.
Fast film	Film with high ISO, can be used with low light levels.
Field of view	Area visible through the camera's viewing system.
Figure and ground	Relationship between subject and background.
Fill	Use of light to increase detail in shadow area.
Fill flash	Flash used to lower the subject brightness range.
Film	Imaging medium.
Film speed	Rating of film's sensitivity to light.
Filter	Optical device used to modify transmitted light.
Filter factor	Number indicating the effect of the filter's density on exposure.
Flare	Unwanted light entering the camera and falling on film plane.
Flash	Mobile 5800K light source, high intensity, short duration.
Floodlight	Diffuse tungsten light source.
Focal	Term used to describe optical situations.
Focal length	Lens to image distance when focused at infinity.
Focal plane	Where the film will receive exposure.
Focal plane shutter	Shutter mechanism next to film plane.
Focal point	Point of focus at the film plane or point of interest in the image.
Focusing	Creating a sharp image by adjustment of the lens to film distance.
Fog/fogging	Effect of light upon unexposed film.
Foreground	Area in front of subject matter.
Format	Camera size, image area or orientation of camera.
Frame	Boundary of composed area.
Fresnel	Glass lens used in spotlight.
Front light	Light from camera to subject.
Front standard	Front section of large-format camera.
Gamma	A mathematical formula describing the relationship between the input and output of a device. The Gamma setting on a monitor and in Photoshop controls the mid-tone brightness.

Gels	Color filters used on light sources.
Genre	Style or category of photography.
Gobos	Shaped cutters placed in front of light source.
Grain	Particles of metallic silver or dye which make up the film image.
Gray card	Contrast and exposure reference, reflects 18% of light.
Grayscale	An image where the color values have been converted to tones of gray.
Ground glass	Viewing and focusing screen of large-format camera.
Guide number	Measurement of flash power relative to ISO and flash to subject distance.
Halftone	Commercial printing process, reproduces tone using a pattern of dots printed by offset litho.
Hard/harsh light	Directional light with defined shadows.
HDR	High Dynamic Range.
High Dynamic Range	An image with full detail in the darkest shadows and brightest highlights that has been created from a subject with a brightness range that exceeds the latitude of the capture device. The HDR image is assembled in the image-editing software using multiple exposures.
High key	Dominant light tones and highlight densities.
Highlight	Area of subject giving highest exposure value.
Histogram	A graphical representation of a digital image indicating the pixels allocated to each level of brightness.
Hot shoe	Mounting position for on-camera flash.
HSL	Hue, Saturation and Luminance. Color controls found in Adobe Camera Raw and Photoshop Lightroom.
Hue	The name of a color, e.g. red, green or blue.
Hyperfocal distance	Nearest distance in focus when lens is set to infinity.
Image sensor	Light sensitive digital chip used in digital cameras.
Incandescent	Tungsten light source.
Incident	Light meter reading from subject to camera using a diffuser (invercone).
Infinity	Point of focus where bellows extension equals focal length.
Infrared film	A film sensitive to wavelengths of light longer than 720nm invisible to the human eye.
Invercone	Trademark of Weston. Dome-shaped diffuser used for incident light meter readings.
Inverse square law	Mathematical formula for measuring the fall-off (reduced intensity) of light over a given distance.
Iris	Aperture/diaphragm.
ISO	Film speed rating – International Standards Organisation.
JPEG (.jpg)	Joint Photographic Experts Group. Popular image compression file format used for images destined for the World Wide Web.

Key light	Main light source relative to lighting ratio.
Laboratory	Film processing facility.
Landscape	Horizontal format.
Large format	5 x 4 inch camera, 10 x 8 inch camera.
Latitude	Ability of the film or image sensor to record the brightness range of the subject.
Lens	Optical device used to bring an image to focus at the film plane.
Lens angle	Angle of lens to subject.
Lens cut-off	Inadequate covering power.
Lens hood	Device to stop excess light entering the lens.
Light	The essence of photography.
Lightbox	Transparency viewing system.
Lighting contrast	Difference between highlights and shadows.
Lighting grid	Studio overhead lighting system.
Lighting ratio	Balance and relationship between light falling on subject.
Light meter	Device for the measurement of light.
Long lens	Lens with a reduced field of view compared to normal.
Loupe	Viewing lens.
Low key	Dominant dark tones and shadow densities.
Luminance range	Range of light intensity falling on subject.
M	Flash synchronisation setting for flash bulbs.
Macro	Extreme close-up.
Matrix metering	Reflected meter reading averaged from segments within the image area. Preprogrammed bias given to differing segments.
Maximum aperture	Largest lens opening, smallest f-stop.
Medium format	2¼ inch or 6cm film or image sensor size.
Meter	Light meter.
MIE	Meter-indicated exposure.
Minimum aperture	Smallest lens opening, largest f-stop.
Monorail	Support mechanism for large-format camera.
Multiple exposure	More than one exposure on the same piece of film.
ND	Neutral density filter.
Negative	Film medium with reversed tones.
Negatives	Exposed, processed negative film.
Neutral density	Filter to reduce exposure without affecting color.
Noise	Electronic interference producing speckles within the image.
Non-cord	Flash not requiring direct connection to shutter.
Normal lens	Perspective and angle of view approximately equivalent to the human eye.
Objective	Factual and non-subjective analysis of information.
Opaque	Does not transmit light.

Open up	Increase lens aperture size.
Orthochromatic	Film which is only sensitive to blue and green light.
Out of gamut	Beyond the range of colors that a particular device can capture, display or print.
Overall focus	Image where everything appears sharp.
Overdevelopment	When manufacturer's processing recommendations have been exceeded.
Overexposure	Exposure greater than meter-indicated exposure.
Panchromatic	Film which is sensitive to blue, green and red light.
Panning	Camera follows moving subject during exposure.
Perspective	The illusion of depth and distance in two dimensions. The relationship between near and far imaged objects.
Photoflood	3400K tungsten light source.
Photograph	Image created by the action of light and chemistry.
Plane	Focal plane.
Polarising filter	A filter used to remove polarised light.
Portrait	Type of photograph or vertical image format.
Positive	Transparency.
Posterisation	Visible steps of tone or color in the final image due to a lack of tonal information in a digital image file.
Post production	Modifications made to an image after the initial capture using image-editing software such as Adobe Camera Raw or Photoshop.
P.o.v.	Point of view.
Preview	Observing image at exposure aperture.
Previsualise	The ability to decide what the photographic image will look like before the exposure.
Primary colors	The basic colors used to create all other colors. The colors blue, green and red are the additive primarics while cyan, magenta and yellow are the subtractive primaries.
Process	Development of exposed film.
Profile	A record of the unique characteristics of how a device records, displays or prints color and tone.
ProPhoto RGB	The largest of the working spaces used in Photoshop.
Pull	Underprocessing of film.
Push	Overprocessing of film.
QI	Quartz iodine light source.
Raw	The unprocessed data recorded by a digital image sensor. Sometimes referred to as Camera Raw or the 'digital negative'.
Rear standard	Rear section of large-format camera.
Reciprocity failure	Inability of film to behave predictably at exposure extremes.
Reflectance	Amount of light from a reflective surface.
Reflectance range	Subject contrast measured in even light.

Reflected	Light coming from a reflective surface.
Reflection	Specular image from a reflective surface.
Reflector	Material used to reflect light.
Refraction	Deviation of light.
Resolution	Optical measure of definition, also called sharpness.
Reversal	Color transparency film.
Rim light	Outline around a subject created by a light source.
Rise	A movement on large-format camera front and rear standard.
Saturation	Intensity or richness of color.
SBR	Subject brightness range, a measurement of subject contrast.
Scale	Size relationship within subject matter.
Scrim	Diffusing material.
Secondary	Complementary to primary colors, yellow, magenta, cyan.
Selective focus	Use of focus and depth of field to emphasise subject areas.
Shadow	Unlit area within the image.
Sharp	In focus.
Shutter	Device controlling the duration (time) of exposure.
Shutter priority	Semi-automatic exposure mode. The photographer selects the shutter and the camera sets the aperture automatically.
Shutter speed	Specific time selected for correct exposure.
Side light	Light from side to subject.
Silhouette	Object with no detail against background with detail.
Slave	Remote firing system for multiple flash heads.
Slide	Transparency usually 24 x 36mm.
Slow film	Film with reduced sensitivity and low ISO rating.
SLR	Single lens reflex camera; viewfinder image is identical to image captured by film or image sensor.
Small format	35mm film or a digital camera with a sensor no larger than 35mm.
Snoot	Cone-shaped device to control the spread of light.
Softbox	Heavily diffuse light source.
Soft light	Diffuse light source with ill-defined shadows.
Specular	Highly reflective surfaces.
Specular highlight	The brightest tone in an image that is not absolute white (255 or paper white).
Speed	ISO rating, exposure time relative to shutter speed.
Spotlight	Light source controlled by optical manipulation of a focusing lens.
Spot meter	Reflective light meter capable of reading small selected areas.
sRGB	A working space closely aligned to the color space of a typical monitor.
Standard lens	Perspective and angle of view equivalent to the eye.
Stock	Chosen film emulsion.
Stop	Selected lens aperture relative to exposure.
Stop down	Decrease in aperture size.
Strobe	5800K light source.
Studio	Photographic workplace.

Subject	Main emphasis within image area.
Subjective	Interpretative and non-objective analysis of information.
Subject reflectance	Amount of light reflected from the subject.
Swing	A movement on large-format front or rear standards.
Symmetrical	Image balance and visual harmony.
Sync	Flash synchronisation.
Sync lead	Cable used to synchronise flash.
Sync speed	Shutter speed designated to flash.
T	Shutter speed setting for exposures in excess of one second.
T-stop	Calibration of light actually transmitted by a lens.
Text	Printed word.
Thin	Overexposed positive, underexposed negative.
Thyristor	Electronic switch used to control electronic flash discharge.
TIFF	Tagged Image File Format. Popular digital image file format for desktop publishing applications.
Tilt	A movement on large-format front or rear standards.
Time	Shutter speed, measure of duration of light.
Time exposure	Exposure greater than one second.
Tonal range	Difference between highlights and shadows.
Tone	A tint of color or shade of gray.
Trace	Material used to diffuse light.
Transmitted light	Light that passes through another medium.
Transparency	Positive film image.
Transparent	Allowing light to pass through.
Tripod	Camera support.
Tripod clamp	Device used to connect camera to tripod.
TTL	Through-the-lens light metering system.
Tungsten	3200K light source.
Typeface	Size and style of type.
Typography	Selection of typeface.
Underdevelopment	When manufacturer's processing recommendations have been reduced.
Uprating film	Increasing the film speed.
UV	Ultraviolet radiation invisible to the human vision.
Vertical	At right angles to the horizontal plane.
Vibrance slider	A control for increasing color saturation in Adobe Camera Raw or Photoshop Lightroom. This control is less likely to render colors out of gamut when compared to the Saturation slider.
Viewpoint	Camera to subject position.
Visualise	Ability to exercise visual imagination.

White balance	The process of setting a neutral white point or value as the color temperature that is illuminating the subject changes.
White point	The color of white that a device creates, displays or prints.
Wide angle	Lens with a greater field of view than normal.
Workflow	A term used to describe a sequence of steps to achieve a particular result.
Working space	A color space that is optimised for editing images in a product such as Adobe Photoshop.
XMP	eXtensible Metadata Platform. Data saved with an image file.
X-sync	Synchronisation setting for electronic flash.
X-sync socket	Coaxial socket on lens or camera for external flash cable.
Zone System	Exposure system related to tonal values.

Resources

Agfa-Geveart. www.agfa.com.

American Cinematographer. www.cinematographer.com.

American Museum of Photography. www.photographymuseum.com.

An American Century of Photography. www.hallmark-institute.com.

Arriflex Professional Products. www.arri.com.

Australian Centre for Photography. www.acp.au.com.

Basic Design & Layout – Alan Swann. www.phaidon.com.

Basic Photography, seventh edition – Michael Langford. Focal Press. Oxford.

Benetton. www.benetton.com.

Communication Arts. www.commarts.com.

Digital Photography: Essential Skills – Mark Galer. Focal Press. Oxford.

Elinchrom Professional Products. www.elinchrom.com.

Focal Press. www.focalpress.com.

Fuji. www.fujifilm.com.

George Eastman. www.eastman.org.

Graphis. www.graphis.com.

Hugo Boss. www.hugoboss.com.

Kodak. www.kodak.com.

Louis Vuitton. www.vuitton.com.

Masters of Photography. www.masters-of-photography.com.

Museum of Modern Art. www.moma.org.

Photographic Education. www.photocollege.co.uk.

Photographic Lighting: Essential Skills – John Child and Mark Galer. Focal Press. Oxford.

Photographing in the Studio – Gary Golb. Brown & Benchmark. Wisconsin.

Photography – Barbara London and John Upton. www.harpercollins.com.

Photography – Selected from the Graphis Annuals. www.graphis.com.

Photography Until Now. Museum of Modern Art. New York.

Photoshop CS3: Essential Skills – Mark Galer and Philip Andrews. Focal Press. Oxford.

Polaroid. www.polaroid.com.

Richard Avedon. www.richardavedon.com.

Royal Photographic Society. www.rps.org.

Thames & Hudson. www.thamesandhudson.com.

The Focal Encyclopedia of Photography, third edition. Focal Press. Boston.

The History of Photography. Museum of Modern Art. New York.

The Image – Michael Freeman. Collins Photography Workshop. London.

Index